ARMS AGAINST FURY

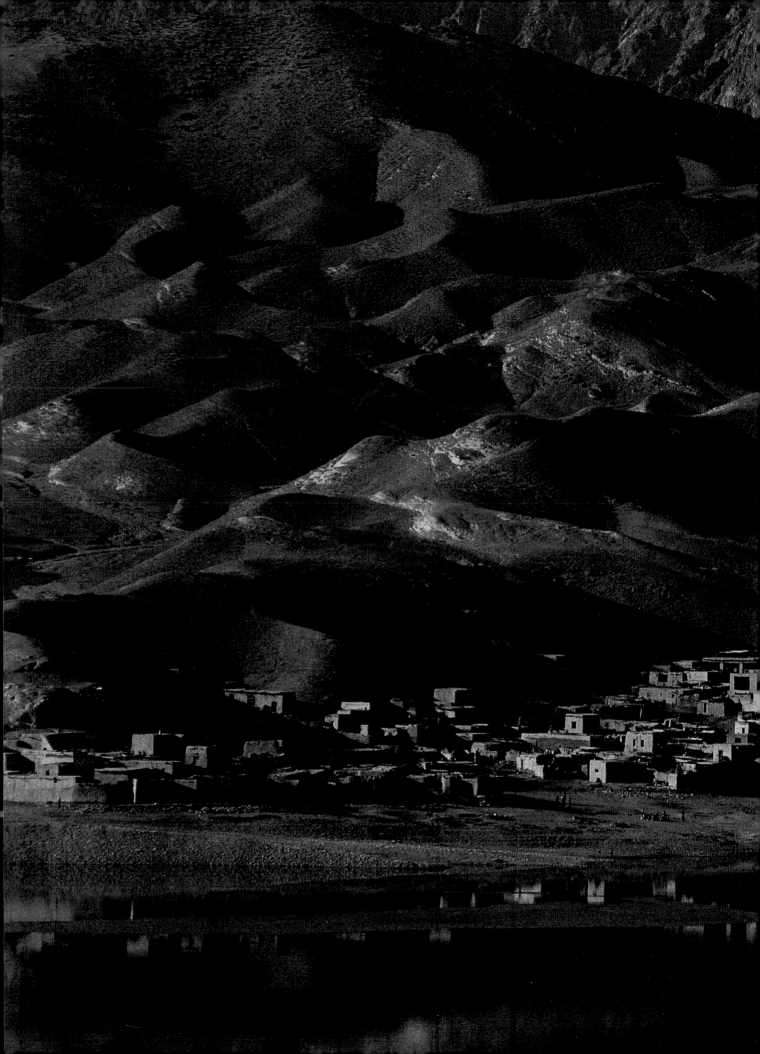

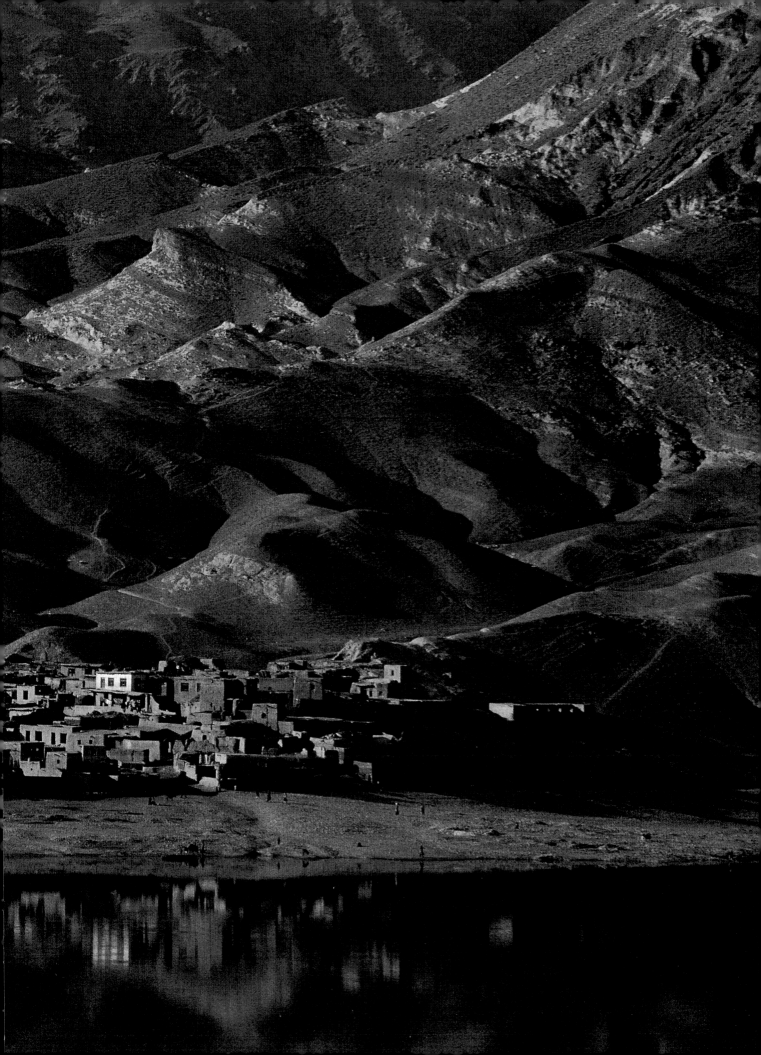

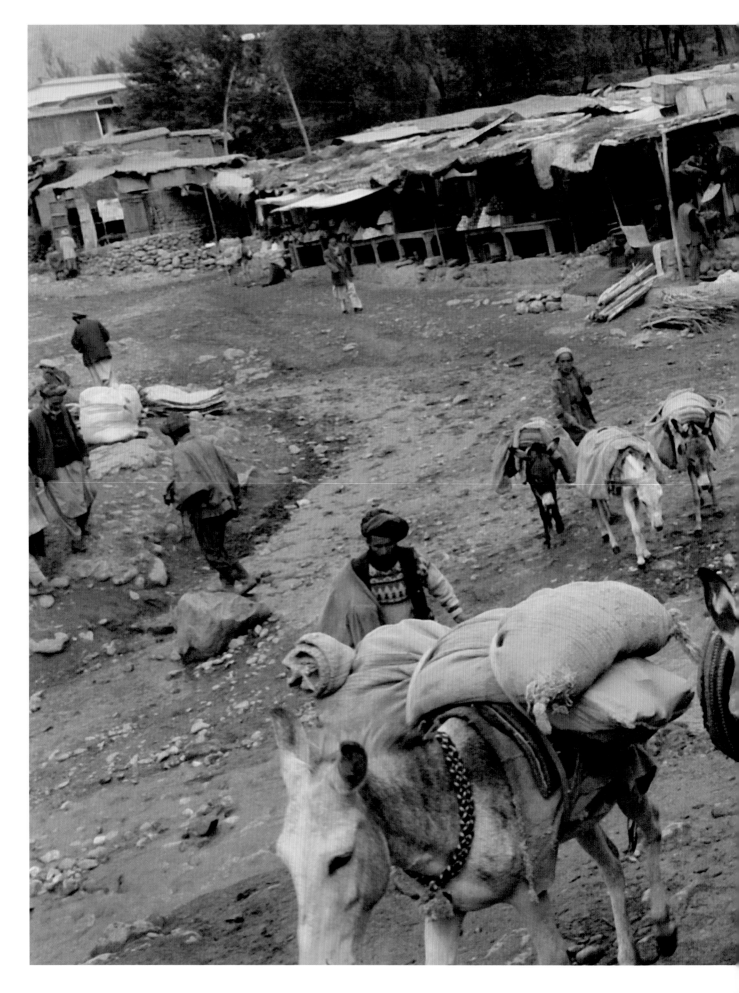

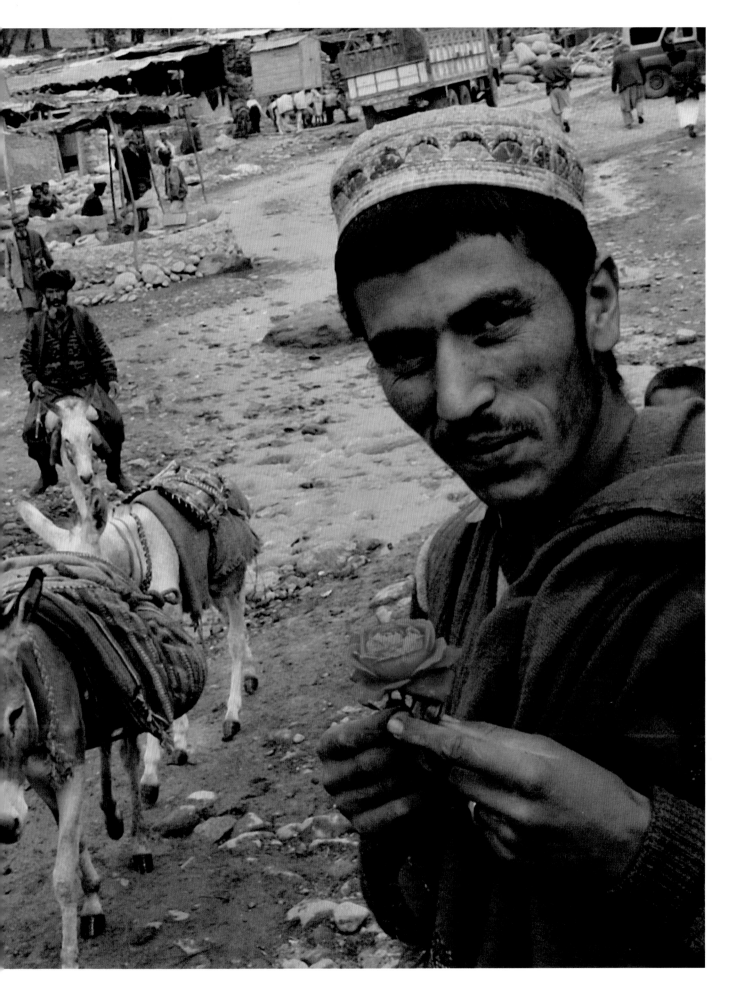

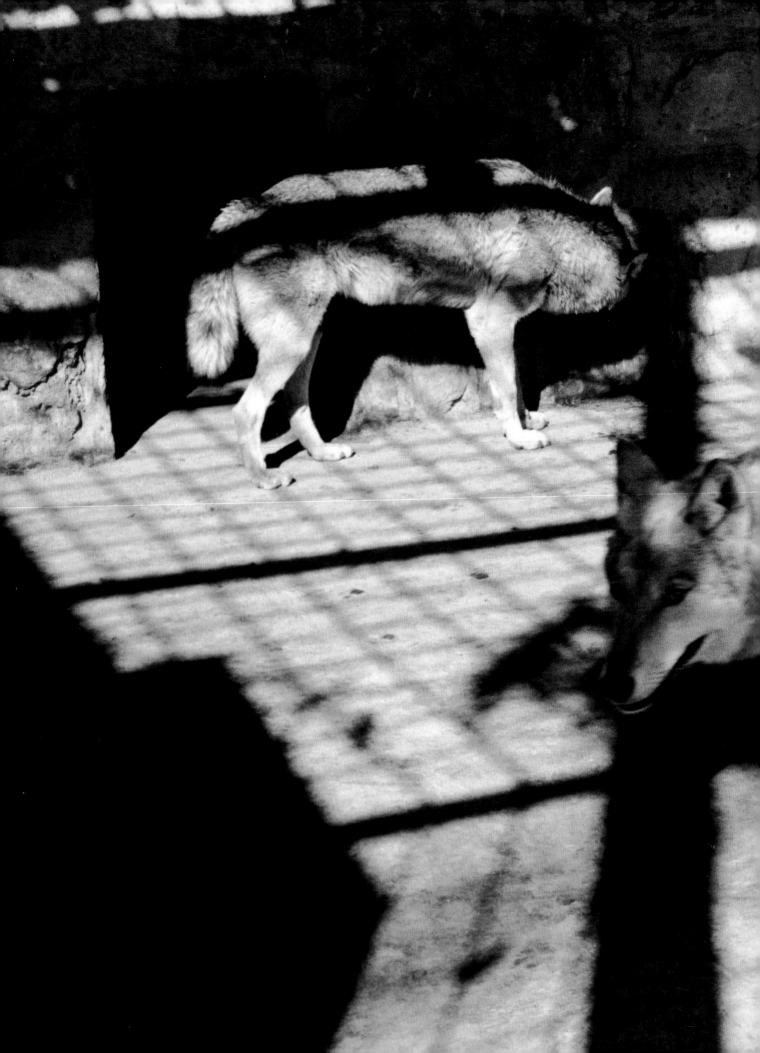

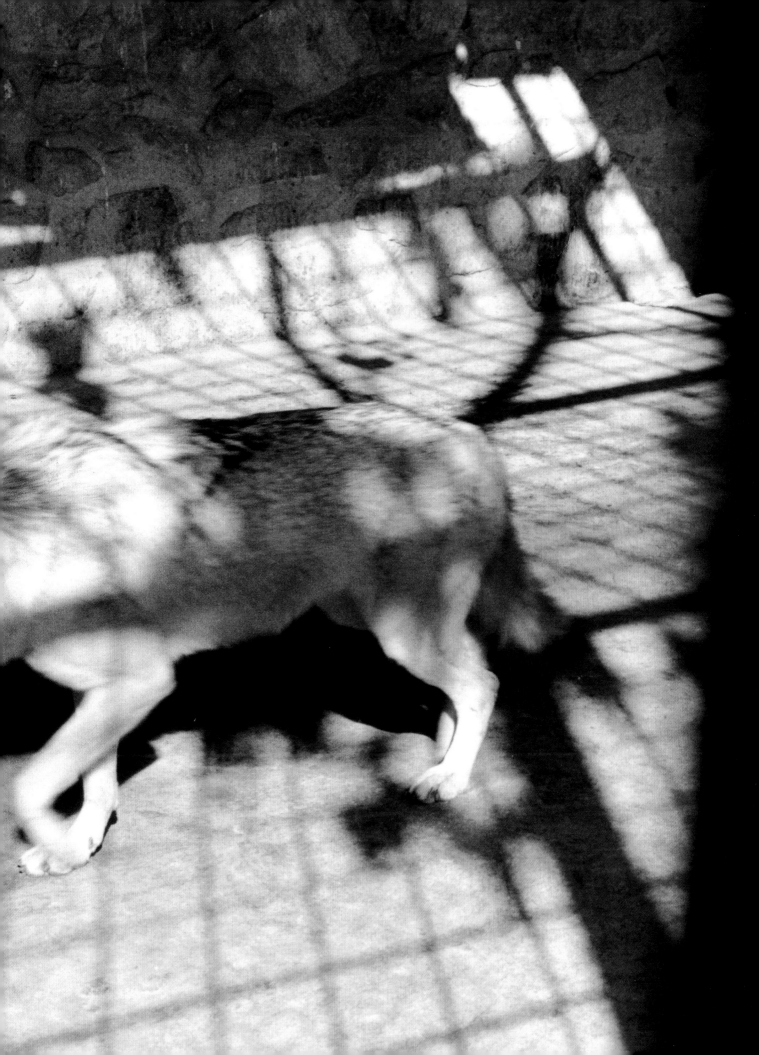

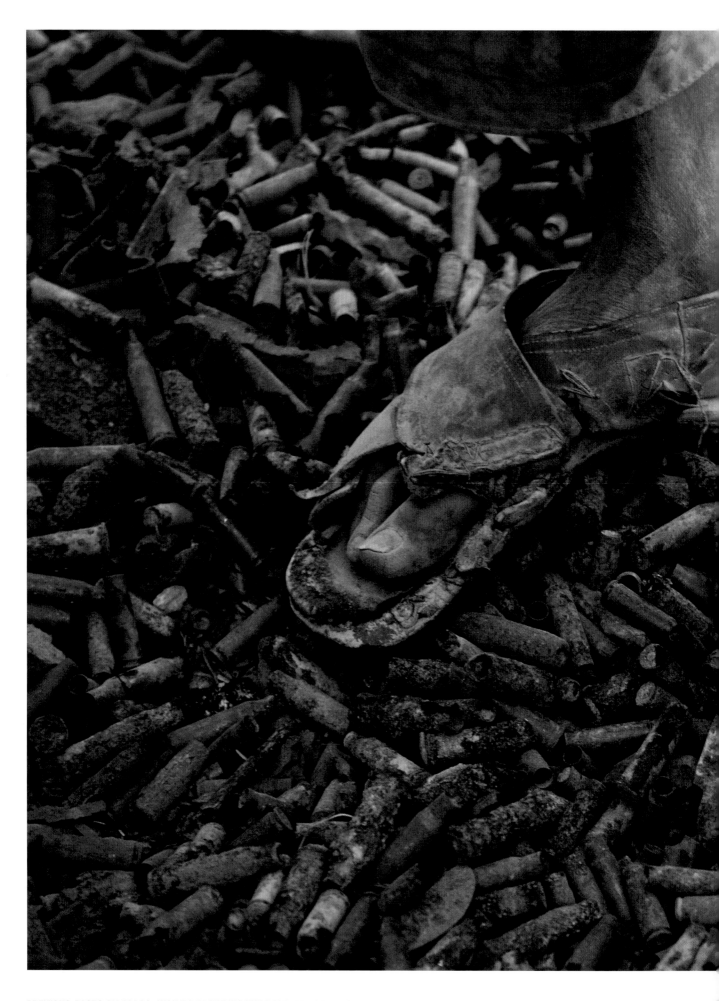

PREVIOUS PAGES BY ABBAS: WOLVES PROWLING THE DESERTED STREETS OF KABUL, 2001. ABOVE: SPENT SHELLS FROM FIGHTING BETWEEN GOVERNMENT

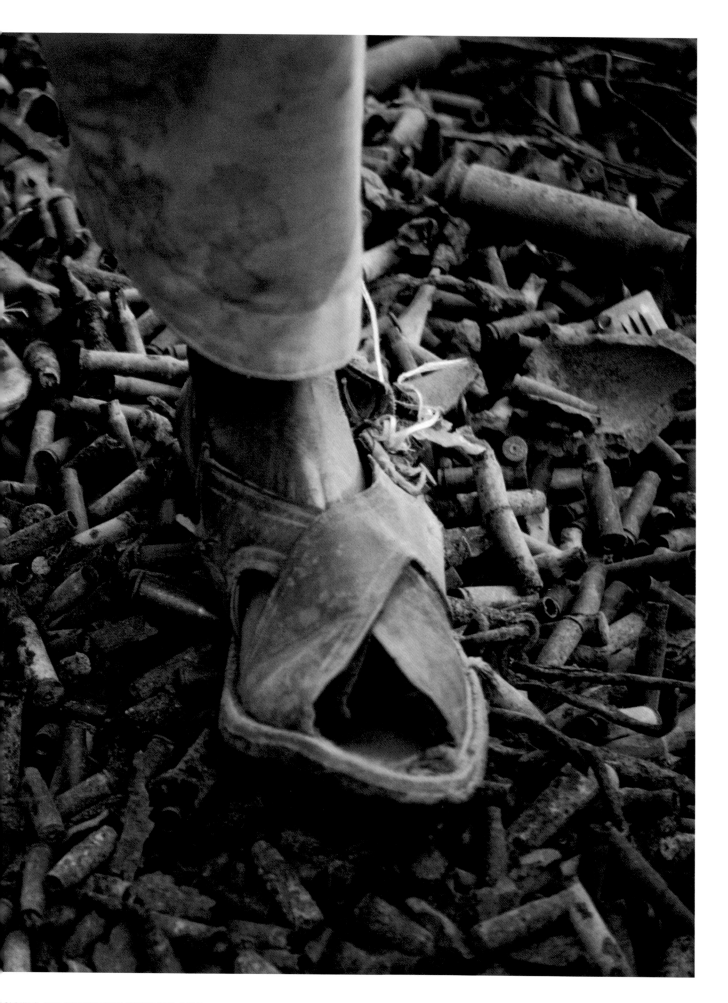

ARMS AGAINST FURY

MAGNUM PHOTOGRAPHERS IN AFGHANISTAN

EDITED BY ROBERT DANNIN

powerHouse Books
New York, NY

MOHAMMAD FAHIM DASHTY,
EDITOR OF *KABUL WEEKLY*

PREFACE

Freedom of the press has finally come to Afghanistan! Following the defeat of the terrorists, the Interim Authority revised the 1964 laws pertaining to print, radio, and television broadcasts. Part of the $4.5 billion pledged by donor countries in Tokyo in 2001 was designated to assist an active and open press. With some technical help from the United Nations and other foreign organizations, there are now eighty-seven different publications. Afghans have responded to these changes enthusiastically by purchasing our newspapers and magazines.

This is an exceptional event in our history as a nation, for the press has long been censored or manipulated by successive governments. During the final years of King Zahir Shah's reign, ironically called the "decade of democracy" (1963-73), the press, though nominally free, was secretly funded by the palace. The revolution of May 26, 1978 promised meaningful social reforms, but delivered instead a controlled media that banned any critical news or commentary unfavorable to the communist regime. The victory of the Mujahidin in 1992 led to the return of many anti-communist publications from exile in neighboring countries. Unfortunately, they did not recognize the principle of open political expression. The darkest days by far, however, were those spent under the Taliban, which forced responsible journalists back into exile if they could not keep quiet.

Today, we celebrate the removal of the Taliban and the dispersion of foreign terrorists who infested our land. Yet it is still too early to proclaim their total demise. Throughout 2002, armed resistance in the south and southeast demonstrated their resilience. It is imperative therefore that journalists explain the difference between terrorism and true religious faith to our many fellow citizens who remain confused after years of tyranny and indoctrination. It is our goal to follow the developed world into the information age, where open expression flourishes in print, over the airwaves, and on the Internet. Our task at hand is to build the foundations of an open press as a fundamental requirement for educating our people.

Afghanistan's newly acquired freedom is the best guarantee for a future of democracy and liberalism. Otherwise, we are certain to face more conflict and the risk of becoming once again a danger to the rest of the world.

It is my belief that the absence of a free press explains much about the years of conflict depicted in this book. I see ARMS AGAINST FURY not only as a record of our past but also a guide to protecting the future.

—Mohammad Fahim Dashty
Kabul, Afghanistan
May 2002

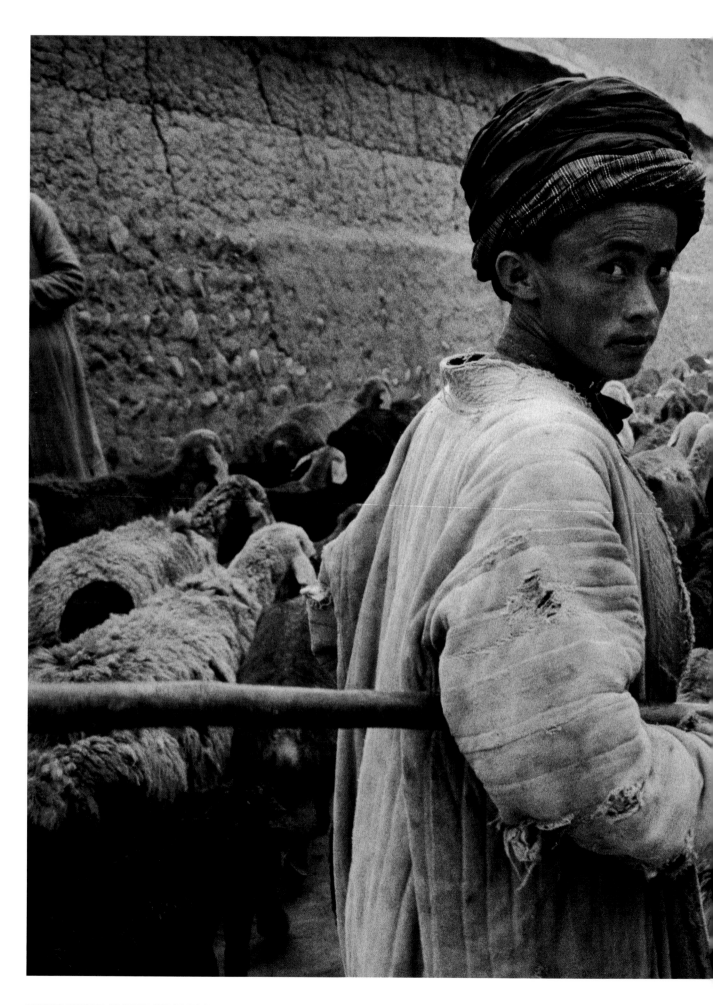

SUMMER-HERDING OF SHEEP AND GOATS TOWARD GREEN PASTURES IN THE MOUNTAINS, 1998.

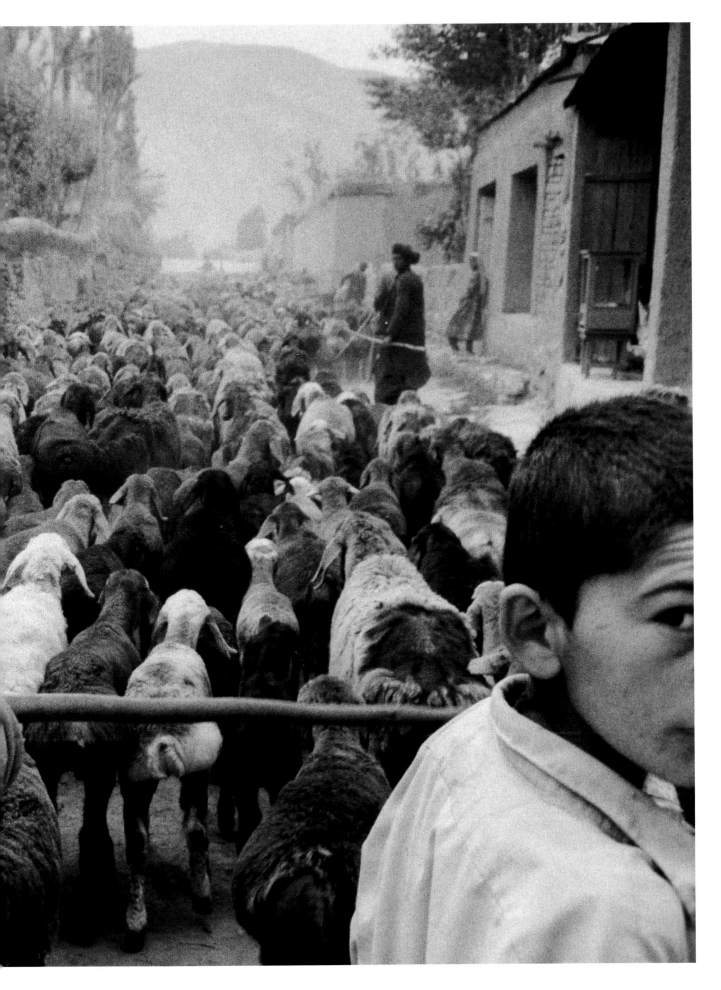

TABLE OF CONTENTS

COVERING THE WAR FROM PESHAWAR, THOUSANDS OF WESTERN
JOURNALISTS GATHERED AT THE GATEWAY TO AFGHANISTAN WHERE
MUSLIMS DEMONSTRATED THEIR OPPOSITION TO THE U.S.
MILITARY CAMPAIGN, FALL 2001.

PETER MARLOW 17

ARMS AGAINST FURY

Afghans understand that American politicians created this mess long before bin Laden. Afghans die every day; no one hears about it. If one American soldier dies, everyone knows. We know that this was a rivalry between the U.S. and the Soviet Union. Americans used us to fight their enemy and then they disappeared afterwards. Why did you abandon us?

—**Afghan in the Makaki refugee camp in Nimruz near the Iranian border**

The widows, orphans, and paraplegics of Afghanistan have a message to deliver above the raucous din of war. They do not proclaim themselves warriors of jihad nor antagonists in a clash of civilizations, only the unfortunate inhabitants of a place that has yet to become a monument to material excess. They are beggars in a world of luxury. Also the victims of stupid leaders, twisted preachers, malicious neighbors, and a global tyranny that reduces life-and-death judgements to market calculations or legislative appropriations. The violence they experience is an abstraction to us; its images are softened merely by juxtaposition to the picture of an imported automobile or an item of designer apparel. Bombs fall silently, their devastating aftermath narrated by pretty faces framed by expensive haircuts. Yet Afghan mothers explain that living in a tent is humiliating. Their parental dreams are full of fear, poverty, and sick children. Without compensation, their job is to shepherd the rest of the world from the sad twentieth century into a

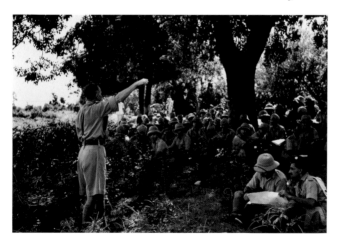

future of uncertain promise.

Their children learn only war, play only war, and grow up as fighters. A Taliban who says, "We wish to be martyrs. We have no fear of dying whoever is doing the killing," might be labeled a religious fanatic. But he can be more accurately described as a bored, emotionally hopeless child. Armed, of course, with weapons we have purchased for him, his beliefs tend more toward Rambo than the Holy Prophet. What we fear in him is not an alien religious past, but his distorted vision of our own prefabricated existence.

Since the Soviet invasion of December 1979 Afghanistan has experienced endless civil war and total social chaos with little prospect for peace or economic development. Much of the country's infrastructure has been destroyed and its political power dispersed among various regions and tribes. The strife opposed Soviet-backed Communist groups based in Kabul and different Mujahidin forces based in Pakistan and Iran, supported by billions of dollars from the United States and Saudi Arabia. After the Soviet retreat in 1989, these groups developed links with the new independent Central Asian republics whose presidents provided them with further military and financial assistance.

In the civil war that tore the capital apart from 1992 to 1996, virtually every group was at one time both the ally and the opponent of every other group, regardless of its religion, politics, or ethnicity. The militias fought over and consequently destroyed large swathes of Kabul. Elsewhere their struggles plunged Afghanistan's cities, villages, and vast countryside into a state of chronic insecurity, including the rape and abduction of women, and characterized

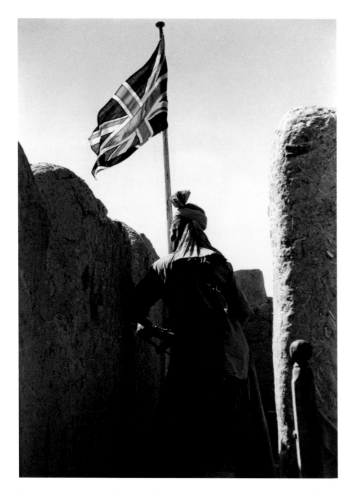

by omnipresent checkpoints of armed men extorting tribute from traders and travelers.

Meaningful political negotiations under United Nations auspices lapsed after 1992. In the immediate aftermath of the collapse of the Soviet Union, Afghanistan's strategic importance vanished in the fury of competing warlords and theocractic mullahs. Humanitarianism appeared at this time as an all-encompassing international response to state collapse and ethnic conflict. This approach failed in Afghanistan as it had previously in Bosnia and Somalia. When the Taliban captured and took control of Kabul in 1996, even emergency relief efforts were disrupted and subjected to periodic suspension according to the whims of their novice political authority. Once characterized by its harsh natural terrain, Afghanistan enters the millennium as the capital of land mines (8-10 million), opium production, and human rights abuse. Though freed from virtual home detention under Taliban rule, Afghan women still cannot publicly articulate their desires for equality and respect.

Four million Afghans have been driven from their homes since 1979. Countless thousands have perished. Some have lost all hope for a better future. As survivors, they carry only grim memories and bitter resentment into the future—unless essential human values can be nurtured among the ruins.

In this notion there is always hope for a renaissance. Though no one can predict where or when, it is nonetheless instructive to know that there was also an unrealized potential in the chronic disorder of fourteenth-century Italy, which prompted Francesco Petrarch, its most literate exponent, to proclaim, "Virtue will take up arms against fury and may the battle be brief, for the ancient valor is still alive."

MAGNUM PHOTOGRAPHERS IN AFGHANISTAN

The documentation in this book records a dynamic history of Afghanistan through the individual eyes and minds of Magnum photographers. They too deliver messages that are unique in their quest for a sustained vision of social and historical events. While they cannot create authentic representations of the Afghani's experience, they work on the raw materials of news reporting quite differently than newspapers and the electronic media. Some are forensic specialists who select their images in direct relation to a particular event. Others practice their craft by associating images with wider networks of meaning—for instance, a social or geographical space. Still others have become master griots, spinning narratives in the complexity of one or more frames. Finally, there are the technical experts whose narrative license derives from mastering the image

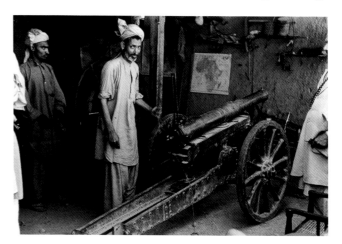

LEFT: BRITISH FRONTIER FORCE RECRUITS IN TRAINING AT LANDI, KHOTA; ABOVE LEFT: TRIBAL TERRITORY ON THE BORDER BETWEEN INDIA (NOW PAKISTAN) AND AFGHANISTAN. EVERY ROAD AND HILLTOP WAS HEAVILY GUARDED BY A LOCAL TRIBESMAN; ABOVE: DEMONSTRATION OF LOCALLY MANUFACTURED ARTILLERY AT THE ZARGHUNKHEL FACTORY, 1941.

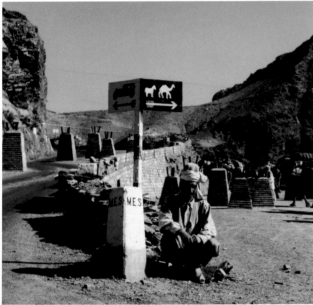

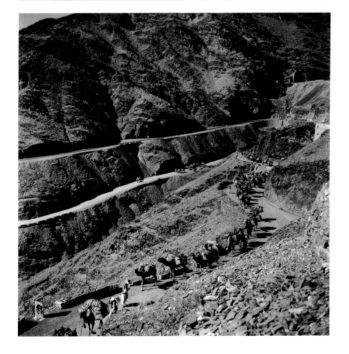

as the unifying symbol of its particular elements. Here, faces, objects, and ensembles assert their autonomy as signifiers and can transform a single photograph into an icon or statement. Nothing of this sort is possible in the hypnotic staccato of televised images.

Established in April 1947 at the beginning of the Cold War, the Magnum agency summoned "concerned" photojournalists to unite in the defense of free expression and individual copyright. It was a courageous and bold act in an era of nascent magazine conglomerates who demanded total ownership of their correspondents' pictures. Steeped in the euphoria of Europe's liberation from Nazi terror, Magnum's founders envisioned a cooperative venture that would guarantee a truly independent media. This dream, tethered to the political foundations of social democracy, brought together a Frenchman, Henri Cartier-Bresson, and an Englishman, George Rodger, with two East European émigrés, Robert Capa and David Seymour. Their chemistry imbued the new organization with Rabelaisian surrealism, a Kiplingesque spirit of adventure, and a brooding, Conradian fascination for the darker aspects of human character. More than fifty years later, the calling of Magnum's peer-selected members has not changed. In an age of real-time events broadcast via television and transmitted over the Internet, they continue the struggle to represent history through the lens of personal experience, competing against all odds in an age of predatory media giants.

Arms Against Fury examines the extraordinary land and dramatic struggles of the Afghan people over a half-century through the lens of Magnum photographers. It begins with co-founder George Rodger's documentation of British military strategy in the Khyber Pass during World War II. When the Nazis were expelled from Iran in 1941, the British quickly deployed colonial troops along the Khyber Pass to prevent them from moving eastward across Afghanistan to attack the North-West Frontier Province (now Pakistan). George Rodger photographed the British defensive preparations and observed general conditions of both sides along the border.

TOP TO BOTTOM: FORTIFIED VILLAGES ON THE PESHAWAR-KABUL ROAD; SIGN DIRECTING CAMEL CARAVANS AND HORSES ONE WAY, MOTOR VEHICLES THE OTHER, KOHAT PASS; CAMEL CARAVAN ON ROUTE TO KABUL FROM PESHAWAR, KHYBER PASS, 1941. OPPOSITE PAGE: TRIBAL LEADERS IN PESHAWAR.

Ever since, Magnum's intrepid photographers have crisscrossed Afghanistan's striking landscape, from the Central Asian steppes to the parched southern desert by way of the Hindu Kush mountains surrounding Kabul and the adjacent Panshir Valley. In the 1950s and 1960s, Eve Arnold, Marc Riboud, and Wayne Miller filed unprecedented stories from a legendary Shangri-la to the outside world. They showed a small kingdom struggling for statehood and a modern identity, though seriously limited by underdevelopment and its unfortunate geographic position in the Cold War.

Following the overthrow of the monarchy in 1973, the brutal liquidation of Afghanistan's "republican" government, in 1978, heralded the arrival of Soviet-style Communism. Peasants in Nuristan rebelled immediately against the Kahlq-Parcham regime's plans for forced collectivization by initiating a jihad that was covered first by Raymond Depardon, then Steve McCurry. Their hosts insisted that the photographers bear witness to their fight on behalf of the entire Western media, a request McCurry honored by returning sixteen times in the next two decades. His passionate interest was joined by that of the renowned photojournalist Abbas, who documented the regime's efforts at modernization and social reform for Afghan men—and women too.

When American weapons and Saudi Arabian money helped the Mujahidin defeat the Soviet invaders in 1989, it contributed significantly to the disintegration of the U.S.S.R. Ironically, this pyrrhic victory also signaled the end of Western interest in Afghanistan and the beginning of a civil war that lasted from 1992 to 1997. Photographed by Luc Delahaye, Chris Steele-Perkins, Abbas, and Steve McCurry, the incessant fighting destroyed most of Kabul, and led to widespread lawlessness, including rape and the abduction of women. The country's only cash crop was opium for manufacture into heroin as barter for more weapons.

After the ultra-religious Taliban militia finally subdued other warring factions in 1996, they proclaimed an Islamic emirate, alluding to the splendor of the ancient Silk Road once dominated by Muslim caliphs. Chris Steele-Perkins was one of the few journalists to report from Afghanistan during this period of theocratic tyranny. Significantly, his book *Afghanistan* (Westzone, 2001) is notable for its depiction of the devastation and nefarious consequences of this war.

In the wake of the September 11 attacks on New York and Washington, the U.S. government eschewed diplomacy and relentlessly bombed Afghanistan. The hated Taliban were shaken from power by a loose alliance of Mujahidin and other tribal warlords, but nothing seemed to remedy the miserable spectacle of a ruined country littered with land mines, limbless bodies, and broken spirits. Amid the death and destruction wrought by American bombs, this phase of the war liberated Afghans from the yoke of the Taliban tyranny. As depicted by Abbas, Luc Delahaye, Thomas Dworzak, Alex Majoli, and Francesco Zizola, however, its outcome is far from certain as few people bothered to even count the innocent victims of the hi-tech "war on terror."

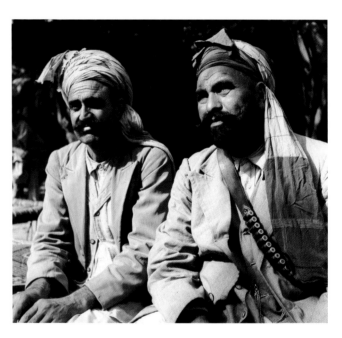

Several photographers present during pivotal moments in Afghanistan's timeline have contributed commentary. One text, Lesley Blanch's "Beyond the Veil," was originally published with Eve Arnold's pictures in the *London Sunday Times Magazine*; it is reprinted here both for its lyricism as it is for its ability to inform the reader about the status of Afghan women thirty years ago. Additional photographs by Ian Berry, Elliott Erwitt, Stuart Franklin, Peter Marlow, and Susan Meiselas fill in some of the blind spots of a visual chronicle that makes no claim to be historically comprehensive; rather they further the cause of an interpretive work by concerned photographers

—Robert Dannin
May 2002

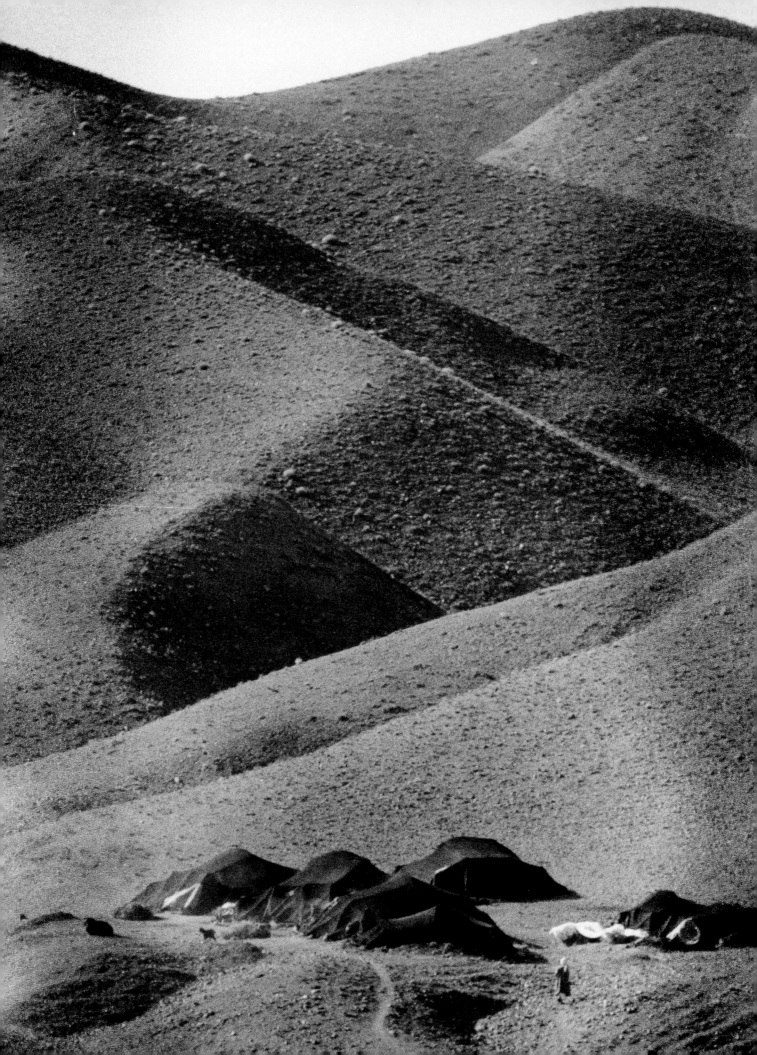

1

THE LIMITS OF EMPIRE

Afghanistan represents the geographical limits of ancient and modern world empires. In the classical era, Alexander the Great sought to make landlocked Bactria into the eastern outpost of Hellenistic civilization. By the third century B.C., Greek merchants and craftsmen had carved cities and amphitheaters into the Hindu Kush mountains. They minted coins and erected temples dedicated to their deities, including Zeus, the god of war.

In the first century B.C., Bactria was conquered by Central Asian nomads, followed by Persians, and finally by Indus Valley kingdoms whose artisans sculpted the giant Buddhas at Bamiyan between the fourth and sixth centuries A.D. Chinese dynasties also coveted Afghanistan, but lost the prize to the Muslim Arabs at the beginning of the eighth century. For the next thousand years, Afghanistan's diverse cultures rose and fell according to the fortunes of trade along the legendary Silk Road.

In the nineteenth century, the British fought two unsuccessful wars to extend their colonial domain westward from India. Their defeat at the hands of guerrilla warriors signaled the decline of London's imperial domain, and prompted the following dire warning from Rudyard Kipling:

> *When you're wounded and left on Afghanistan's plains*
> *And the women come out to cut up what remains*
> *Just roll to your rifle and blow out your brains*
> *An' go to your Gawd like a soldier.*

The poet's admonition went unheeded by the Russian Red Army who invaded Afghanistan in 1979. A decade later they were forced out in a shattering defeat that marked the spatial and historical limits of the crumbling Soviet empire. Afghanistan began the twenty-first century in the midst of a new contest between Americans and Arabs who both claimed credit for this victory.

ENCAMPMENTS ON THE ROAD FROM JALALABAD TO KABUL, 1971.

1955 A SYMBOL THEN AND NOW

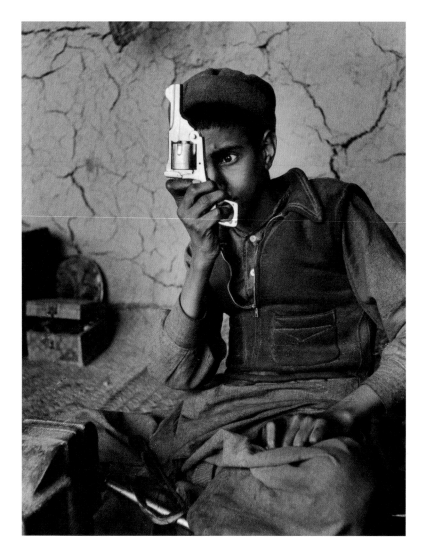

TRIBAL MUNITIONS FACTORY NEAR KOHAT
PASS ON AFGHANISTAN'S LAWLESS BORDER WITH PAKISTAN;
RIGHT: FAMILY OUTING ALONG THE KABUL RIVER.

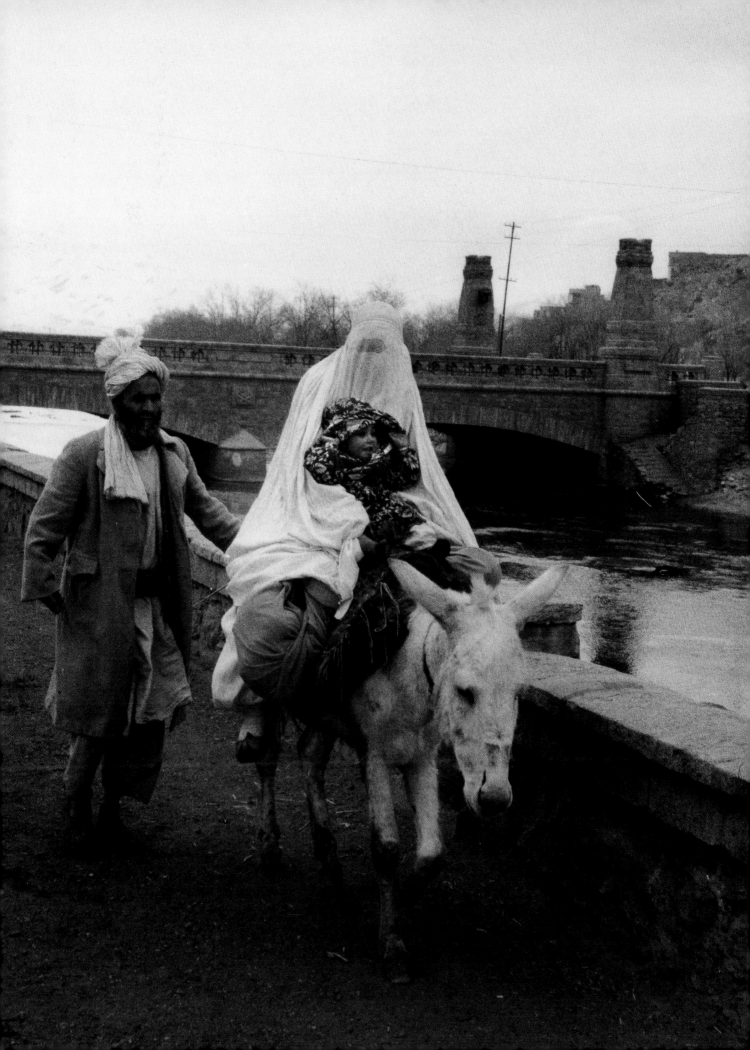

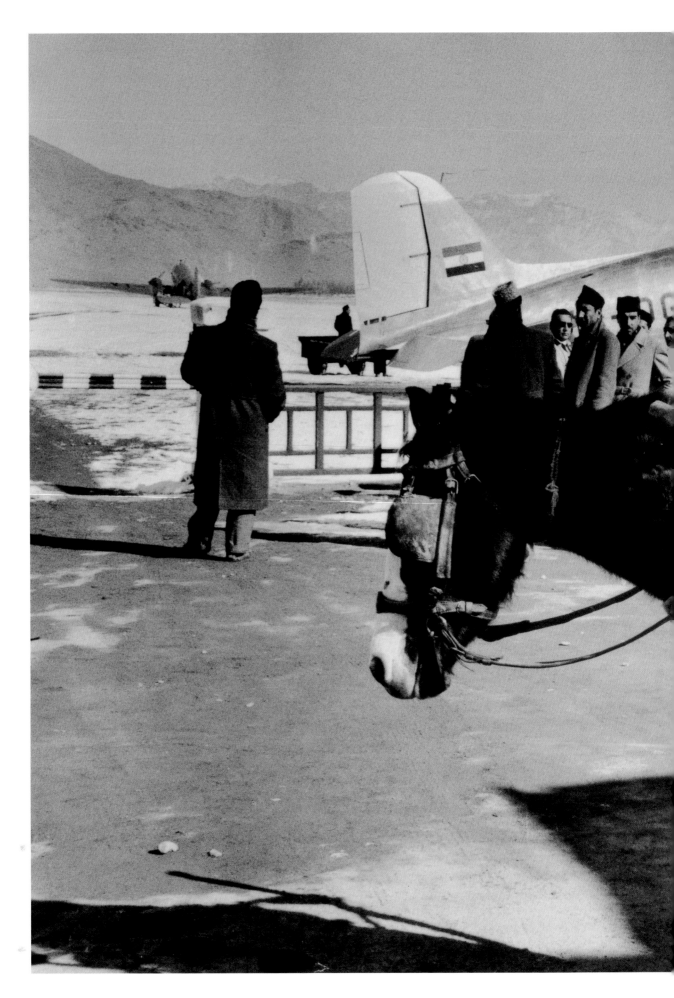

ARIANA AFGHAN AIRLINES ASSURED INTERNAL TRANSPORTATION IN ASIA'S ONLY COUNTRY WITHOUT RAILROADS.

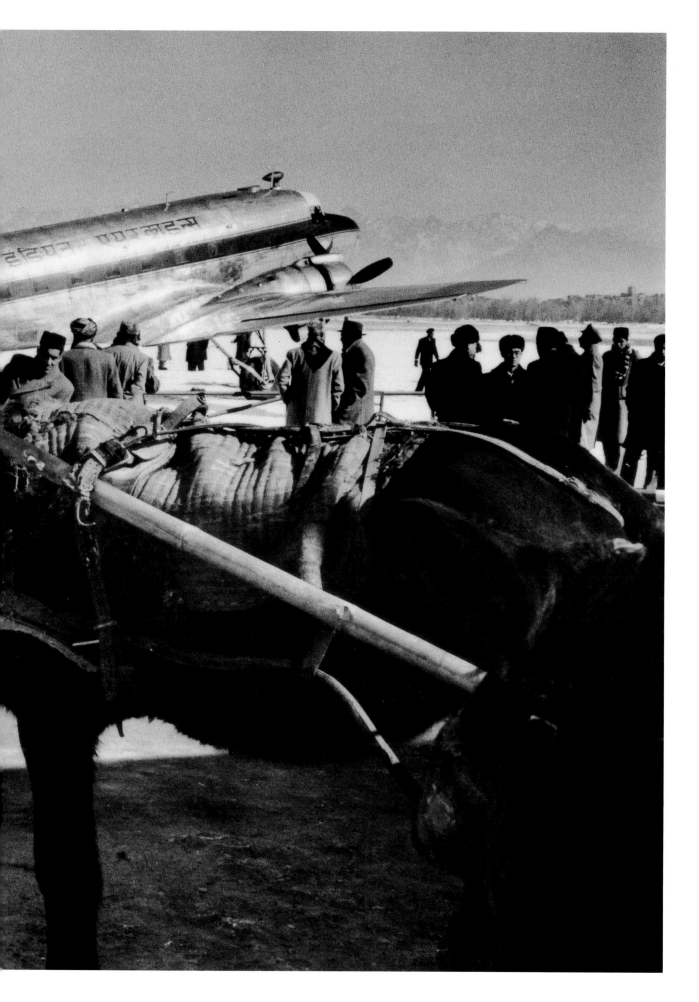

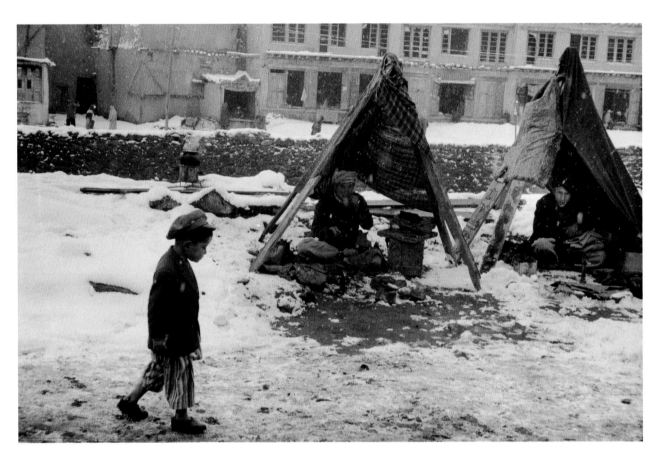

KABUL STREET VENDORS TAKING SHELTER FROM THE WINTER CHILL.

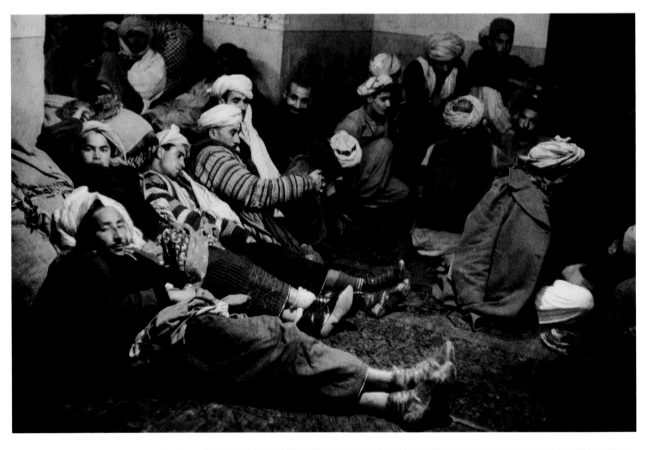

ABOVE AND OPPOSITE PAGE: SCENES FROM A TEA HOUSE ON THE ROAD BETWEEN KABUL AND BAMIYAN WHERE MANY TRAVELERS SPEND THE NIGHT.

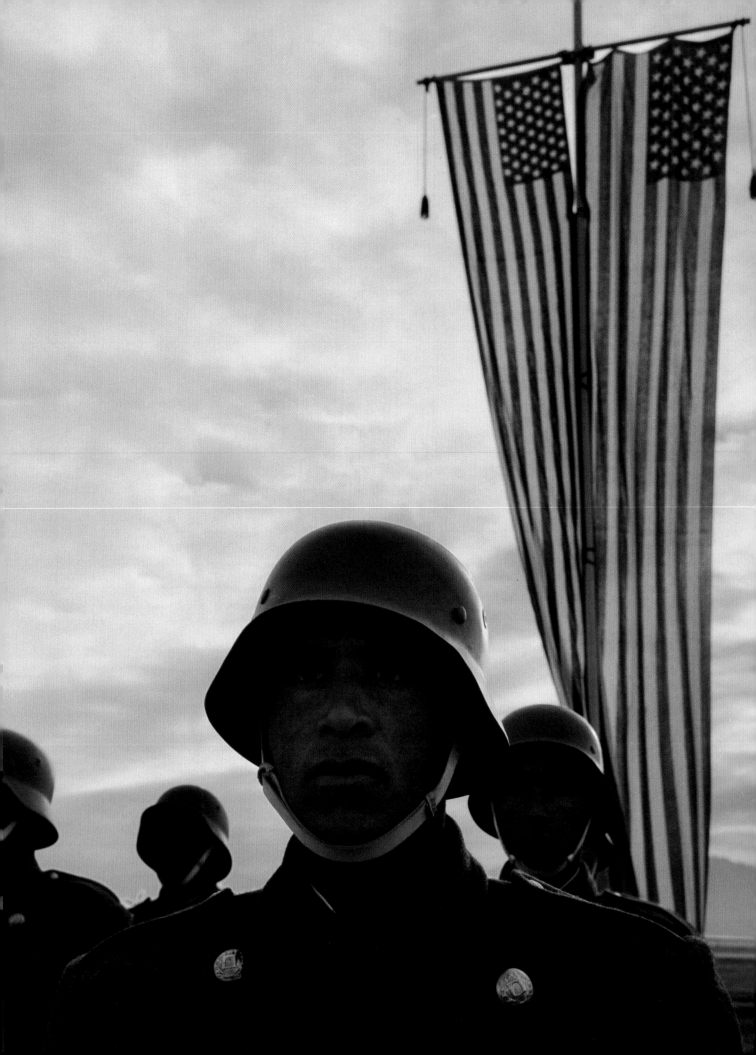

1959 EISENHOWER IN KABUL

BY DOUGLAS BRINKLEY

On December 9, 1959, Dwight D. Eisenhower, while on a goodwill mission to Central Asia and the Middle East, made a pilgrimage to Kabul. There, he met with the eager, 45-year-old Afghan king Mohammad Zahir Shah, the same king many now would like to see return from exile to reclaim the throne in Kabul.

President Eisenhower had long been eager to visit that strange and forbidding land. "It was a boyhood dream of his to see the Khyber Pass and size up how tough their soldiers were," General Andrew Goodpaster, who served as Eisenhower's assistant on that Afghan trip, recently recalled. On the morning of December 9, Eisenhower, who had been in Karachi to discuss with President Mohammad Ayub Khan Pakistan's troublesome relationship with India, flew from Pakistan to Bagram Airport, 38 miles from Kabul. The flight, as reported by Russell Baker in *The New York Times*, was harrowing: as the president's jet swooped across the snow-capped peaks dividing Pakistan from Afghanistan and prepared to land, "six Soviet MIG-17s flown by Afghan pilots streaked out to escort it in." This was no accident; Soviet aid had been pouring into the country since 1955, when Nikita Khrushchev had visited. The Kremlin was eager to give Ike a little reminder that it

was in charge in this supposedly neutral nation. This was just the beginning of one of the most curious days of Eisenhower's presidency.

Winter had set in on this landlocked nation of 12 million people and the temperature was near freezing, yet tens of thousands of villagers lined the route from the airport to Kabul. Zahir Shah, looking like a boyish stand-in for Charles de Gaulle, escorted Eisenhower down the route (now paved by the Soviets) that had been traveled by Alexander the Great, the Persians, and Genghis Khan. Many of the tribesmen cheering at the sides of the road had been waiting for hours, warming themselves over small bonfires. "Faces were weather-beaten, often hidden by full beards and turbans, more than faintly similar to biblical pictures of the time of Abraham," Eisenhower later recollected in his memoir, *Waging Peace*. "Few, if any, women were present."

Once at Chilstoon Palace, Eisenhower and the king talked for five hours, with Eisenhower raising concerns over the Afghan monarchy accepting so much Soviet aid, and the king asking for more than the $145 million in economic assistance that the United States already had promised him for building roads, a new airport in Kandahar and dams, and for training teachers.

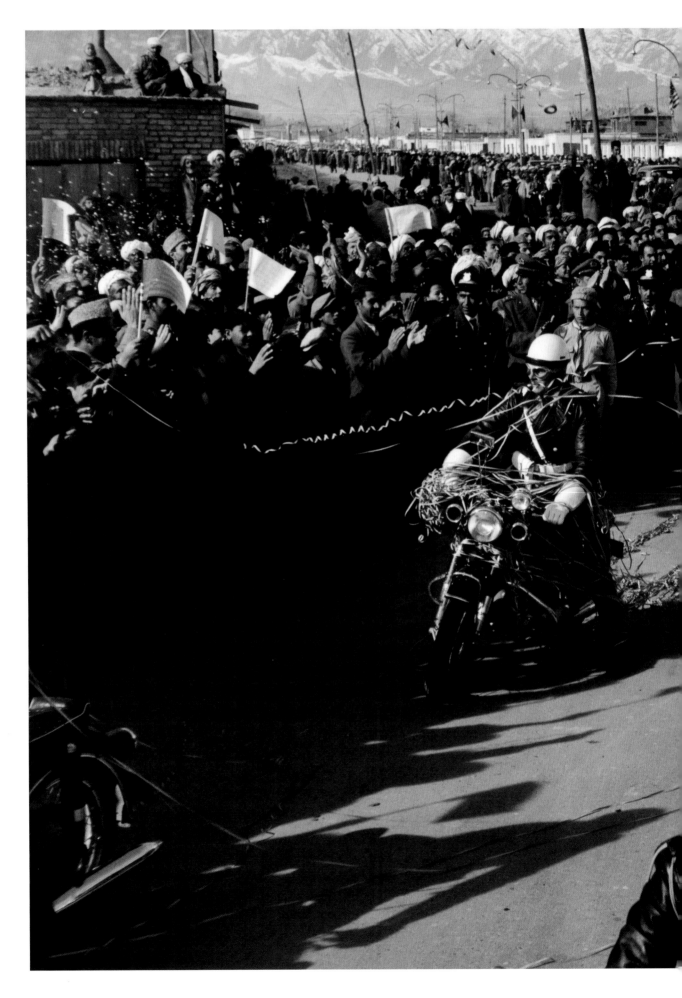

TENS OF THOUSANDS OF VILLAGERS LINE THE ROUTE FROM BAGRAM AIRPORT TO KABUL.

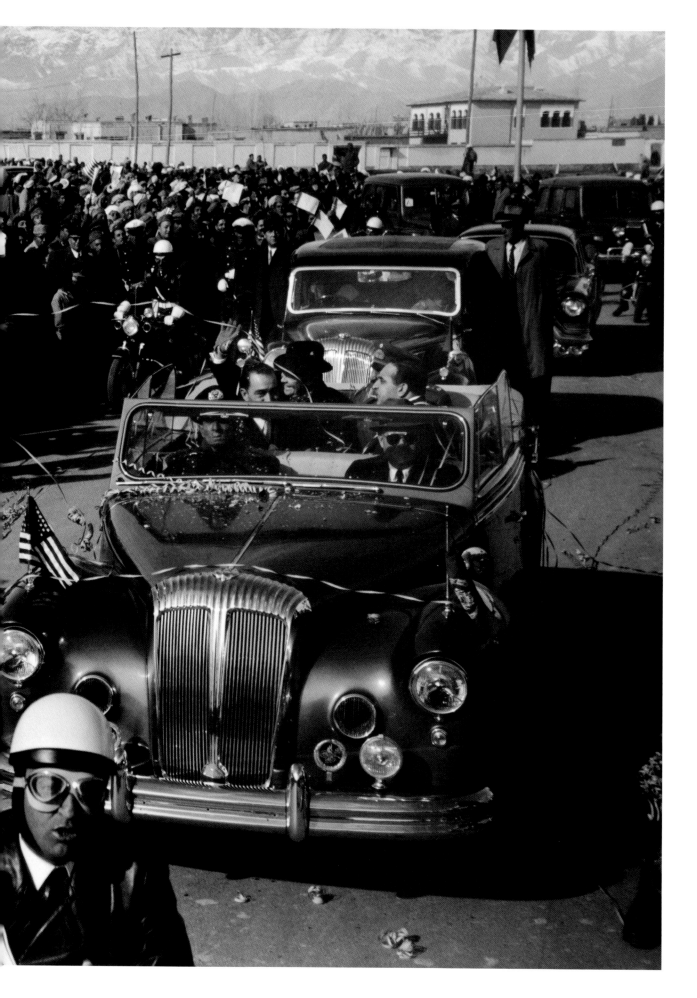

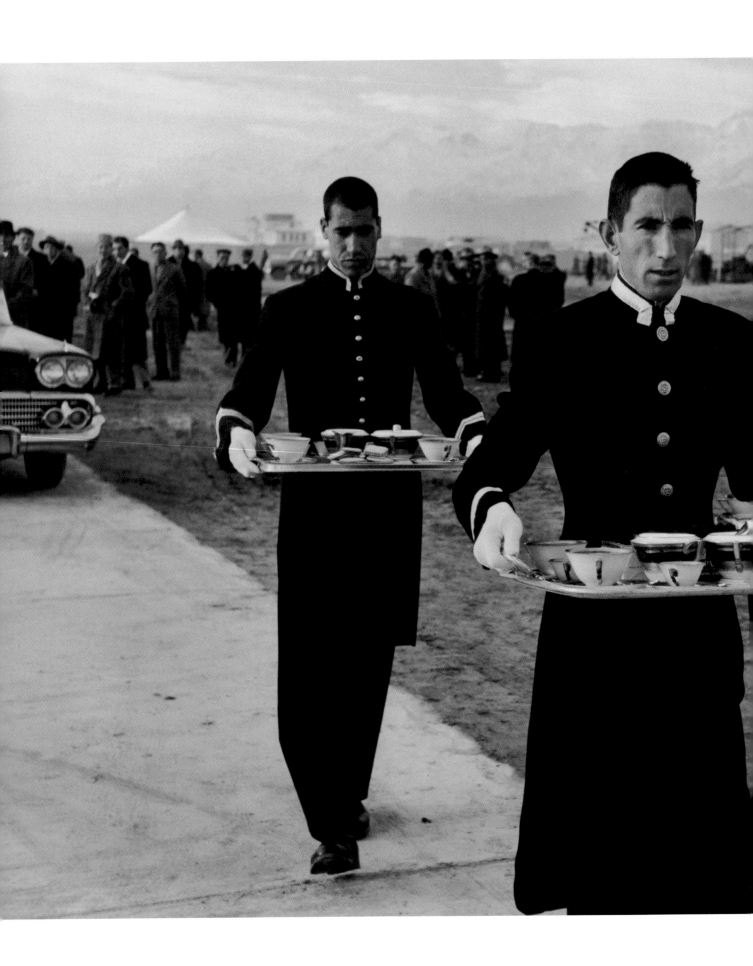

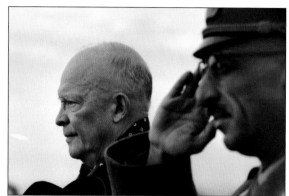

Besides making a plea for more money, the king also hoped that Eisenhower could intervene with two particularly difficult problems: improving Afghanistan's relationship with Pakistan and help in solving a prickly water dispute with Iran. According to a later declassified report on the Eisenhower-Zahir Shah meeting, the president told the king that "nothing was easy these days," and that he was "not a mediator," but would "do what he could."

General Goodpaster remembers talking to Ike as the president's plane finally left Afghan soil. The president liked Zahir Shah, but his mind was not on cold war politics or economic aid. (The joint communiqué issued by the two leaders said little of substance, mainly noting that the trip "had strengthened the already warm and friendly relations between the two countries.") Instead, Eisenhower was most interested in the chanting tribesmen he had seen and the desolate majesty of the Hindu Kush. As General Goodpaster recalls, Ike considered the Afghans "the most determined lot he had ever encountered."

Douglas Brinkley is director of the Eisenhower Center for American Studies and professor of history at the University of New Orleans. Originally published in The New York Times, January 12, 2002.

KING MOHAMMED ZAHIR SHAH GREETED EISENHOWER AT THE AIRPORT. ROYAL SERVANTS BEARING REFRESHMENTS APPROACH IKE'S PLANE.

1969 BEHIND THE VEIL

BY LESLEY BLANCH

"Come out from behind your veils and into the 20th century," President Bourgiba appeals to the women of Tunis. And everywhere Muslim leaders and progressives exhort women to shed this reviled piece of drapery. Judged by Western standards it is an archaic stranglehold, something which imprisons a woman, prevents her from breathing properly or being seen by any eye but that of her overlord. But the veil is a whole way of life, as well as a mystique.

The veil—a loose term, for it goes by many names and forms—came to Islam by way of Byzantium. Thus it is the veil of tradition, and Islam does not give up its traditions lightly. It is the veil of protection, of refuge, for a woman importuned by a man or in danger. Islam still considers women in need of protection, and there is a time-honored Afghan custom that if a woman in distress sends her veil to any man, calling on him as her brother to come to her aid or to her family's, he must in all honor comply. Next it is the veil of convenience, a point upon which even the most emancipated women agree, for it can hide shabbiness or nakedness. And it is the veil of equality, ever a pillar of Islam, where fortune and noble birth are regarded as accidental: it is not the burka, chadri, melaiyeh, yashmak or whatever it goes by that, in general, a woman's status is gauged. Then, it is the veil of coquetry—now you see her, now you don't—and here again it acts as an equalizer, for a melting pair of eyes glimpsed through the muslins or latticed eye-pieces may or may not indicate further delights. However, Muslim men everywhere say they know at a glance if it conceals a pretty woman or plain, young or old. I am reminded of the French girl married to an Afghan, who, when she went out á l'Européen, passed unremarked (although she was pretty); but when she wore the chadri she was pursued with gusto. Afghan men, like most others, appreciate the erotic connotations of mystery.

Which brings us to another aspect of the veil. It is also the garment of intrigue, of adventure, lending itself to secret assignations—"the midnight's kind admittance," either sheltering a daring woman or disguising her lover. The *Thousand and One Nights* tells several such tales, and much of it can still be read as a primer to that ardent world of the senses which Islam has never denied. Lastly, it is the veil of seclusion, or privacy, another essential aspect of Muslim life. This sense of reticence, of the inviolability of private life, is deeply rooted in both men and women. It is particularly expressed in their discretion over family affairs. For instance, it is indeed bad etiquette to inquire after a man's wife, for theoretically, if no longer literally, she is in purdah, a phantom figure not to be conjured by word or deed. This basic sense of withdrawal or retreat is also expressed architecturally in the enclosed, hidden world of courtyard and rooftop. It also manifest in the narrow entrance way, usually blocked by a blank wall, screening from the casual eye all domestic life within. This is the harem—sanctuary, or forbidden, in the double sense of the word. How far—how *very* far—from the permissive society of the West.

Afghanistan, this wild and lovely kingdom, ruled by a constitutional monarch, lies at the crossroads of Central Asia, and if it has remained curiously unknown compared with its neighbors, it is because it was once considered inaccessible: you could not reach it by boat, for there was no coast; nor by train or airplane, for there were no railways or airfields; and the roads were best left untried. Now, although there are still no railways, there are magnificent roads. Russians built the one north, which climbs over and tunnels through the Hindu Kush, and Americans the fine highway south, to Kandahar and beyond. And so the tourists begin to venture.

A YOUNG KANDAHAR GIRL GROOMING HERSELF.

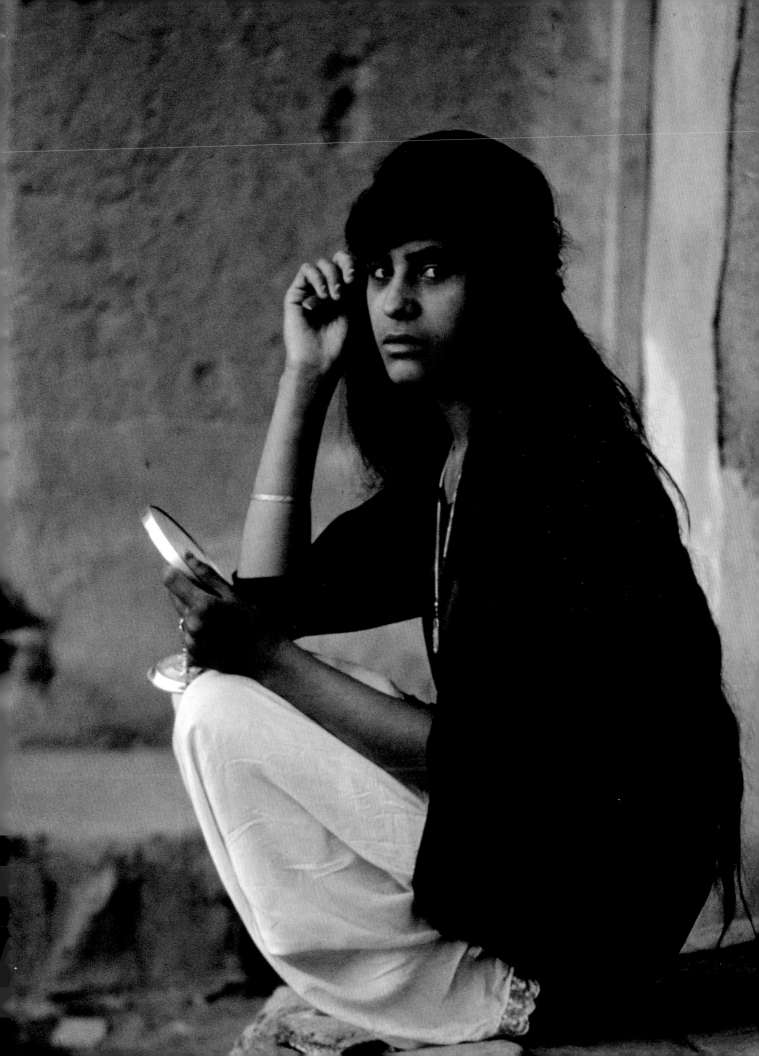

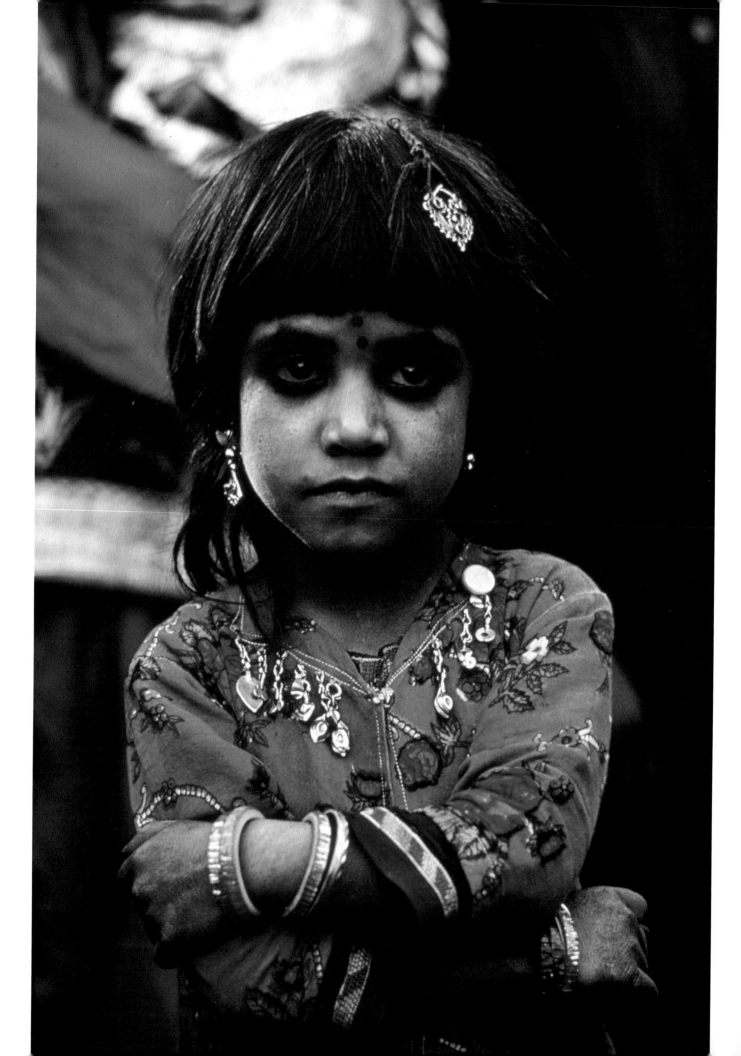

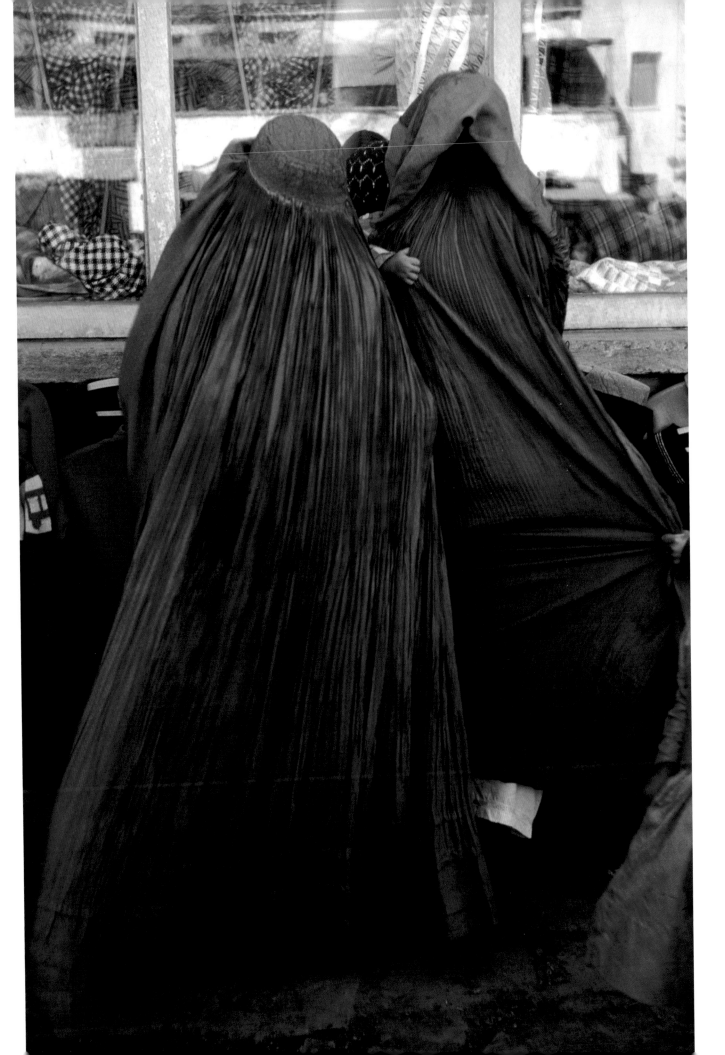

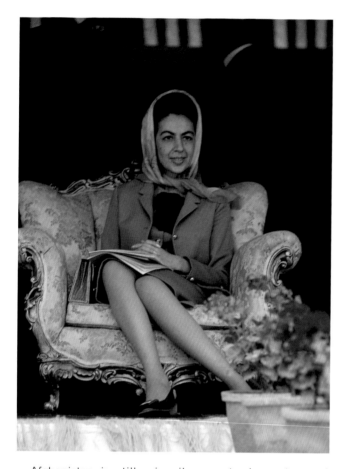

Afghanistan is still primarily a pastoral country, and Kabul a modest little capital: there is poverty, but not squalor; nor are there any architectural glories. It is in its citizens and its splendid setting that Kabul enthralls. The city lies in a green plain ringed by magnificent mountains, the Hindu Kush, the Koh-i-Baba, the Paghman range; every perspective is glorified by their towering presence, ever changing—orange in a blaze of fierce sunlight, violet and sugared over with snow on autumn evenings. And always the vast horizons, wild and free like the spirit of the people.

Even the British at the height of their Imperialistic might were unable to hold Afghanistan in fee, and after the third Afghan War in 1919, they gave up trying. British military archives and Afghan folktales alike record the horrors, ineptitudes, and heroism of the retreat from Kabul in the

PREVIOUS PAGES, LEFT: TRIBAL GIRL ADORNED WITH JEWELRY. BRIDEPRICE REMAINED IN FORCE THROUGHOUT THE COUNTRY; PREVIOUS PAGES, RIGHT: A BRIGHTLY COLORED BURKA WAS A COSMOPOLITAN SYMBOL FOR AFGHAN WOMEN. ABOVE, LEFT AND RIGHT: QUEEN SORAYA AND KING MOHAMMED ZAHIR SHAH. THE DURRAND DYNASTY RULED AFGHANISTAN UNTIL 1973.

first Afghan War of 1842, when an entire British force was massacred by Afghan irregulars—peasants, nobles, the veiled women and their children, ill-armed but united, and all fiercely resolved on liberty.

Yet women had little of liberty, legally, until the new constitution of 1964 gave them equal rights as citizens, the chance to vote at twenty, and the right to inherit and control their own property. This was one of Muhammad's original rulings for the benefit of women. These are more numerous and comprehensive than is widely supposed—except on the subject of divorce. Until lately, while a man might divorce his wife by the formula of pronouncing, in the presence of witnesses, that he did so, his wife had no redress, nor could she institute proceedings herself. Now, in Afghanistan, she may, on a few specific grounds, do so; but the feminists still clamor for further amendments. Primary education is the vital, first step to a woman's advancement, but illiteracy is still widespread, and impedes a more progressive attitude in the rural areas. "Education breeds rebellion," warn the diehards. "Just so," reply the reformers, the light of battle in their eyes. Now school education is compulsory for boys, and soon will be for girls. Classes for illiterates, often run by volunteer teachers, are established everywhere, together with birth control centers, and child welfare and maternity clinics.

Yet, the feminists rage, education without opportunity is not enough. Women must feel free to defy lingering taboos and family pressures, and choose their own way of life. Nurses and midwives, for example, often come up against fathers or brothers who refuse to allow them to go out to attend to patients at night. In industry, women are entitled to equal pay; in practice they do not get it. In a court of law, it still takes the word of two women to equal that of one man. The arithmetic of subservience.

In 1929, the impetuous King Amanullah had tried prohibiting the veil, among other reforms and innovations, and lost his throne in consequence. It was only three rulers later, in 1959, that women, led by the present queen and by the court, emerged officially supported and quietly determined. It is a curious fact that in this profoundly traditional land the most revolutionary constitutional reforms and psychological upheavals, such as the removal of the veil, have been achieved not by force, but by King Mohammed Zahir Shah's subtle but resolute approach.

Those former rulers who tried to impose westernization by violent means met violent ends. Few ruled for any length of time. The present king, who was educated in France, has reigned triumphantly since 1933, when he succeeded his father, who was assassinated at the hand of a fanatic.

Some of the older women told me that shedding the veil was the most traumatic experience of their whole lives. A few remain stubborn. "When I was young, they made me hide my beauty. Now that I'm old, they want me to show myself—I prefer to remain veiled," said one bitterly. In general, there was little opposition, even from the mullahs, or priests—usually a reactionary element. But out in the villages and rural areas an abiding patriarchal discipline still favors the veil. "If I have to sell my wife's chadri!" is an old and desperate oath.

Perversely, village women who seldom wore the veil while working in the fields, as it hampered them, now see it as a status symbol. To them it was once the badge of the fine city lady at her ease. So now, when they go into the towns to work in industry, they adopt the chadri as a badge of advancement. And when some begin to follow fashion and we see fishnet stockings and high heels emerging from the chadri in place of the former baggy pantaloons, the effect is particularly piquant.

Although the young, educated Afghan women are now entirely westernized in their way of living and dressing, and respond to the new mystique of emancipation—and now that the freedom-giving Pill is sold freely up and down the bazaars—I fancy that some part of their thinking remains basically Oriental. There is some indefinable and subtle air of reserve that still seems to surround them, much like an invisible chadri. It sets them a little apart, giving them an allure absent from the more assured women of the West. Looking into the beautiful, dark eyes of many Afghan women, I seem to detect some lingering timidity, something faintly startled even—perhaps a legacy of purdah. It calls to mind classic Arab poetry, where the lover always likened his mistress to a gazelle.

Yet, however much this gazelle-like image lingers, women still walk a pace behind their man, or crouch on one knee, slightly behind him, to serve his food, addressing him as "Presence;" these women are very much flesh and blood. Furious passions are soon roused here, and *crime passionel* is accepted as inevitable. Adultery used to be punished by

stoning to death (as recently as twelve years ago), and a woman's dishonor still dishonors her whole family, the stain removable only by death—usually dealt out by a father or brother. The law now sometimes takes a woman into prison to protect her from family vengeance rather than to punish.

Polygamy is still practiced in Afghanistan, though it is on the decline, and quite out of fashion among the elite and the more westernized—all of whom, led by the Royal Family, are strictly monogamous. But this is still a thorny subject, for polygamy is an institution which still prevails throughout much of Islam. It is also one which I view with considerable sympathy; wherever I have encountered it, I thought it worked well enough for men and women. But the Prophet, limiting the institution to four wives, stipulated that they must be treated equally in all things. This is one of the principal reasons for its decline, for few men today can afford as many as four wives. As for the women, they never mention jealousy; but then they have not been brought up to believe that monogamy, or possessiveness, is necessarily best.

Reprinted from the London Sunday Times, November, 1970. Used by permission.

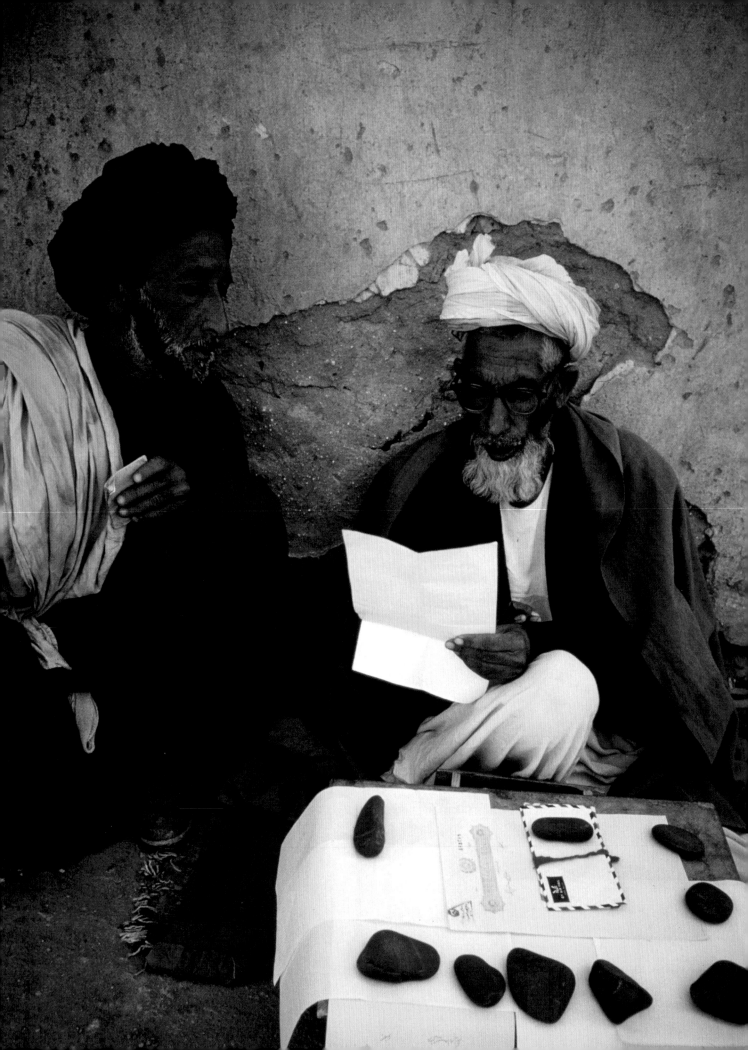

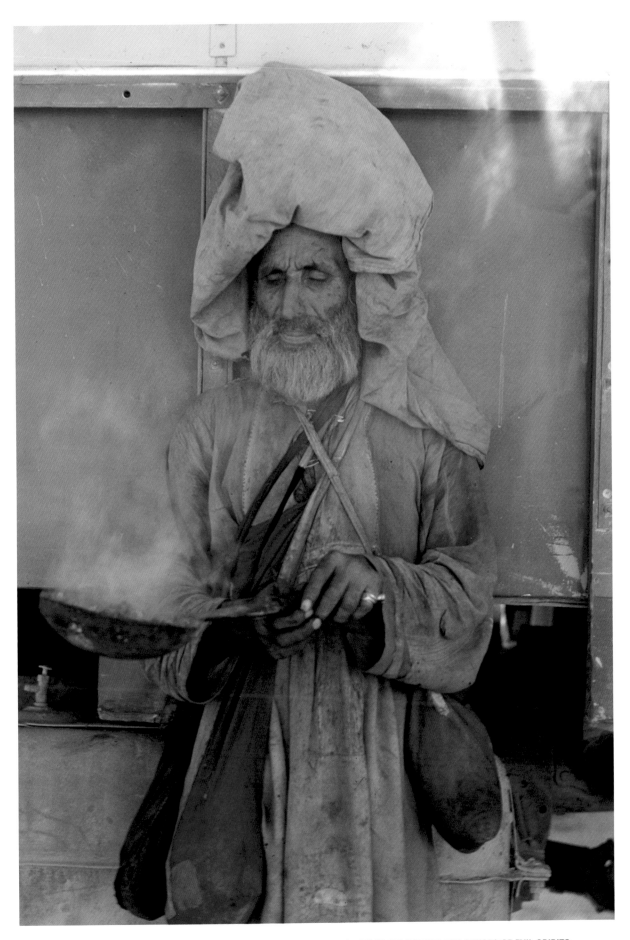

LEFT: SIDEWALK SCRIBE IN KABUL; ABOVE: A MAGICIAN USING INCENSE TO RID HOUSES AND OFFICES OF EVIL SPIRITS.

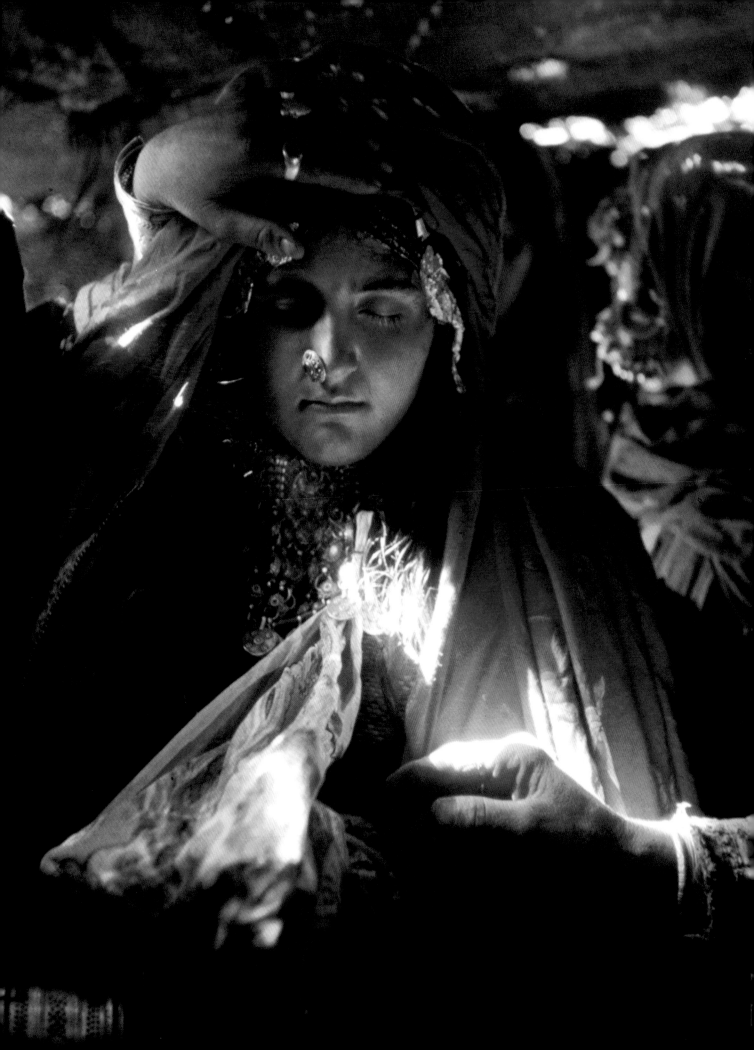

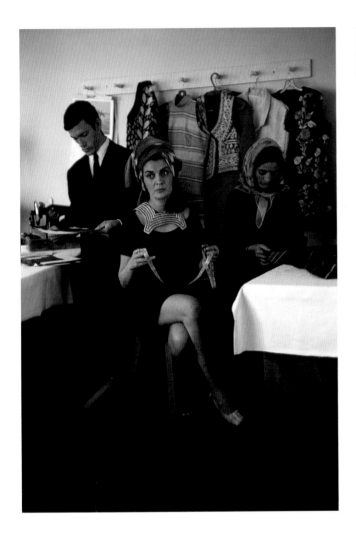

LEFT: THE BRIDE KEEPS HER EYES CLOSED FIRMLY TO AVOID GAZING AT THE BRIDEGROOM'S FACE
UNTIL THE CEREMONY IS COMPLETED; ABOVE: A DRESS DESIGNER'S STUDIO AND EUROPEAN FASHIONS
WERE EVIDENCE OF THE KING'S MODEST EFFORTS AT PROMOTING MODERNIZATION.

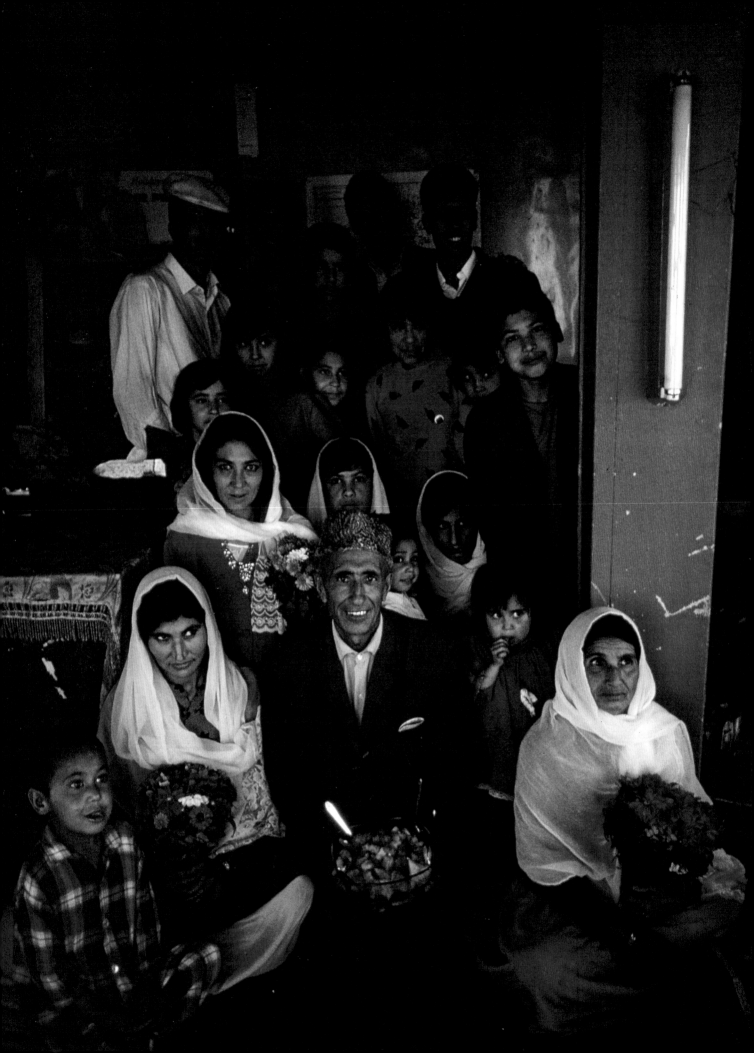

LEFT: A KABULI WITH HIS TWO WIVES AND SOME OF THEIR EIGHTEEN CHILDREN. ACCORDING TO ISLAM, THE POLYGAMIST
MUST TREAT HIS CO-WIVES WITH ABSOLUTE EQUALITY; ABOVE: MONOGAMOUS COUPLE IN KABUL, 1969.

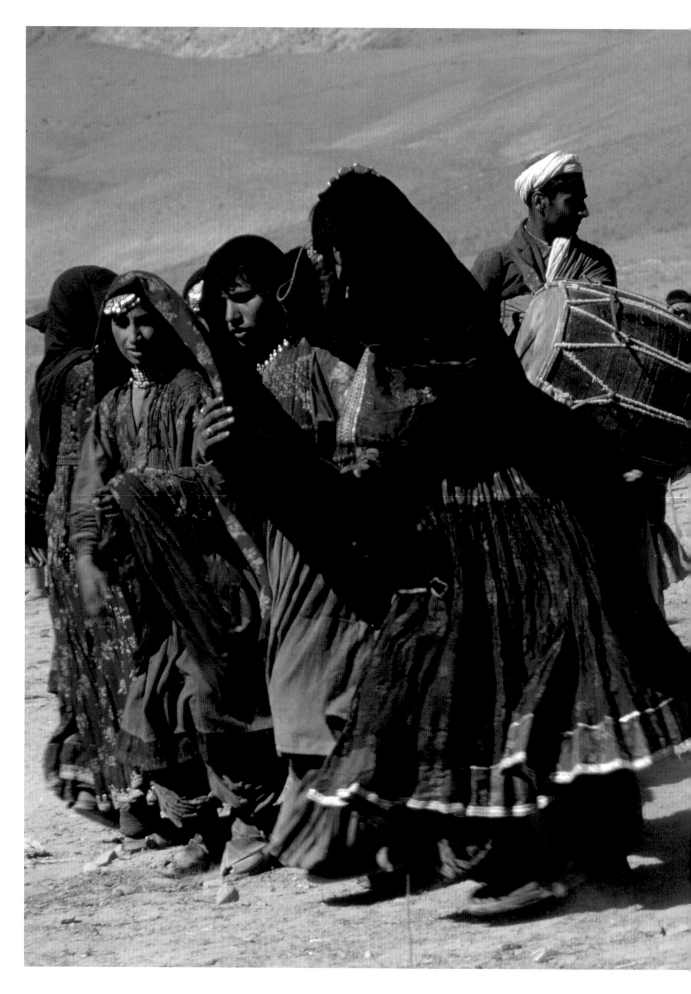

WOMEN DANCING AT A NOMAD WEDDING IN THE HINDU KUSH.

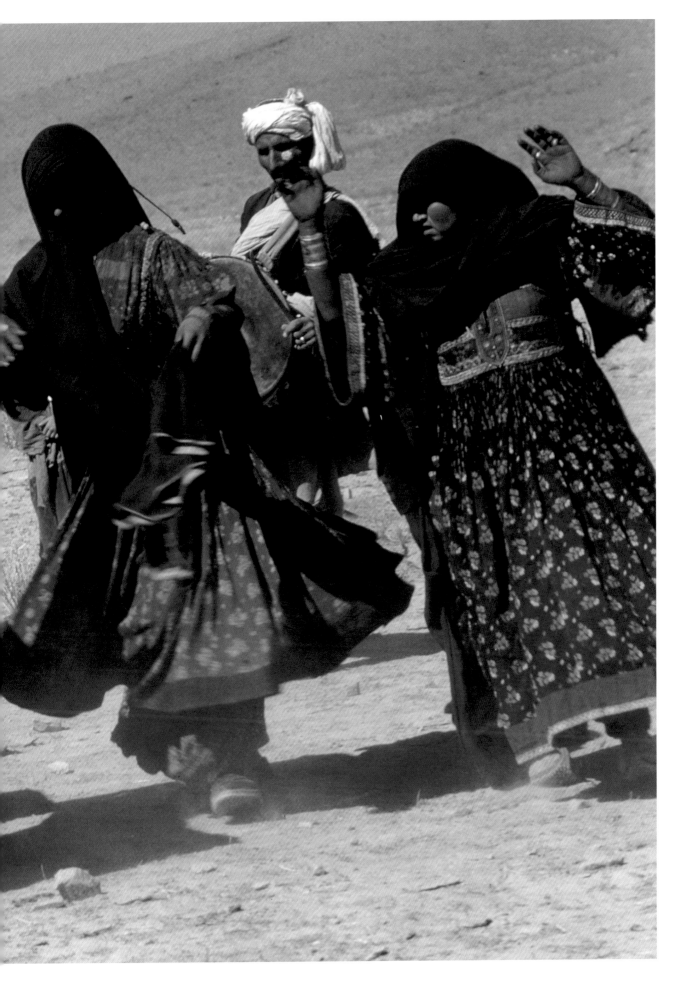

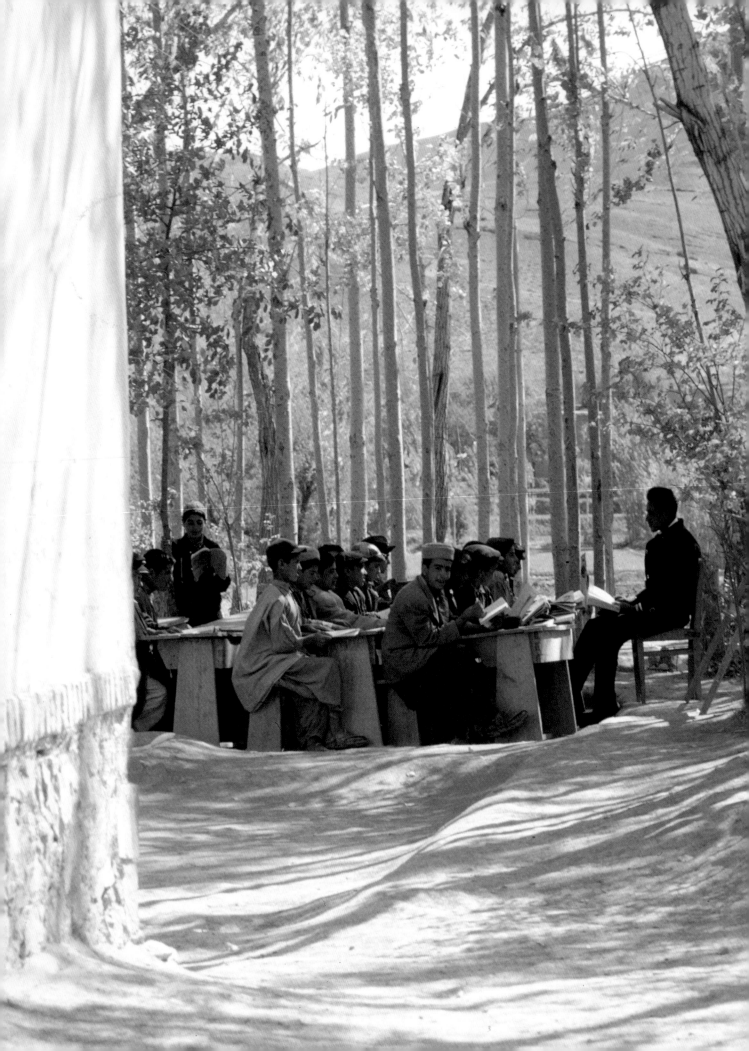

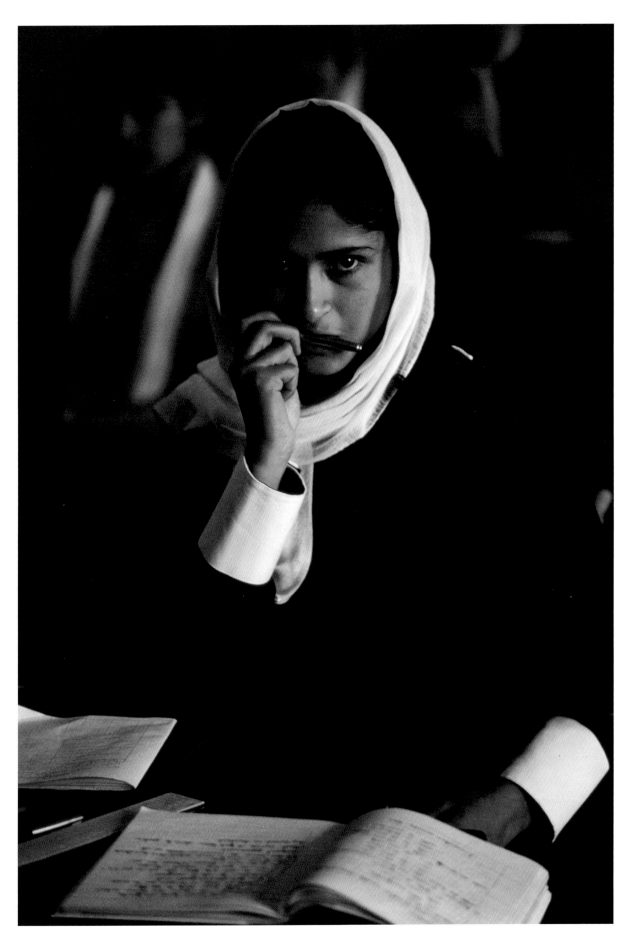

LEFT: OPEN AIR CLASSROOM FOR BOYS IN KANDAHAR; ABOVE: ANOTHER ELEMENT OF THE KING'S REFORMS
WAS LITERACY TRAINING AND THE EXTENSION OF UNIVERSAL EDUCATION TO FEMALES.

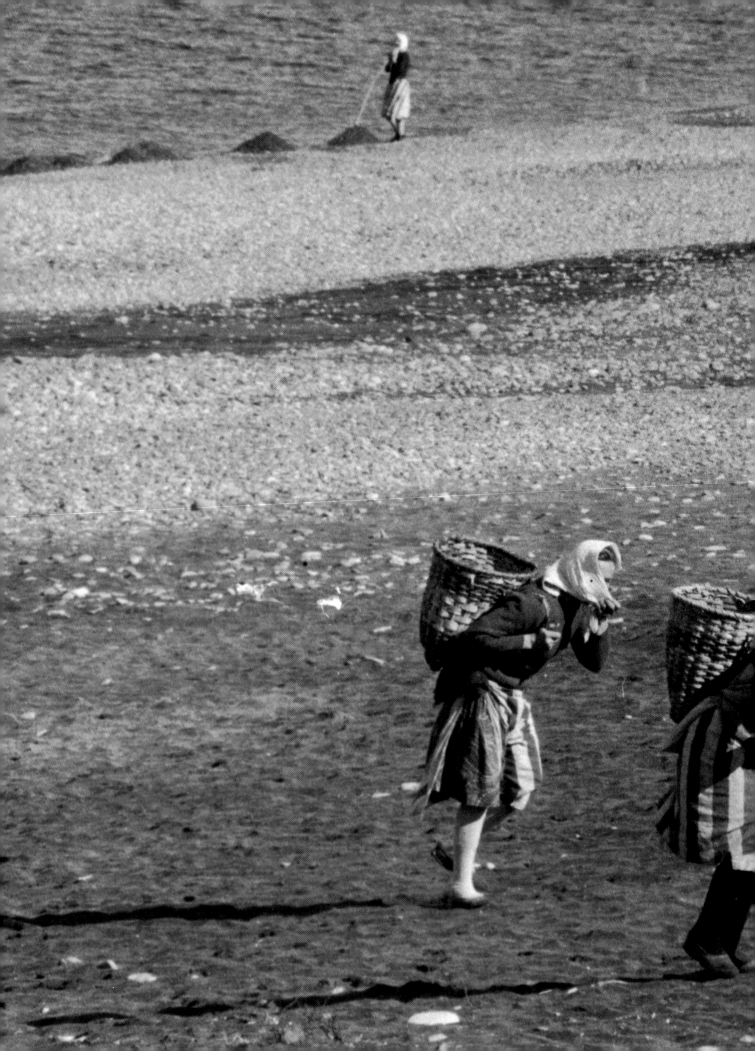

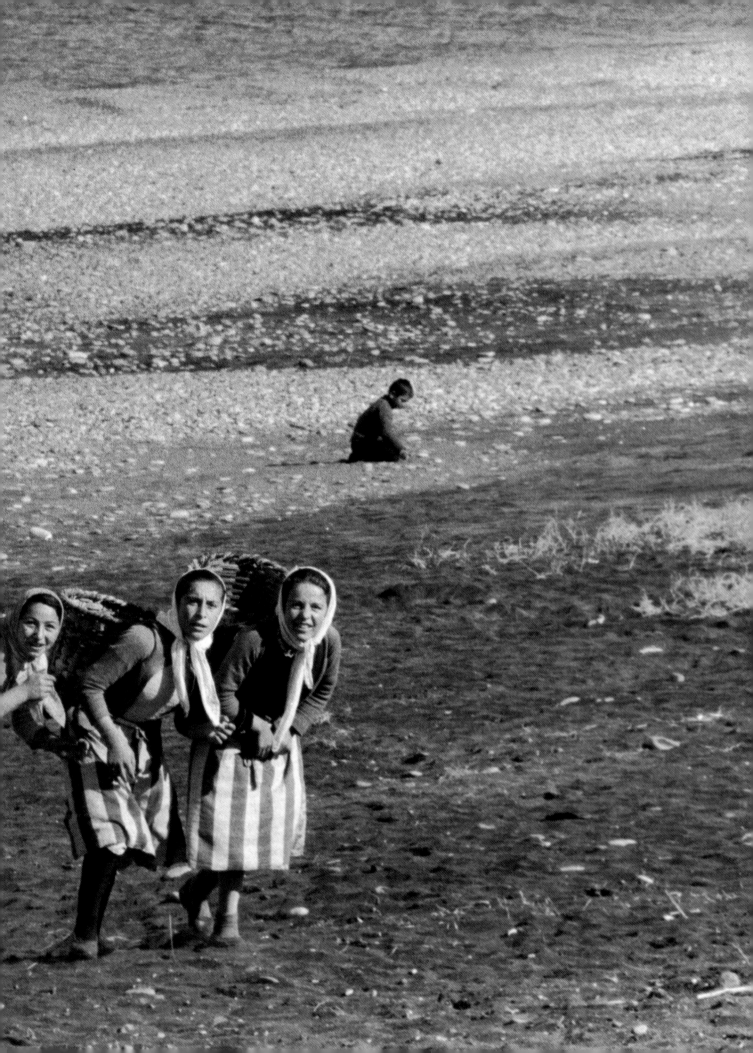

PREVIOUS PAGES BY IAN BERRY: WORKING WOMEN UNRESTRAINED BY THE BURKA IN THE FIELDS BETWEEN JALALABAD AND KABUL, 1971; ABOVE: HERAT, 1977.

HERAT, 1977.

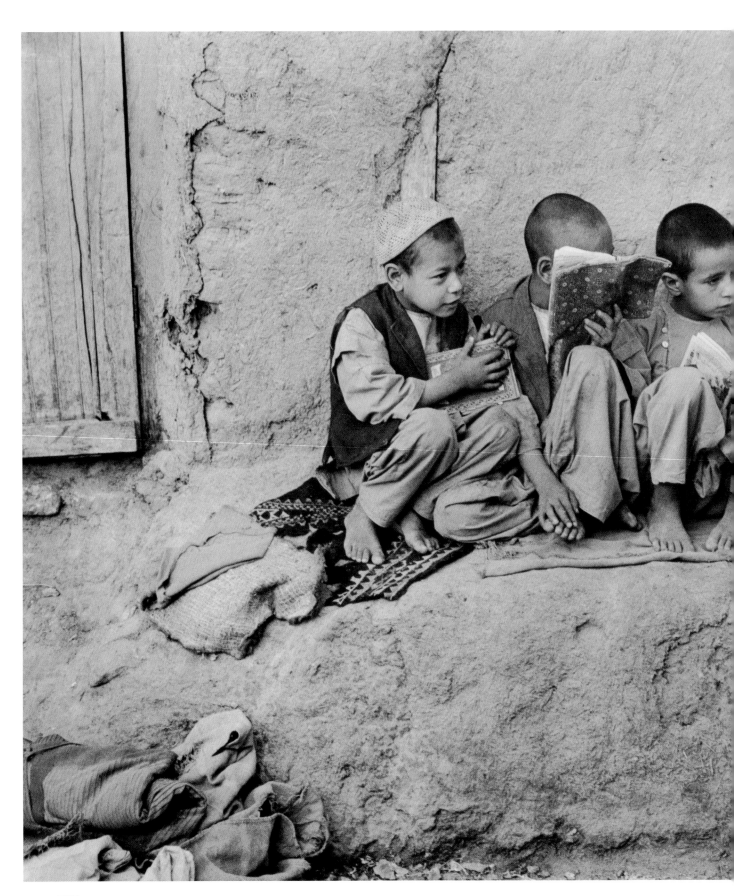

HERAT, 1977.

HERAT, 1977.

2

FIRST BLOOD

In 1973, Afghanistan's two-hundred-year-old monarchy collapsed, followed several years later by the demise of a moderate republican government. Thereafter, a shaky coalition of two leftist parties allied with the Soviet Union implemented a revolutionary Communist program to end feudalism. The forced modernization campaign abolished usury and the traditional brideprice. It decreed land reform, and proposed a national literacy program to educate men and women. Islamic beliefs were publicly attacked while thousands of mullahs and village leaders were imprisoned and often murdered. Consequently, agricultural production fell dramatically, affecting almost every part of the country.

Peasants reacted to the total disruption of their traditions by organizing armed resistance to liberate their religious leaders, and to retaliate for the military's brutal repression. The rebellion first flared in the eastern provinces of Kunar and Nuristan, as documented below. When government troops were sent to quell the uprising, they soon defected rather than kill fellow Muslims. Spurred by their religious leaders, the rebels hoisted the banner of Islam to transform political opposition into a sacred anti-Communist jihad. Over eighty thousand people poured over the border into refugee camps in Pakistan where various Mujahidin factions received international military and financial assistance. In Kabul, one failed dictator replaced another in a series of violent successions, which led to a massive Soviet invasion on December 24, 1979.

RIGHT: GUERRILLAS OF THE JAMIAT ISLAMI SEEK
PROTECTION FROM A GOVERNMENT BOMBING RAID NEAR JALALABAD, 1980.

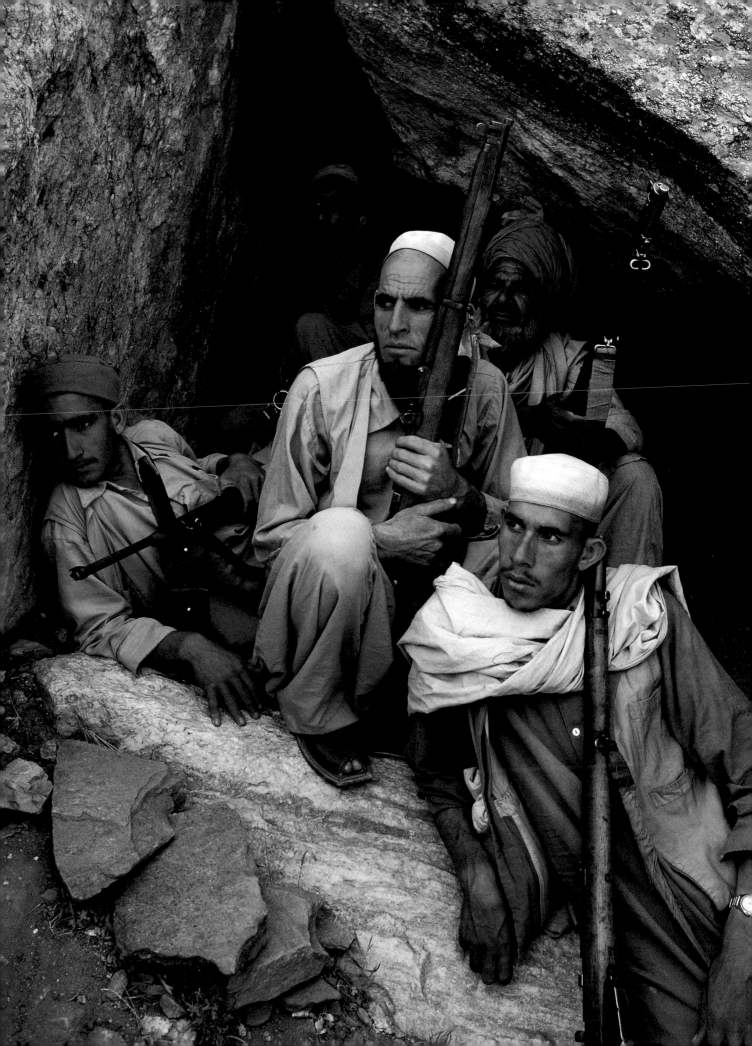

1978 MOUNTAIN UPRISING

BY RAYMOND DEPARDON

PESHAWAR

NOVEMBER 18, 1978

A newspaper in Beirut reported problems in Afghanistan, and described a sudden influx of Pashtun refugees into northwest Pakistan. Following up on this information, I came to Peshawar and found hundreds of these refugees in a miserable camp on the outskirts of the city. I met some representatives of the Islamic Front of Afghanistan, and proceeded to plan a trip to document what was happening. I realized quickly that they were extremely conservative. Nonetheless I was intrigued, and wanted to find out more about this movement.

After a forty-eight-hour trek across the mountains, I passed clandestinely from Pakistan into Afghanistan, slept off my fatigue in a hayloft accompanied by my guides and interpreter, and finally entered Nuristan province. The first Nuristanis I met resembled the backwoodsmen of my childhood fantasies. The biggest surprise was seeing their feet wrapped in animal skins instead of boots.

NOVEMBER 26, 1978

War. Afghan army regulars entered this area less than five days ago and burned down the entire village of Gawardesh. Most villagers fled to safety in the mountains. I didn't really understand the import of the military situation until my interpreter, Ahmad Shah Massoud explained that this was an act of retaliation for a rebel strike. Knowing that the army was less than a kilometer away, we left the scene quickly. Combat occurs mostly at night here. The men kept looking for grenades and ammunition for the Kalashnikovs they captured from the enemy.

Back in the Kamdesh Valley, almost three hundred rebels gathered on the banks of the rapids. They were mainly peasants and mountaineers in rebellion against the new Communist government in Kabul. I was a witness from the outside world, and according to custom, had to shake everyone's hand.

The uprising began after the government tried to arrest a few local religious leaders. Outraged peasants responded by attacking the army fort at Ourmour, where they killed almost five hundred soldiers and seized tons of small arms and ammunition. They viewed the government leaders in Kabul as enemies of the Qur'an and allies of the godless Communists in Russia. Three Soviet officers were among the dead when their jeep was ambushed by rebels near Ourmour. Four other Russians were also killed near the town of Barakat.

The rebellion then spread like wildfire throughout the valley. The rebels estimated their fighting strength at about one thousand men. But their vintage British Enfield rifles seemed mismatched against a modern army supplied by helicopters. The rebels had neither doctors nor medicine.

A couple of Afghan army lieutenants who defected to the peasants explained that the uprising had no foreign support. It was so popular, however, that any farmer would gladly sell his livestock to buy ammunition if necessary.

NURISTANI REBELS CLAD THEIR FEET IN SKINS RATHER THAN BOOTS.

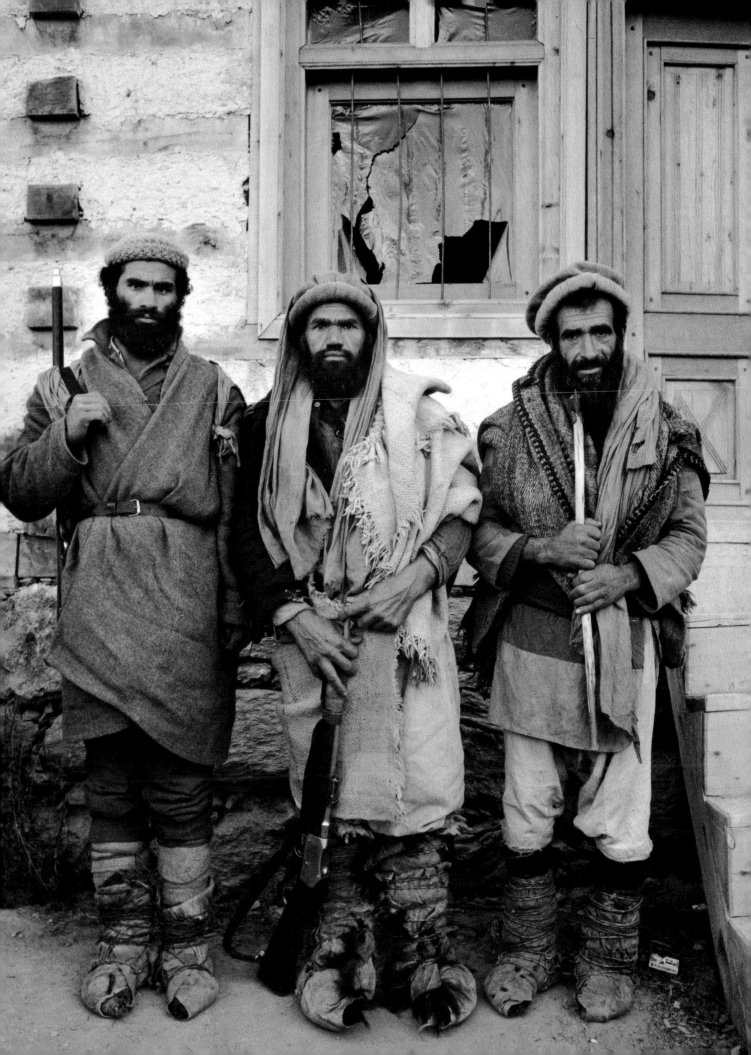

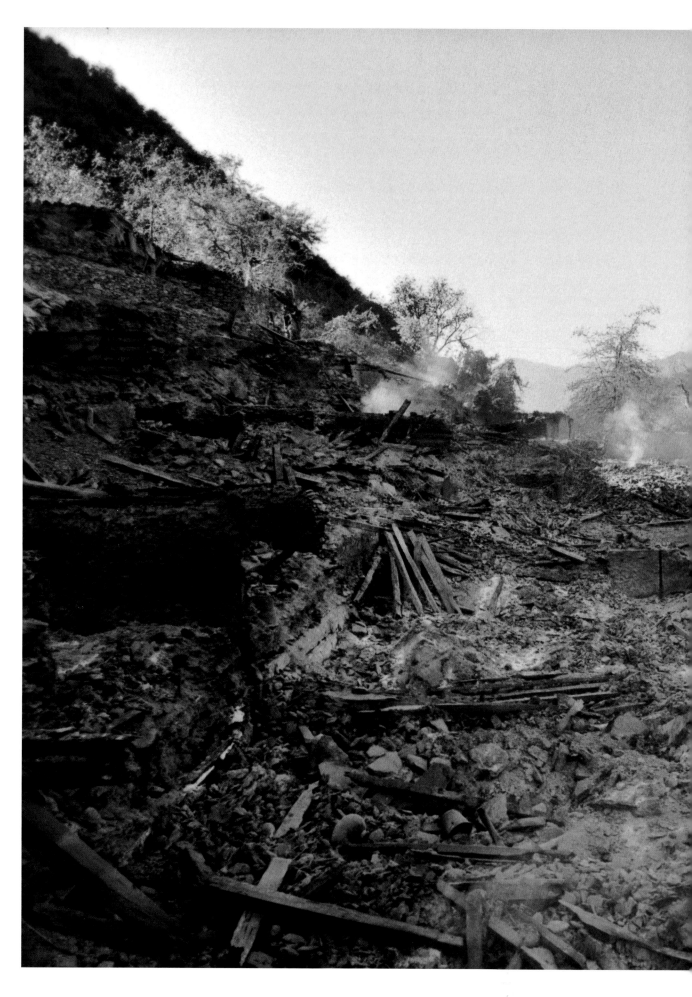

GAWARDESH VILLAGE IN EASTERN NURISTAN, DESTROYED BY FIGHTERS LOYAL TO THE COMMUNIST GOVERNMENT THAT SEIZED POWER ON MAY 26, 1978.

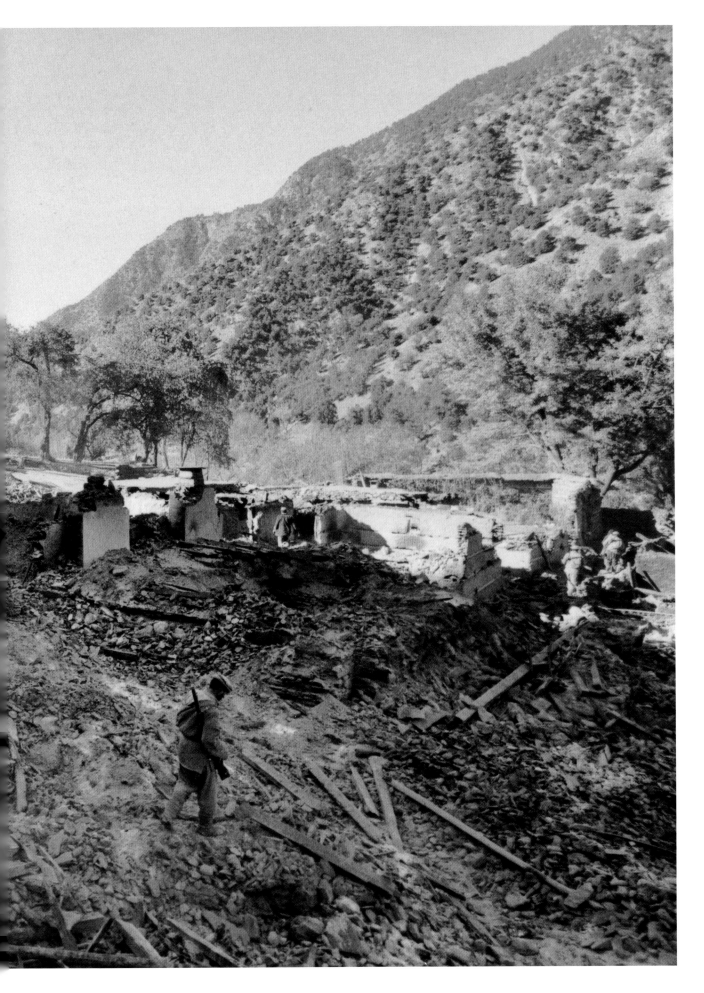

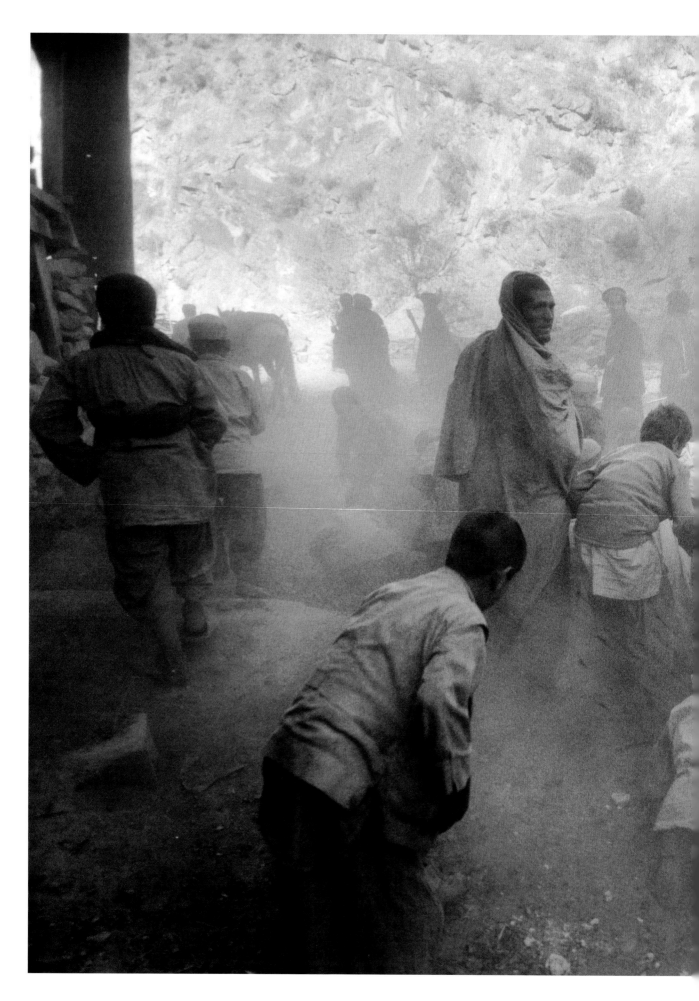

MANDAGHAL VILLAGERS RUSHING TO WELCOME THE REBEL ARMY.

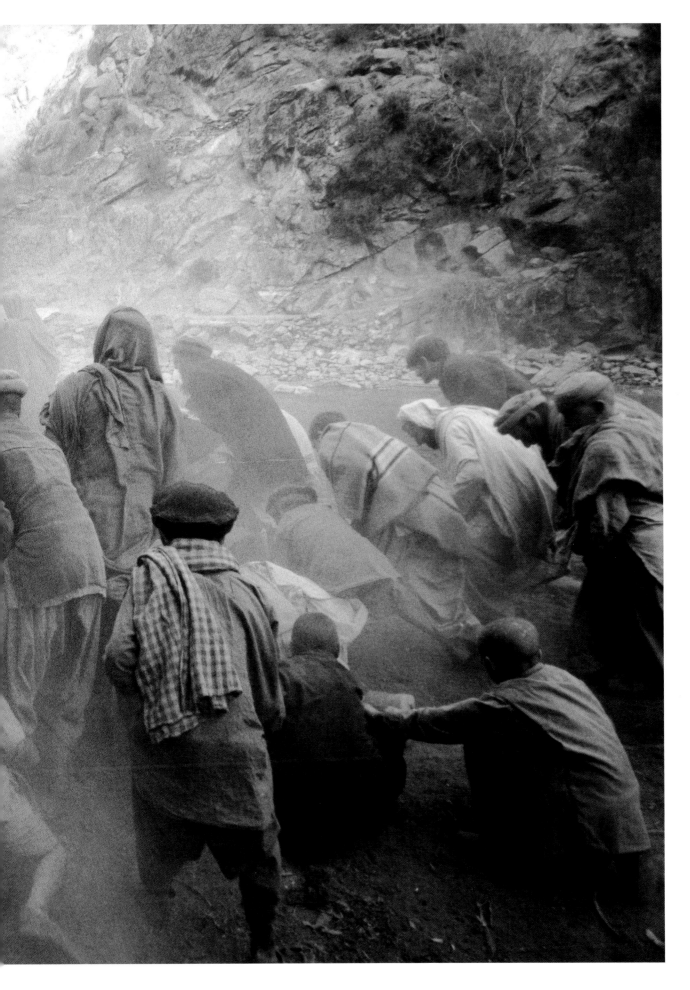

Furthermore, they speculated, neighboring valleys had also risen up spontaneously against the communists. During the evening we slept a little in the shelters in each village we passed through. I asked many questions, despite my fatigue. Unfortunately, Massoud wasn't very talkative.

TUESDAY, NOVEMBER 28, 1978

We arrived at Mandagahl. The women threw nuts from their balconies to greet us. There was more fighting every day. At night I could hear the firing of automatic weapons and artillery. I saw tracer bullets. The army encircled the valley, but were themselves surrounded by the peasant guerrillas. It was difficult to figure out their strategies, but it didn't seem as if we were in any great danger.

WEDNESDAY, NOVEMBER 29, 1978

The rebels captured two hundred seventeen army soldiers. I was starting to get uneasy. At nightfall we started walking again. It was freezing. Winter had definitely arrived in this valley two thousand meters above sea level. Eventually we came to another village, Bashgal; government soldiers had torched it only two hours before our arrival.

THURSDAY, NOVEMBER 30, 1978

We slept in another hayloft and left early the next morning. The only time we stopped marching was to make prayer. We returned to Bashgal around one in the morning and were awakened suddenly at seven with news that the army had surrounded us. I could barely understand what was happening. The villagers had apparently taken flight in anticipation of an invasion. A mountaineer rushed into the camp; breathless, he gestured toward the pine grove indicating that things were very bad. Shots rang out nearby. We ran for our lives—not easy at two thousand meters up. Massoud kept yelling at me to run faster. Meanwhile, Bashgal's elders fled to surrounding villages to rally more fighters for the holy war. The Qur'an says that if they die in combat, they will be considered martyrs for the cause of Islam; they will enter paradise immediately.

The situation was now so dangerous that we decided to return to Pakistan. We were in a hurry to make it back, but the border was two days away. Sometimes I could not continue, and just had to stop. Then we had problems crossing the border because someone recognized me in one of the frontier villages. I remained silent for an entire day so the two guides could pass me off as a stranger from another province who didn't speak Pashtun. Massoud told me to keep quiet and stay dressed in my Afghan garb. The next day only Massoud and the two guides went to the police checkpoint. Another villager told the police that there were originally four of us. Massoud managed to slip away and come back for me near the rapids. Then we made a run for it, flat out for three or four hours, until we reached the road. I literally jumped into the first truck that drove by. "We were lucky, God-willing," commented Massoud, who then returned to find the guides.

I had left all my film with them and was worried about it. It was not until three days later that I met Massoud back in Peshawar; he had the film.

RIGHT, TOP: GOVERNMENT LOYALISTS CAPTURED BY THE REBELS NEAR MANDAGHAL IN NURISTAN PROVINCE; RIGHT, BOTTOM: NEAR THE PAKISTANI BORDER, REBELS PAUSED TO MAKE SALAT (MUSLIM PRAYER). IRONICALLY, THE NURISTANIS, THE MOST RECENT CONVERTS TO ISLAM, WERE THE FIRST TO ENGAGE A JIHAD AGAINST THE COMMUNISTS.

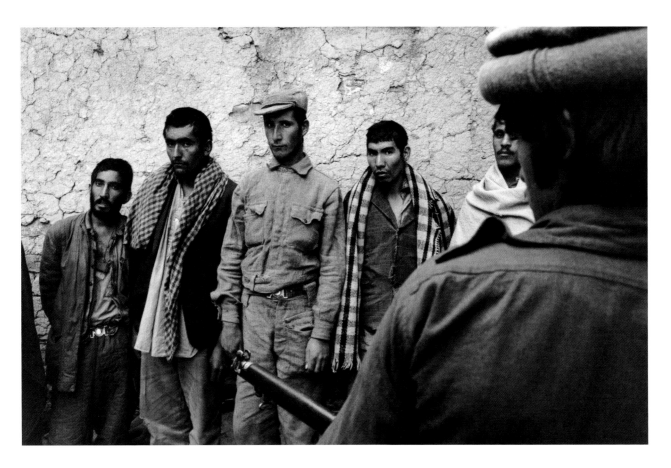

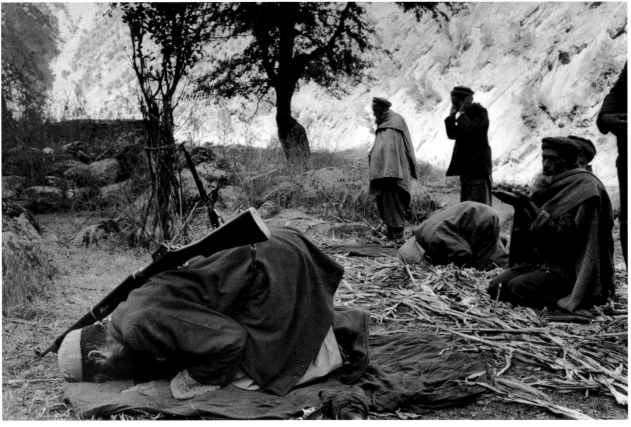

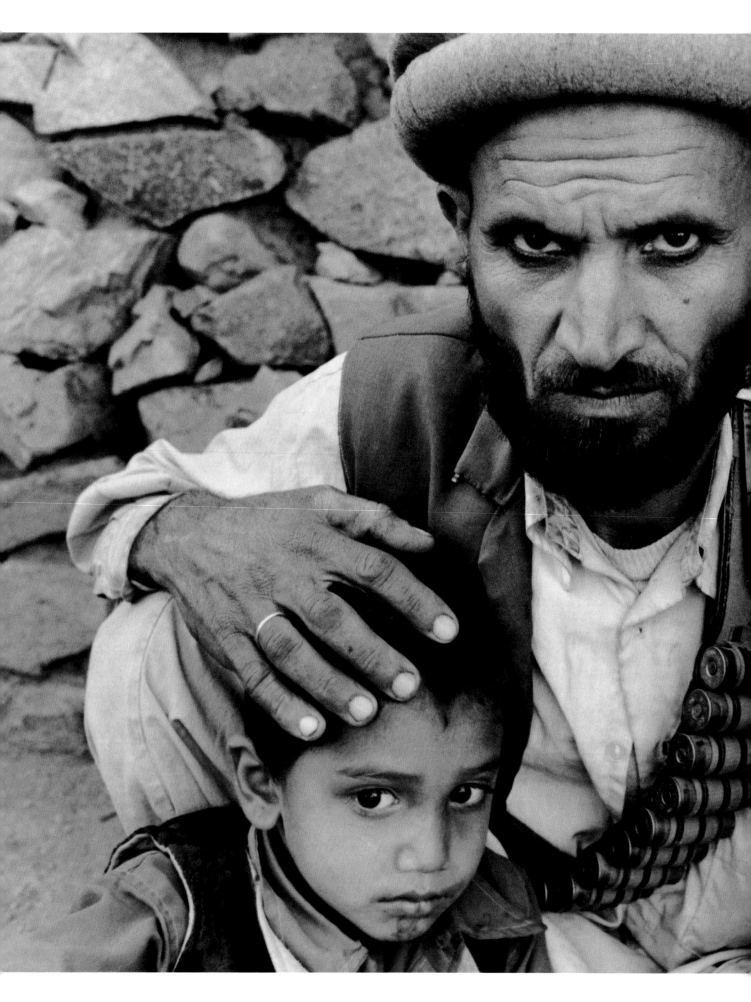

A REBEL SOLDIER AND SON IN EASTERN NURISTAN.

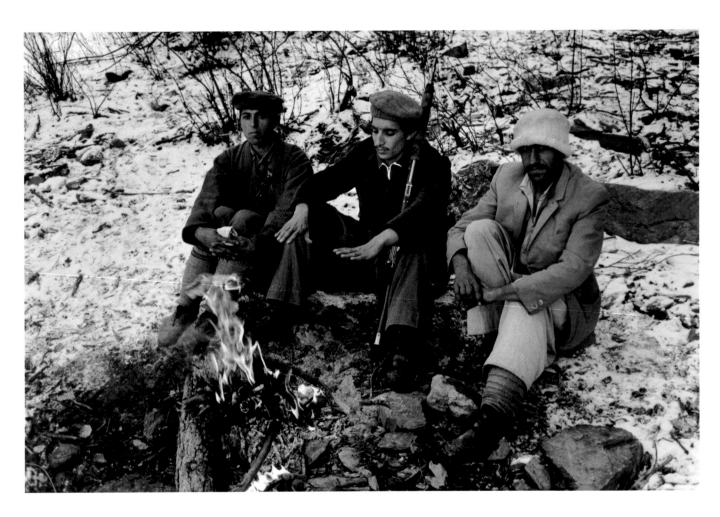

AHMAD SHAH MASSOUD (CENTER) BEGAN HIS CAREER AS THE MUJAHIDIN LIAISON TO THE WESTERN PRESS.
AN ETHNIC TAJIK, HE EVENTUALLY BECAME PRINCIPAL FIELD COMMANDER OF THE JAMIAT ISLAMI HOLY WARRIORS.

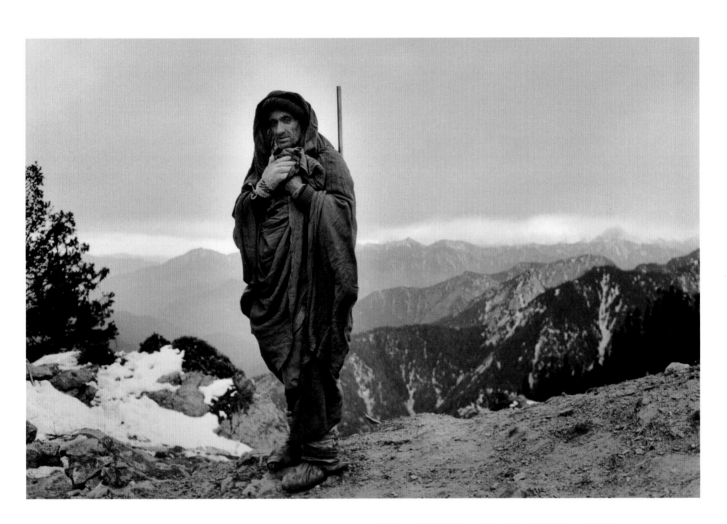

GUARDING THE MOUNTAIN PASS LEADING TO THE RELATIVE SAFETY OF PAKISTAN'S NORTH-WEST FRONTIER PROVINCE.

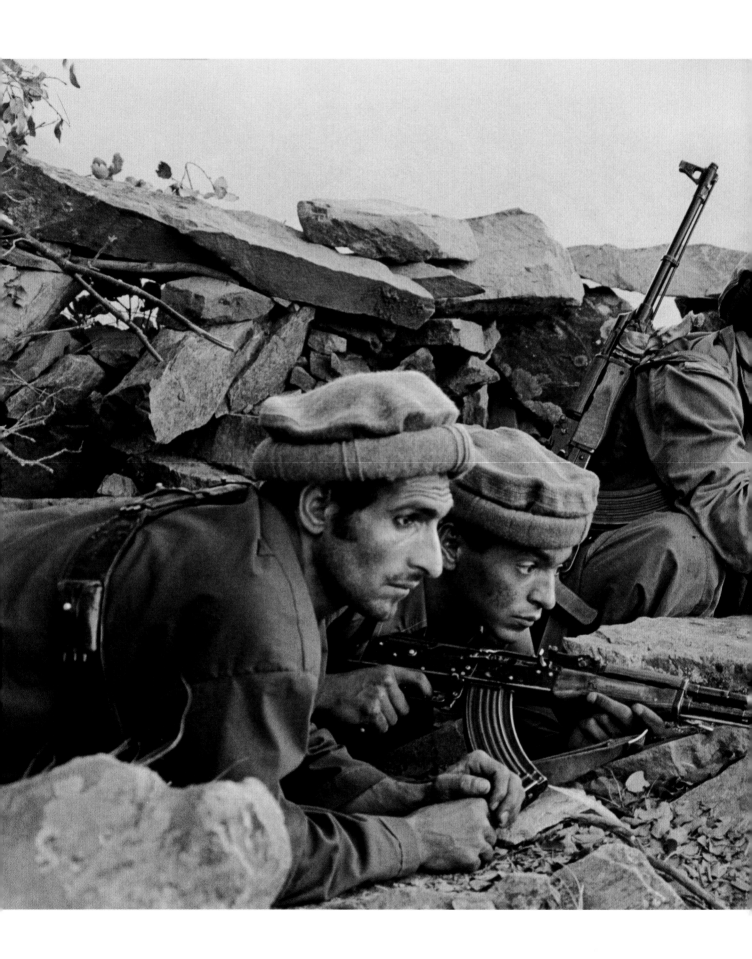

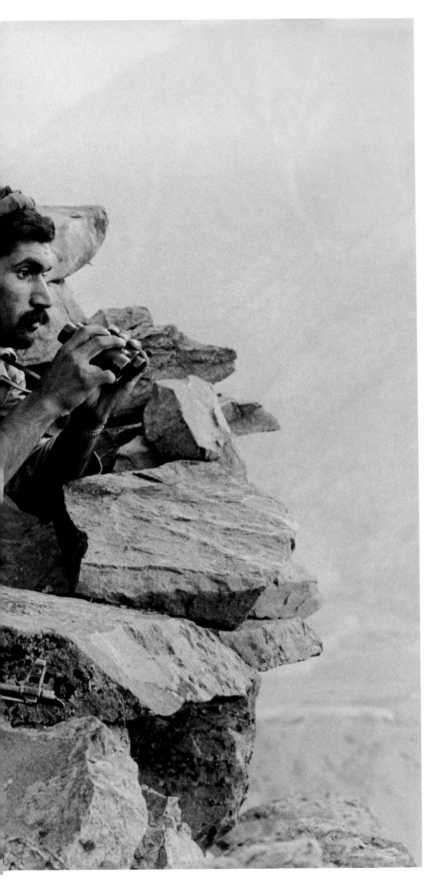

1979 ROOTS OF THE MUJAHIDIN RESISTANCE

BY STEVE MCCURRY

I first went to Pakistan in May 1979. I wandered up into Chitral, part of the North-West Frontier Province. It was very cold because it was the pre-monsoon season. I was staying in a very cheap, fifty-cent-a-night hotel in this small town when I met two Afghan refugees who were in the next room. I had only been in the country for several days, and went to dinner with them. They started talking to me about the civil war raging across the border in Afghanistan, only a mile or two from Chitral. I mentioned that I was a photographer. They were desperate for the world to know about this situation because the war was in its infancy at that point. "You're a photographer. We want you to come with us. We want to show you this and show the world what's going on in Afghanistan."

I agreed to the idea that I would dress in native garb and be smuggled across the border. I was very apprehensive about entering a war zone without a passport. No security, no phones. I was inexperienced and nervous, almost hoping they wouldn't show up. I lay in bed praying that they wouldn't come, but at nine in the morning they came and off we went. I wore an old *showar kinase*, my head was shaved, and I had a beard. I put my cameras in an old burlap sack, and we literally walked from town across the border. We timed our border crossing after dark so that the border guards wouldn't be able to make out that I was a foreigner. Dressed as I was—local attire, headdress, beard—I looked very Nuristani, and we crossed the border into Afghanistan right in front of the border guard's face.

REBELS SCOUTING FOR ENEMY TROOPS AT BARAKAT, KUNAR PROVINCE.

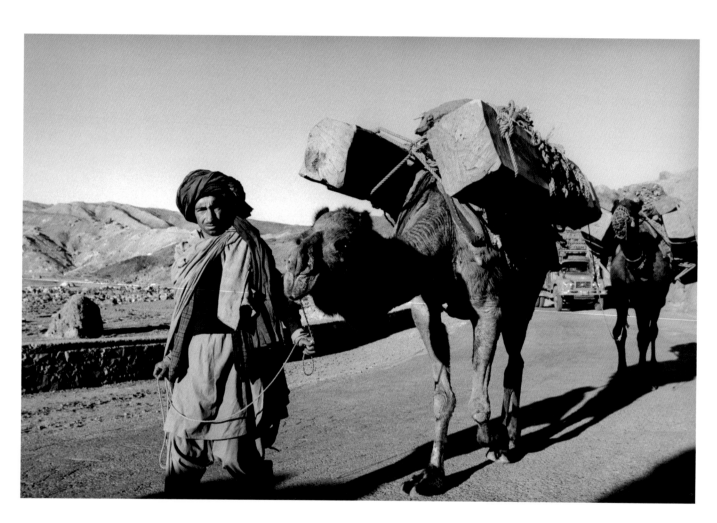

COMMERCE BETWEEN AFGHANISTAN'S EASTERNMOST PROVINCES AND THE MARKETS IN PAKISTAN CONTINUED DESPITE THE UPRISING.

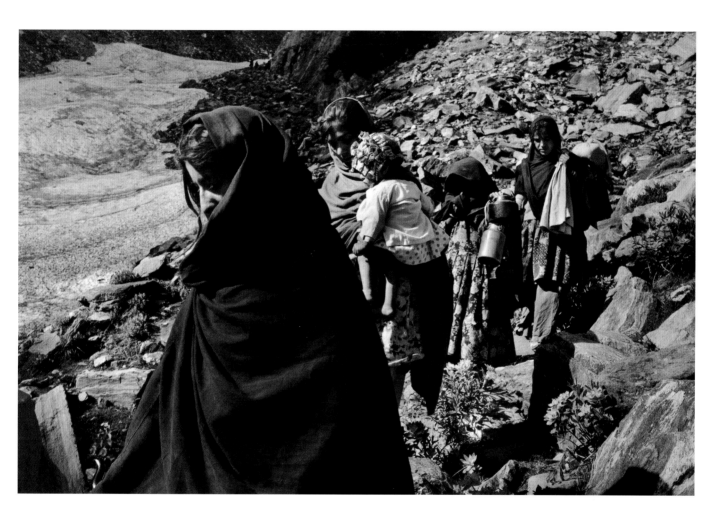

WOMEN REFUGEES EN ROUTE TO PAKISTAN NEAR THE MOUNTAINS OF TORA BORA.

We then walked for two weeks trying to locate the battle front. We went from village to village. Everyone hated the Afghan army; ninety-five percent of them were sympathetic to the Mujahidin. The whole countryside was up in arms. All the villages were sending volunteers to fight with the rebels. They understood that the Communists didn't believe in Islam. Also in Afghan culture women are separate, and they wear the burka. When women in Kabul started exercising liberal Western attitudes, villagers regarded it as an assault on tradition. They saw a godless central government meddling directly in their village affairs.

In the village, everybody had their own plot of land. The village chief was the guy with the most land. It was a feudal land system where the father's land was divided amongst the sons. Since those lands were divvied up in the next generation, after a while everybody was left with a very small plot of land. But the wealth flowed back to the chief. If he owned livestock, he would then sell his wool and broker wool from all the other shepherds. With a tribal monopoly on trade, he would then have enough money to buy a truck and hire guys to cut wood. Consequently, nobody else would be able to get their stuff to market without him. He took a cut of all the commerce in his village or region. He made the deal and redistributed what he believed was fair. His decisions were generally accepted with little or no opposition.

The Communists were trying to change this by instituting land reform and the development of collective farms. The government intended to remake transportation and commerce on a regional level. This was very disruptive to the chiefs, who responded first by organizing pacts and treaties with neighboring villages, and then alliances among various villages, constructing a broad resistance to the central government. The government tried to negotiate, but they weren't willing to abandon their development plans or allow tribal chiefs to dictate policy. So the next thing was to intimidate them—bomb a couple of villages, kill a few people.

A COMPANY OF WELL-EQUIPPED GOVERNMENT SOLDIERS DEFECTED TO THE REBELS, NEAR ASMAR IN KUNAR PROVINCE.

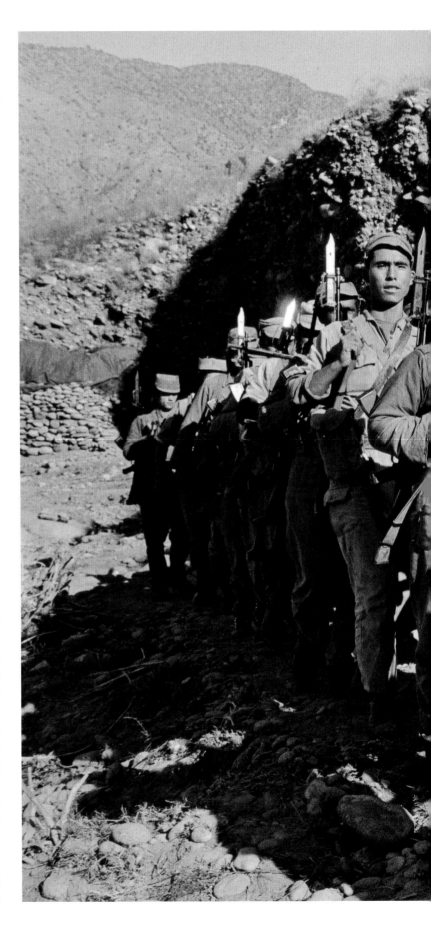

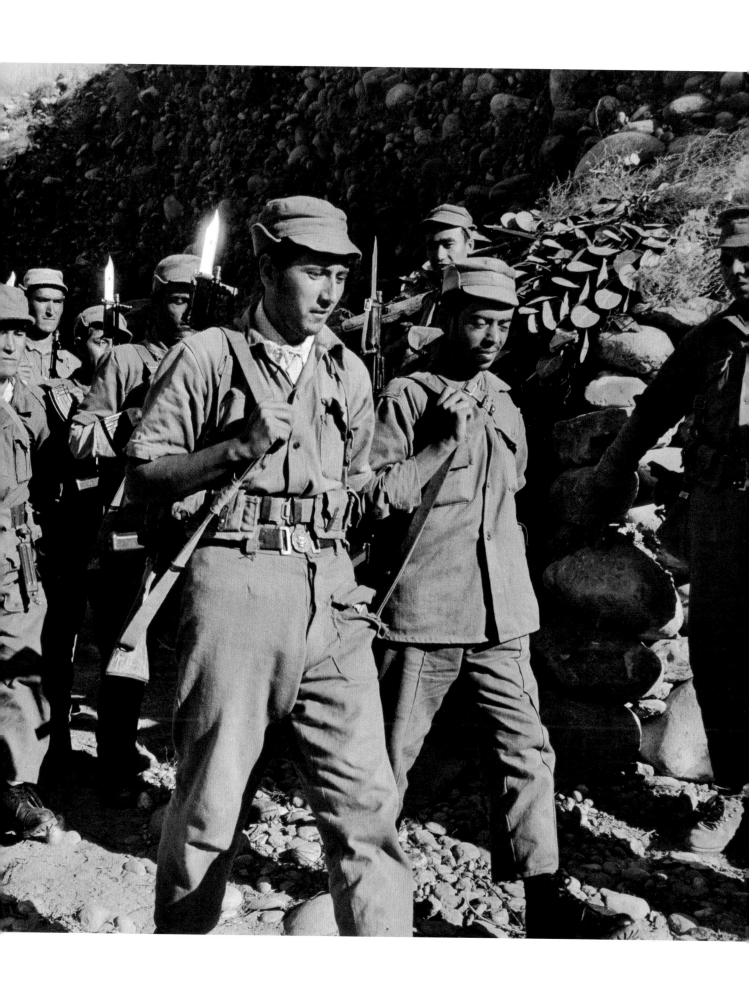

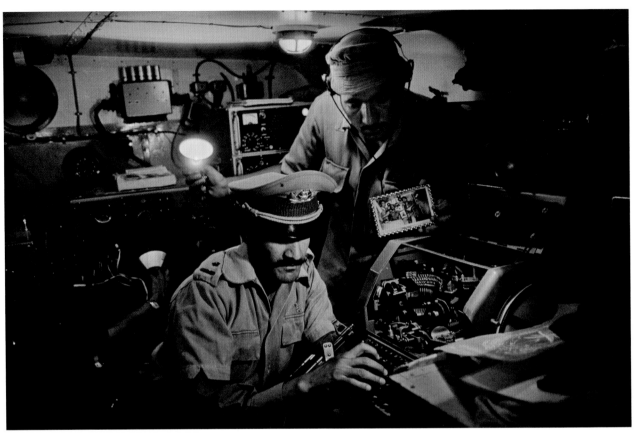

THE CAPTAIN OF A BAND OF ARMY DEFECTORS USED HIS COMMAND VEHICLE RADIO TO LURE A GOVERNMENT
HELICOPTER INTO THE REBEL CAMP, WHERE IT WAS PROMPTLY DESTROYED (BELOW).

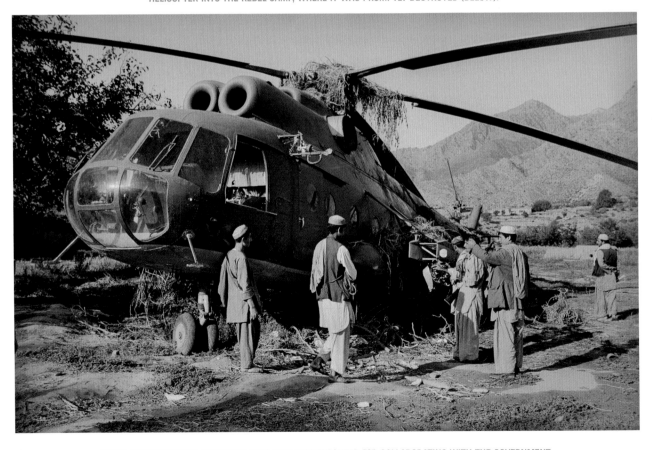

RIGHT: CAPTURED NEAR JALALABAD, THIS MAN WAS EXECUTED FOR COLLABORATING WITH THE GOVERNMENT.

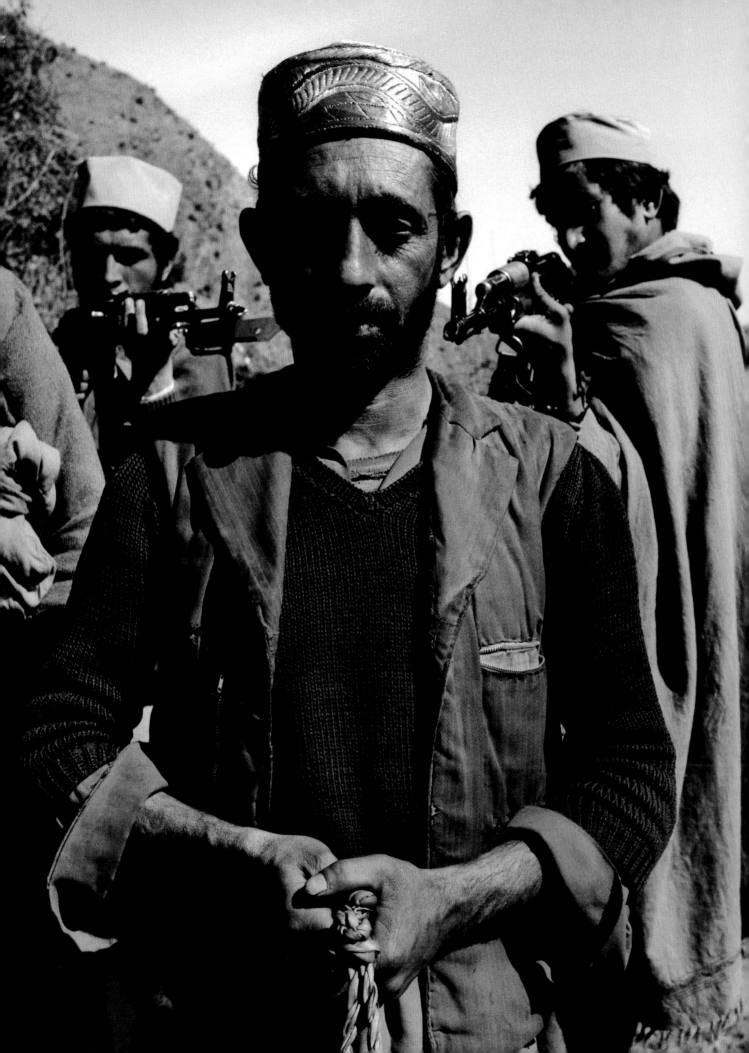

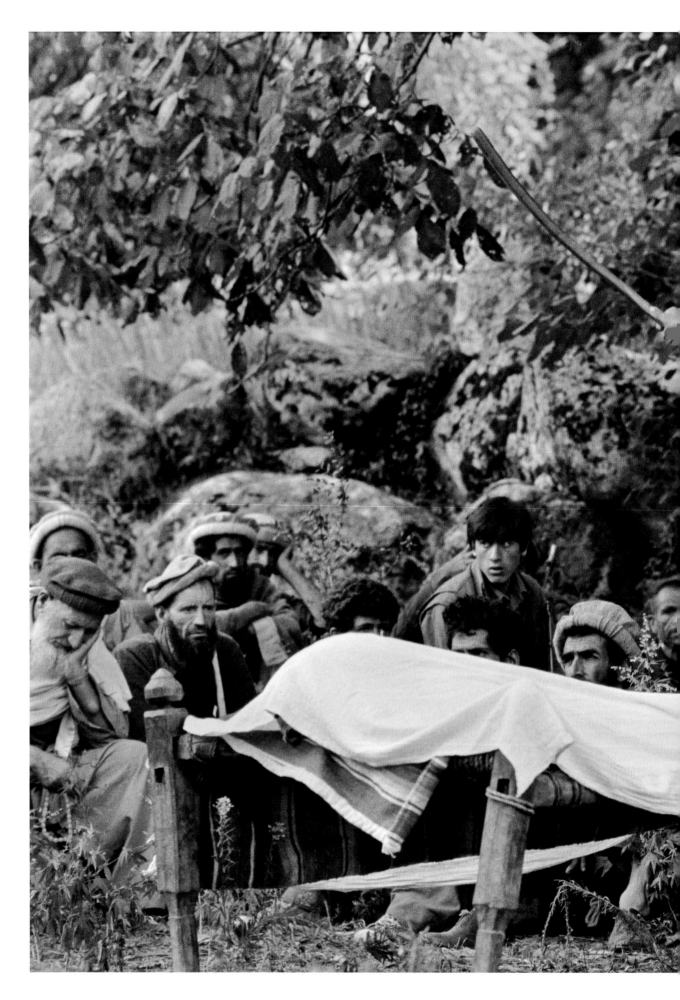

A VILLAGE HEADMAN EULOGIZES OVER THE BODY OF A REBEL KILLED IN A BATTLE NEAR BARAKAT.

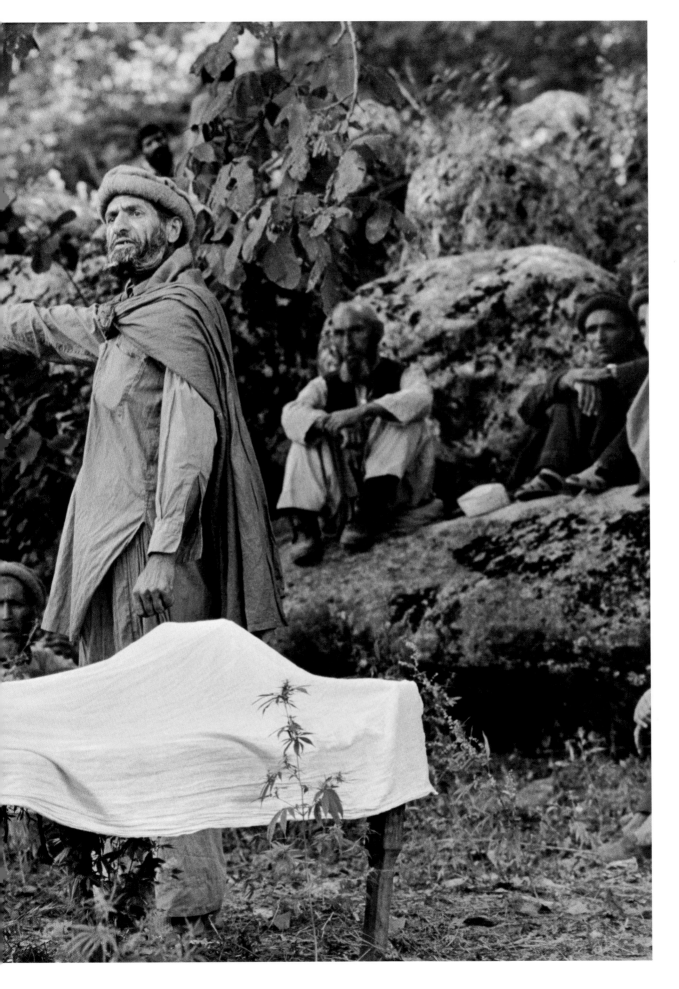

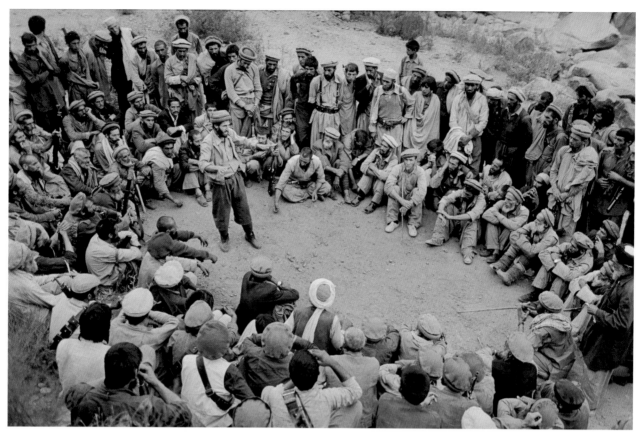

AFTER GOVERNMENT FORCES WERE EXPELLED FROM THE EASTERN PROVINCES, CIVILIAN AND MILITARY LEADERS, SELECTED BY CONSENSUS IN EACH VILLAGE, WERE RESPONSIBLE FOR ENFORCING TRADITIONAL RULES AND ENSURING CONSCRIPTION INTO THE MUJAHIDIN ARMY.

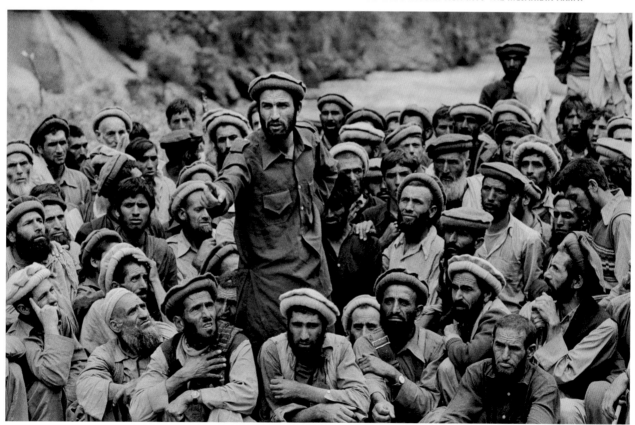

RECITING THE ADAN, MUSLIM CALL TO PRAYER, AT A REBEL CAMP NEAR BARAKAT.

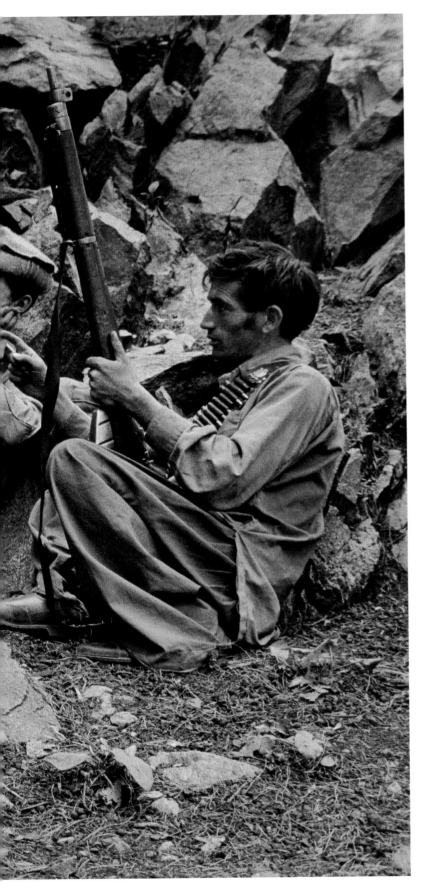

The Communist government thought that the villages of rebellion would cave in. They did not. As soon as they started to bomb them, the peasants rose up. They got behind the banner of Islam, and they just went berserk. They were very loosely organized, very idealistic, but they had already witnessed the destruction of whole villages by the army. As I traveled with this group, we saw many people being killed.

I returned three months later in August to visit a town called Asmar in Kunar Province, just an hour north of Jalalabad. An entire garrison of the Afghan army had defected en masse to the rebel side. The defecting commander invited the local governor to the garrison. As soon as he showed up, they executed him.

The commander then made a radio back to Jalalabad, saying that their helicopter wasn't working: "Send us a new helicopter." Another one arrived, and they captured the crew and destroyed both helicopters. I don't know how many hundreds of men defected with this one event, but the multiplication of these kinds of events prompted the Russian invasion in December 1979. Then Afghanistan became a huge international story attracting thousands of reporters—very similar to the way it is today.

Some have suggested that the Communist government was trying to bring the country into the twentieth century. The fact is most places still don't even have electricity or running water. Tribal leaders don't want women to be educated or to remove the burka. But this is exactly the point: Afghanistan is essentially a traditional, unsophisticated, conservative society. The rebels felt this forced effort to modernize was going against their way of life. Islam was just a kind of banner to rally the opposition. It symbolized an almost absolute resistance to being made part of the modern world.

REBEL CAMP AT BARAKAT IN KUNAR PROVINCE.

In rejecting the modernizing efforts of the Communist government, the rebels would systematically destroy all the elementary schools—all the schools, in fact. There were also these wonderful collective farms that the Russians built early on in Afghanistan, with tremendous facilities, tractors and workshops. They were genuinely trying to help the country's agricultural and industrial and development. The Mujahidin just destroyed all of it.

Everything got smashed and destroyed. They did what they could to destroy the country's electrical infrastructure. They dynamited bridges, and generally did whatever was necessary to disrupt the government. Their tactics were reminiscent of the scene in Francis Ford Coppola's film *Apocalypse Now!,* when Marlon Brando's character Colonel Kurtz talks about how stubbornly the Vietcong resisted the Americans—to the point where they cut all the arms off children whom the Americans vaccinated. A brutal story, but the Colonel Kurtz character thought that was the coolest thing in the world: that insane level of passion, dedication, and commitment.

The Mujahidin were never that brutal, but certainly anything that represented some kind of modernity or advancement was taboo. When they took over in 1992, they systematically closed and trashed all the cinemas. That's when women went back under the veil too. The Arabs were already deeply involved. They had arrived in 1988, and began influencing the cultural and religious interpretations of the rebels, even people like Massoud.

This cast of characters was medieval, equipped with antiquated guns and living in these villages that looked like they had come straight out of the movie *The Man Who Would Be King.* They would fight and they would farm. In a village of eighty adult men, only twenty were actually fighting. Some were too old or too young, or for some other reason they were not fighting. They did the farming. The wife was farming, or the teenage kid. The Afghans are a very hearty people who work until they drop.

Something else about Afghans: guns are very much a part of the culture. Most of the fighters had old British Enfield rifles or shotguns. It's a male dominated society.

They gravitate towards war, and a fighting lifestyle. They seem to thrive on guns and running around the hills with their buddies. It's their way of bonding. "Let's get together, and walk this village." They get there and they sit down, they have tea and they talk, and then they sleep all in the same room. And it's this sort of camaraderie, much like a camping trip. They get together and talk about their guns, and then they go out and they shoot a little bit and they come back and they get all revved up.

I was really struck by this mentality. They would be fighting at night, for example. The Mujahidin would fire a few rounds into the garrison, then the garrison would respond, and then the Mujahidin would sort of respond. It was almost like foreplay. Then suddenly they would get into a full blown battle, and they would rage wildly until sunrise, when both sides collapsed from exhaustion and slept until noon. They thrived on it.

Nobody cared about this story until the Soviet Union invaded. At that point, it became a factor in the Cold War. South Vietnam had fallen just five years before, and now Afghanistan was suddenly being absorbed violently into the Soviet sphere. It became a satellite, and people became nervous. Pictures of the resistance demonstrated that the Afghan people were not going to roll over.

The idea of a bunch of peasants fighting against the Red Army seemed impossible. They were sending in tens of thousands of soldiers, and all kinds of helicopters and matériel. The perception was, "this ballgame is over; the Russians are in there, and there's no chance that the rebels are going win." They knew they couldn't win, in fact. Yet despite impossible odds they just pressed on. On more than several occasions they even admitted to me that there wasn't any chance that they were going to be able to push the Russians out. Everybody was freaked out.

Then the Olympics were canceled, and the media began scrambling for the David versus Goliath story—the Afghans standing up against the Russians. That's what intrigued the media people the most: a backward people was actually going to stand up and fight. They weren't going to roll over after all.

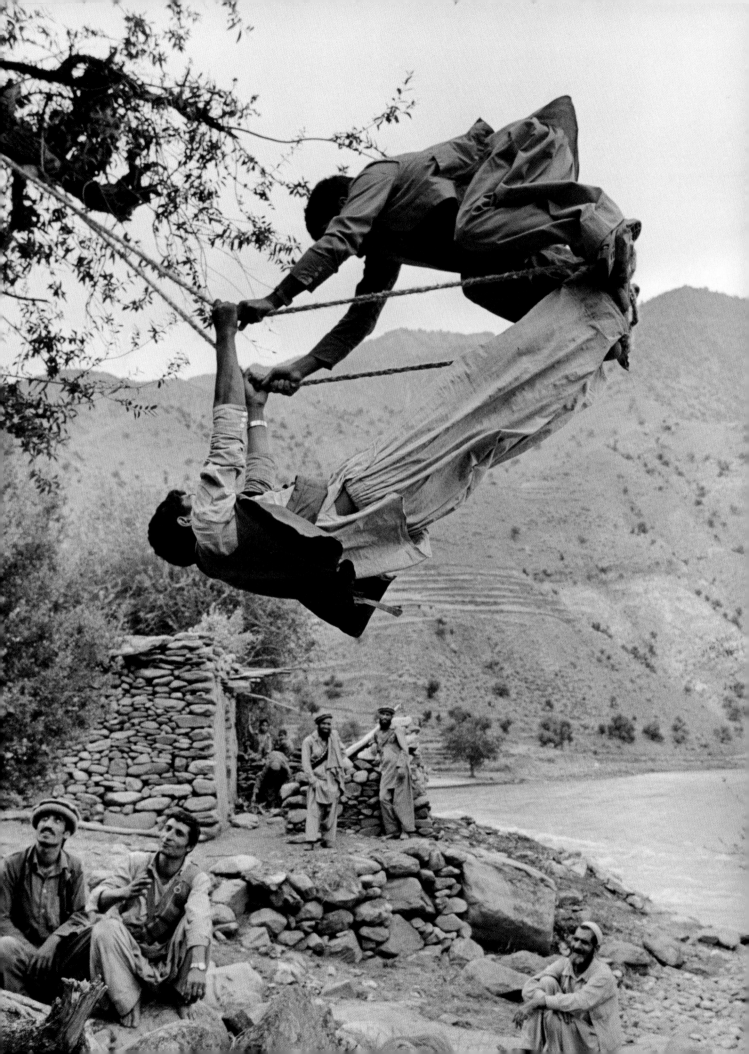

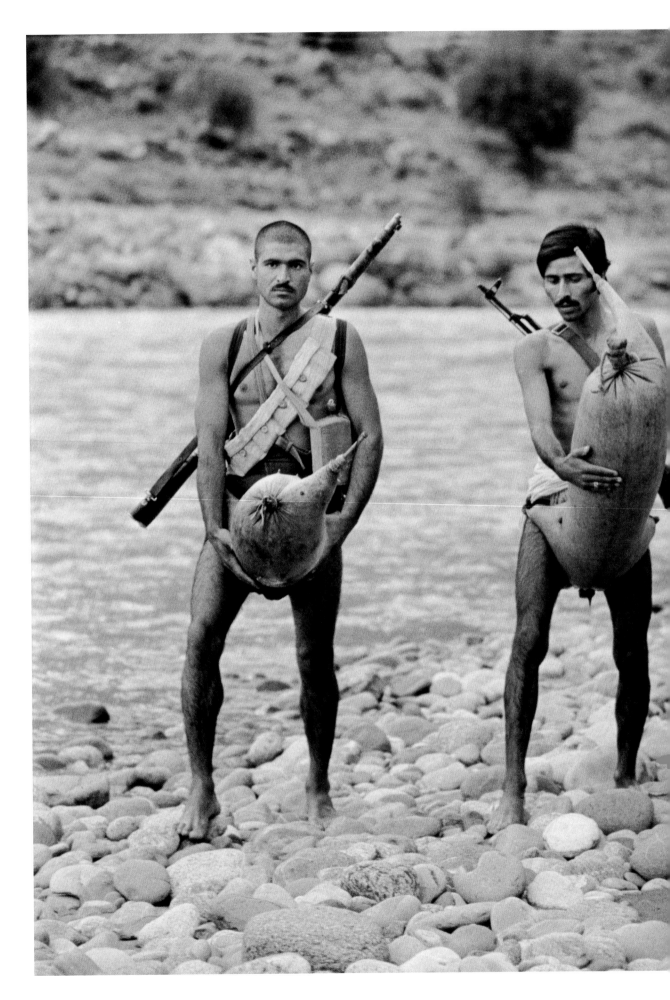

ARMED MUJAHIDIN USING ANIMAL SKINS AS INFLATABLE BUOYS TO CROSS THE RAPIDS.

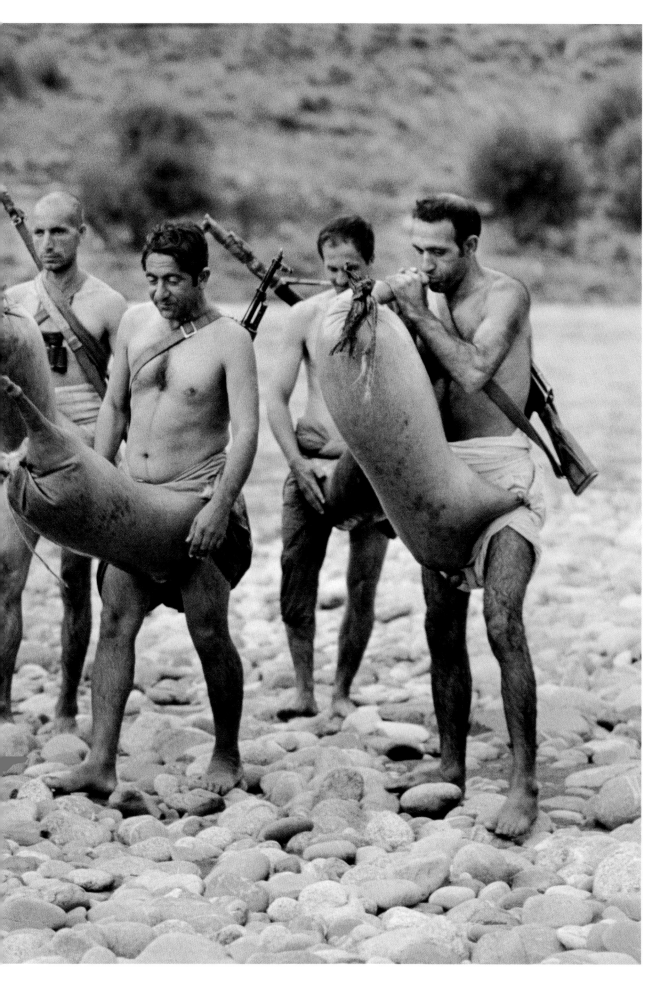

3

BETWEEN COMMUNISM AND THE QUR'AN

Despite the ensuing international outcry, most observers believed that the Mujahidin were outmatched by the Red Army. The Soviets had bolstered Afghanistan's faltering economy with billions of rubles of agricultural and industrial assistance, but could do little to control ethnic or regional antagonisms.

Other forces weakened the rebels, who remained divided amongst themselves according to a varying comprehension of the desired outcome for their holy war. Some thought to restore only their previous tribal autonomy; many Sunni Muslims believed they were fighting jihad to establish an Islamic republic whose laws would correspond to the sharia dictated by the Holy Qur'an; a few wanted a return to monarchy. Increasingly, there were also splits between guerrillas fighting inside the country and mullahs pulling strings from Pakistan's refugee camps, where they profited from foreign cash assistance and trafficking narcotics.

Realizing that the Soviets were trapped in a Vietnam-like quagmire, the United States committed its vast resources to assisting the rebels. The C.I.A. directly funneled them weapons, cash, and logistical intelligence. With help from Pakistan, the Central Intelligence Agency recruited and trained Mujahidin from masses of restive young men throughout the Arab and Islamic world. Saudi Arabia donated billions of petro-dollars and its ultra-radical form of Islamic theology. By 1985, the alliance was delivering the hi-tech surface-to-air missiles needed to destroy Russian air power.

More than one million Afghans died as a result of the U.S.S.R.'s final, ignominious military adventure. Many thousands more were hobbled and disfigured by millions of anti-personnel mines disguised sometimes as children's toys or food packages. Six million refugees huddled in camps in Pakistan and Iran. The Communist regime now rehearsed its last scene.

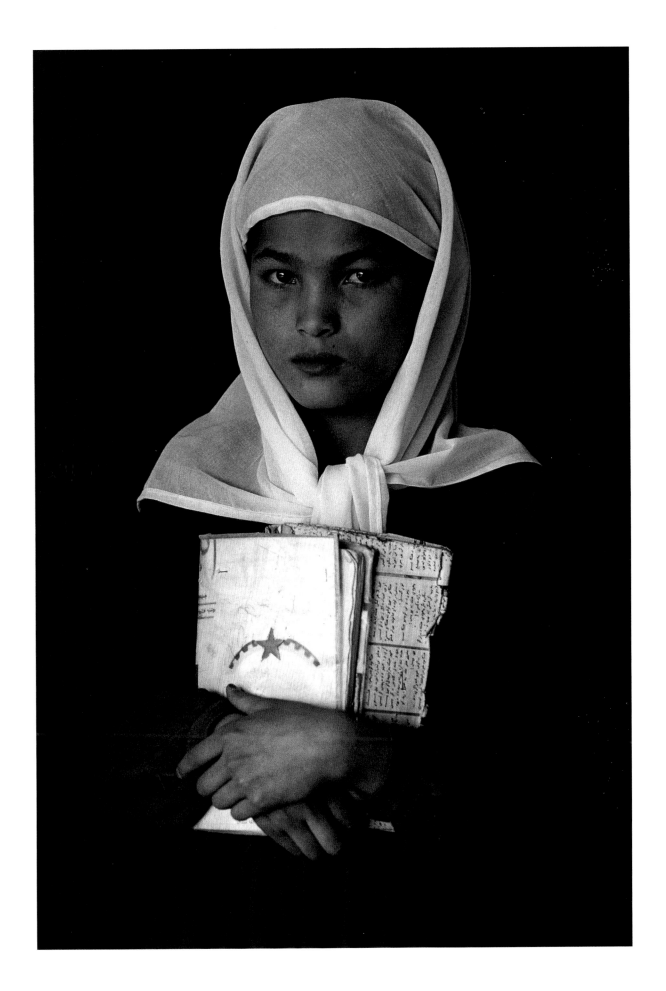

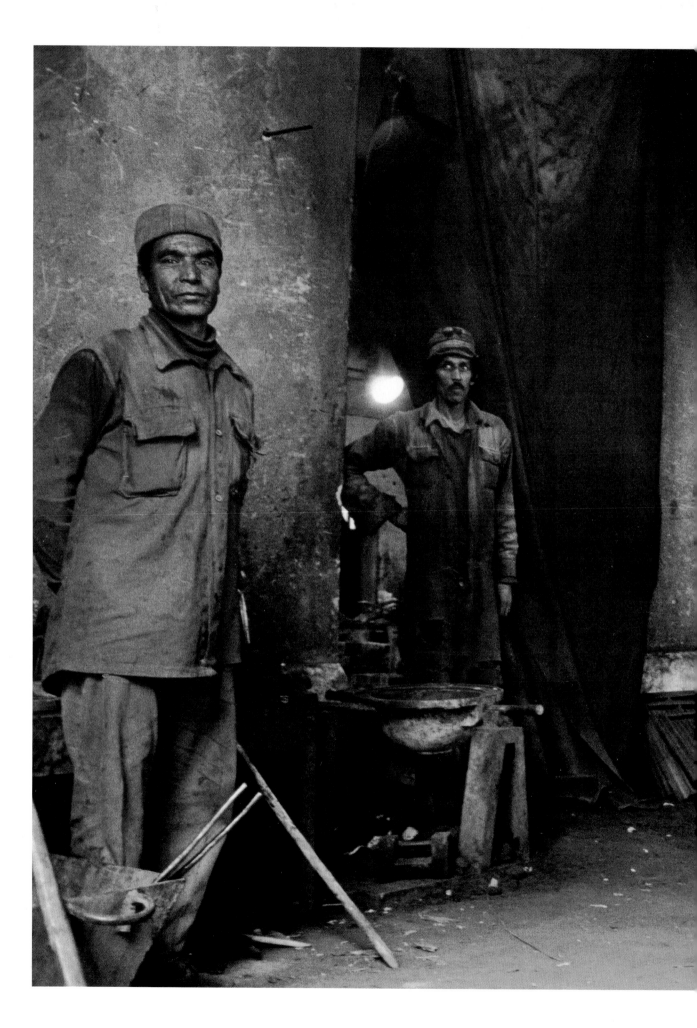

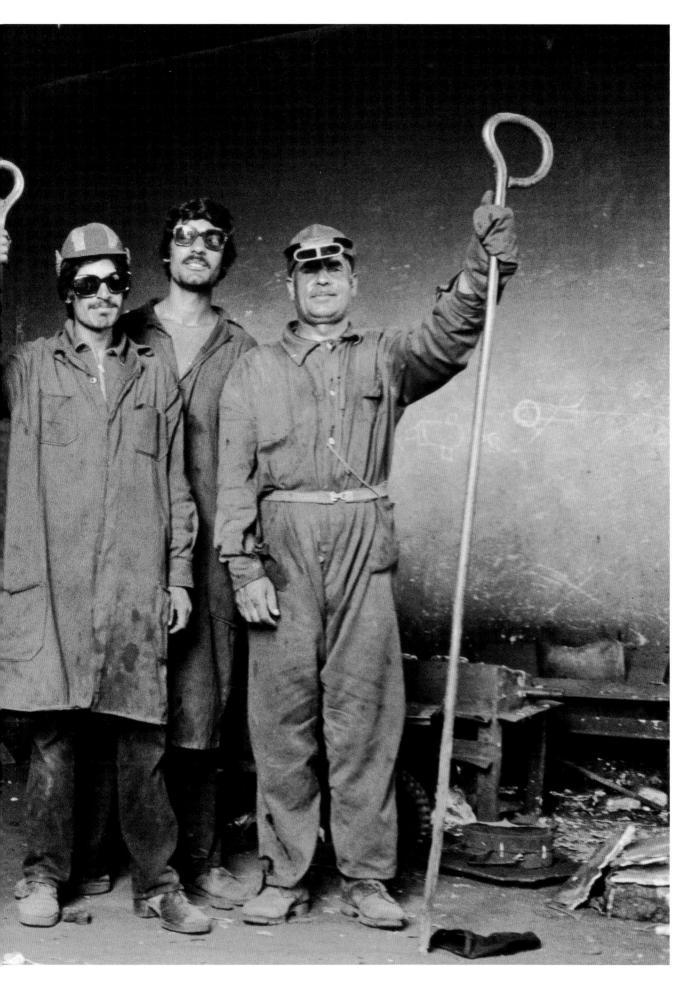

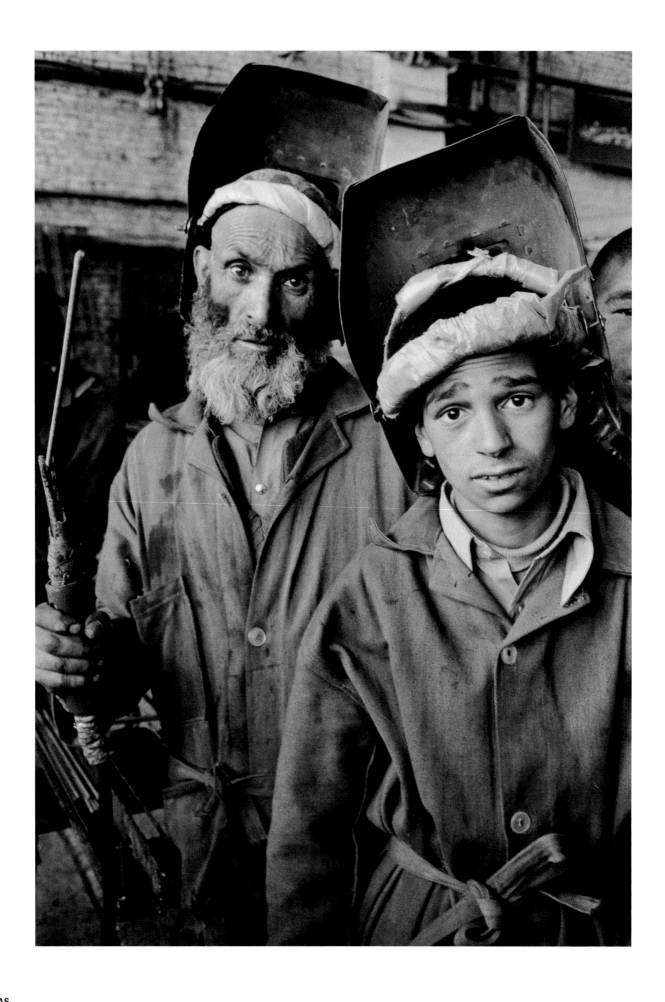

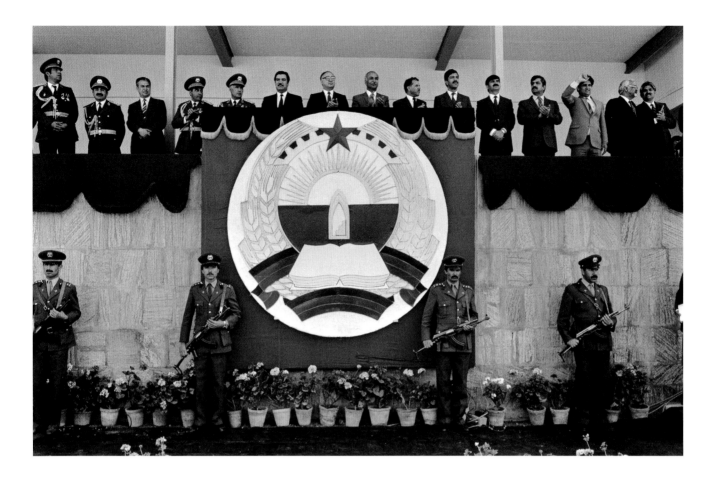

1986 LENIN VS. MUHAMMAD

BY ABBAS

In 1986, Lenin was at war with Muhammad. Instead of covering the anti-Communist Mujahidin, I traveled to the Soviet-occupied areas of Afghanistan. Extremist mullahs had already turned my country, Iran, into a fanatical Islamic republic, and I saw no reason to join the Western press in glorifying Islamists, even if they were defined as "freedom fighters."

Getting off the plane in Kabul was like entering the Iran of fifty years ago. A few days passed, and I felt I was back in the Iran of three hundred years ago. Both the Shah of Iran and Afghan Communists wanted to modernize their respective countries. The Shah was successful. The roads he built are still in use today, but the roads built by Afghan communists have turned into dirt tracks. Both regimes failed abysmally in secularizing their country. And this is a great lesson. Perhaps the only way to secularize a Muslim country is by following the politics of Mustafa Kemal Ataturk who, early in the twentieth century, forced Turkey to become a modern, secular state.

With their mentor the U.S.S.R. bombing civilians and occupying their country, Afghan Communists, who were no less nationalistic than the Mujahidin, had a something of a hard time presenting their case for modernization to the world. Returning from my first trip in 1986, I was criticized for sympathizing with this tragedy. Let us not forget that the U.S.S.R. was the "evil empire."

King Amanullah could have been the Ataturk of Afghanistan. Testimonies to this failure are the imported locomotive still rusting today in the courtyard of the National Museum, and the imposing palace he built in the periphery of Kabul—a palace so shell-ridden as to become a monument to the folly of the civil war.

PREVIOUS PAGES AND LEFT: WORKERS AT THE JANGALAK MECHANICAL FACTORY IN KABUL; ABOVE: MEMBERS OF THE RULING POLITBURO AND GENERAL STAFF AT A MILITARY PARADE COMMEMORATING THE ANNIVERSARY OF THE COUP D'ETAT WHICH BROUGHT THE COMMUNISTS TO POWER. GENERAL NAJIBULLAH (SIXTH FROM LEFT), FORMERLY THE DIRECTOR OF THE SECRET POLICE, EMERGED AS THE RULING STRONGMAN.

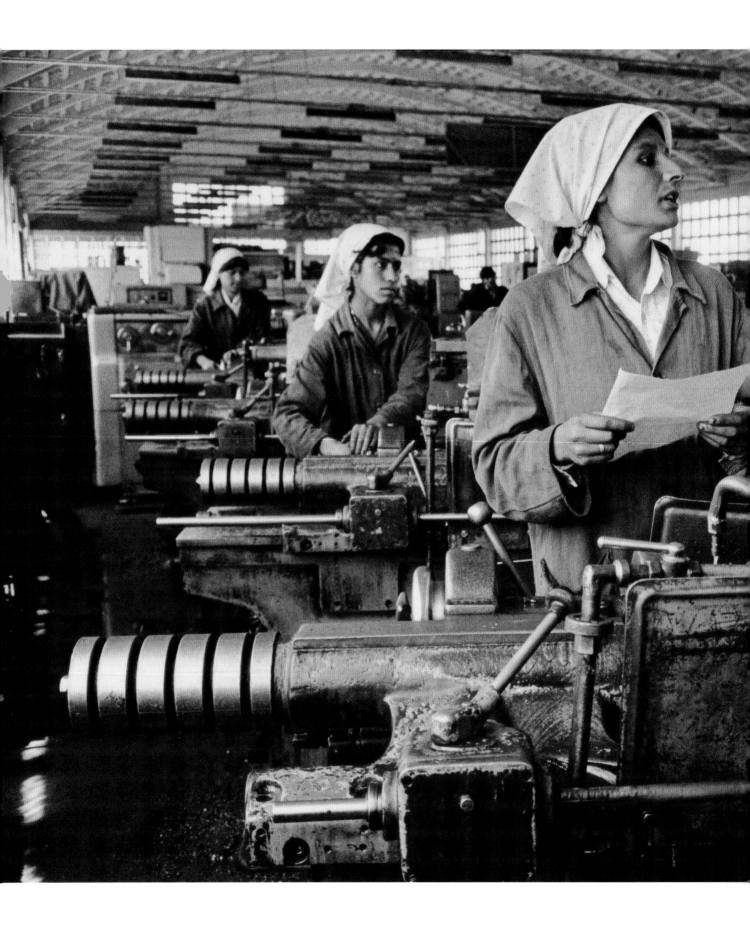

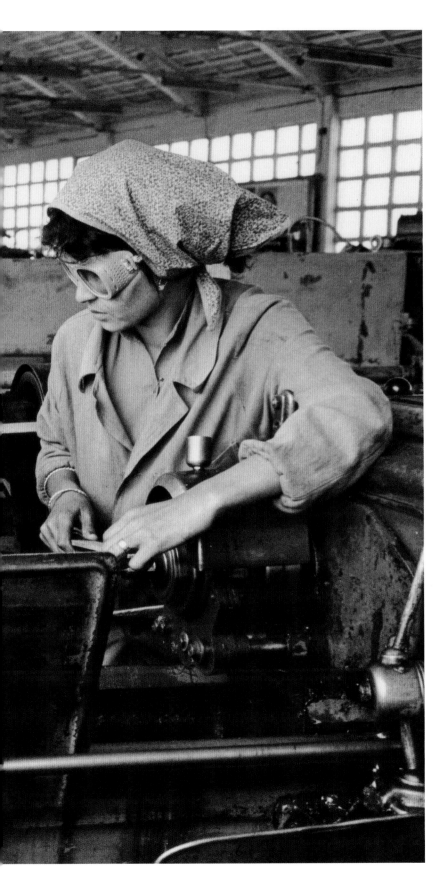

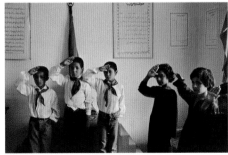

LEFT: JANGALAK MECHANICAL FACTORY. PLANS FOR THE INDUSTRIALIZATION OF AFGHANISTAN CALLED FOR THE RECRUITING AND TRAINING OF WOMEN FOR THE PRODUCTION LINE; TOP: A CHEMISTRY CLASS AT KABUL STATE UNIVERSITY WHERE 55% OF THE 6,000 STUDENTS WERE WOMEN; BOTTOM: YOUNG PIONEER SCOUTS SALUTING VISITORS.

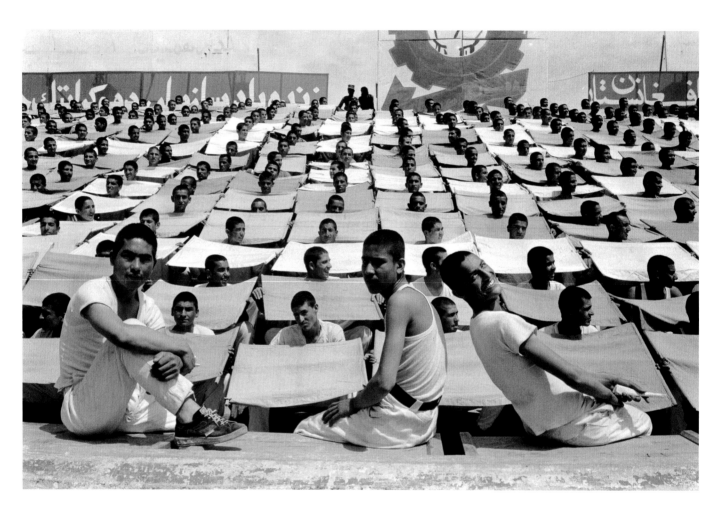

YOUNG BOYS DISPLAYING THE INTERNATIONAL WORKERS STANDARD DURING A CELEBRATION OF THE DEMOCRATIC YOUTH ORGANIZATION.

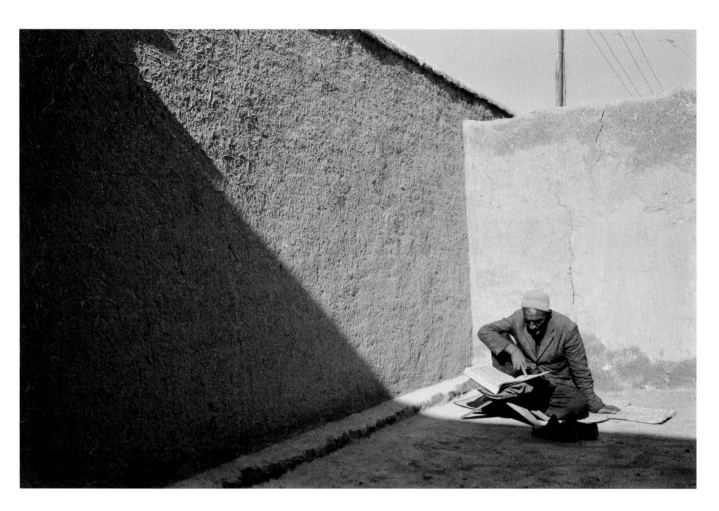

OLD MAN READING FROM THE QUR'AN IN THE COURTYARD OF HIS KABUL HOME.

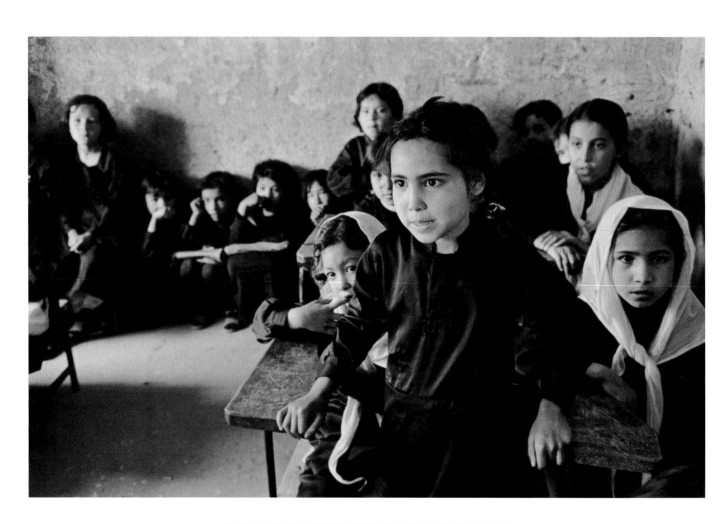

CLASS AT THE AICHE AFGHAN SCHOOL FOR GIRLS IN MAZAR-I-SHARIF.

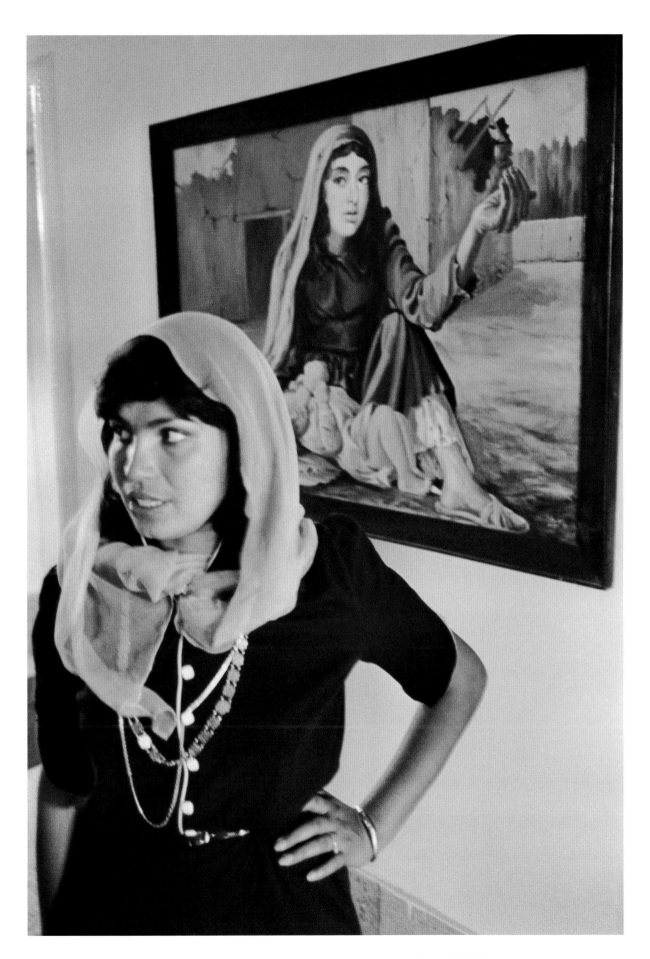

AN EXAMPLE OF THE MODERN ART FROM AFGHANISTAN'S NATIONAL GALLERY.

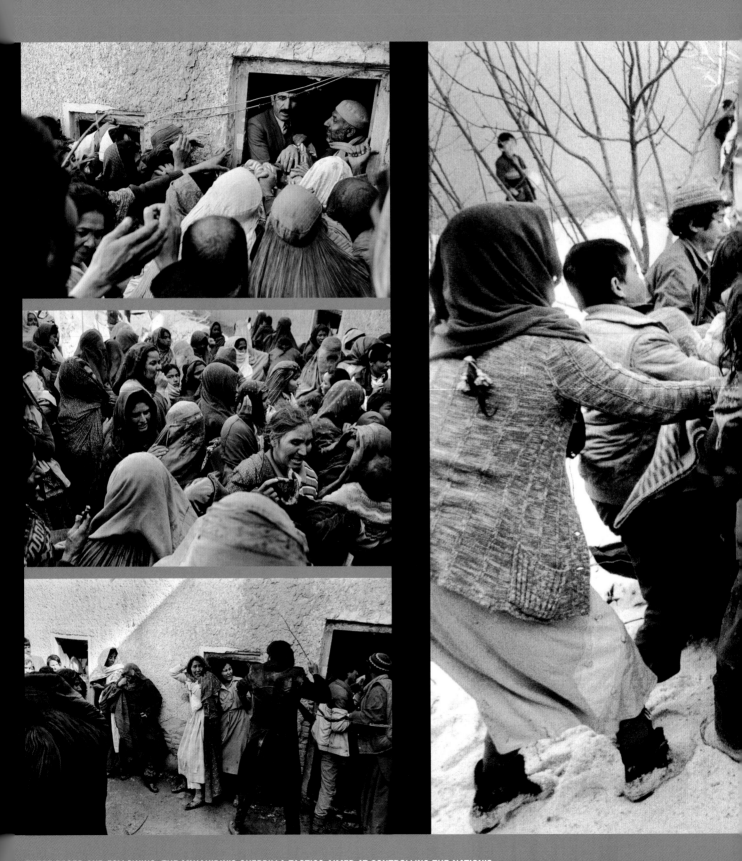

THESE PAGES AND FOLLOWING: THE MUJAHIDIN'S GUERRILLA TACTICS AIMED AT CONTROLLING THE NATION'S
HIGHWAYS TO CUT SUPPLIES OF FUEL AND OTHER ESSENTIALS. IN THE MIDST OF THE GLACIAL WINTER OF 1989,
VILLAGERS AT VALAI ZAMAN KHAN (19 KM FROM KABUL) FOUGHT FOR BLANKETS DISTRIBUTED BY UNICEF.

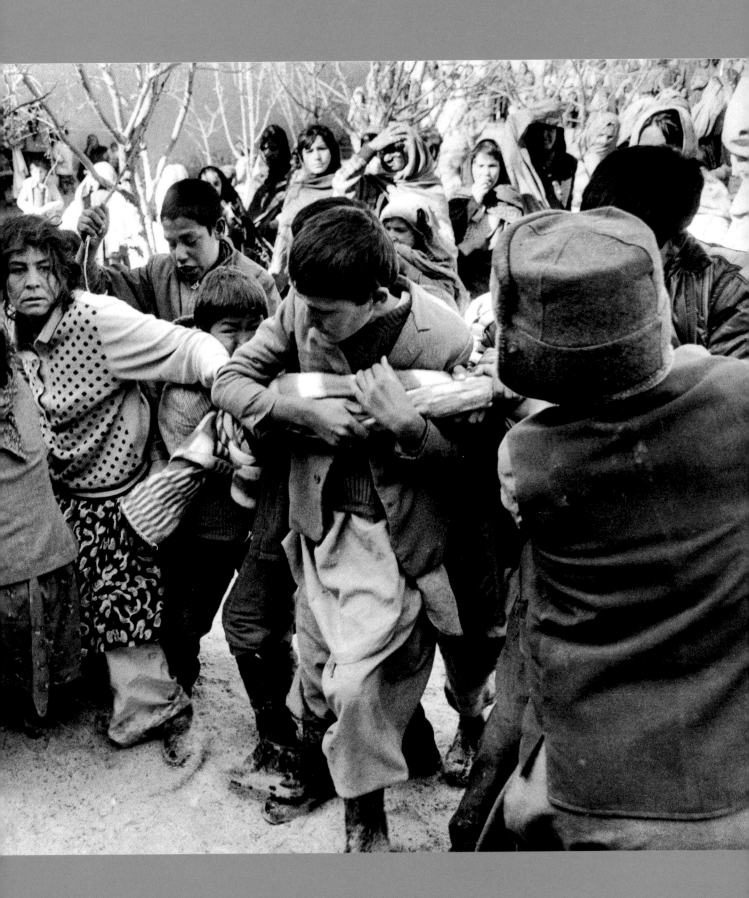

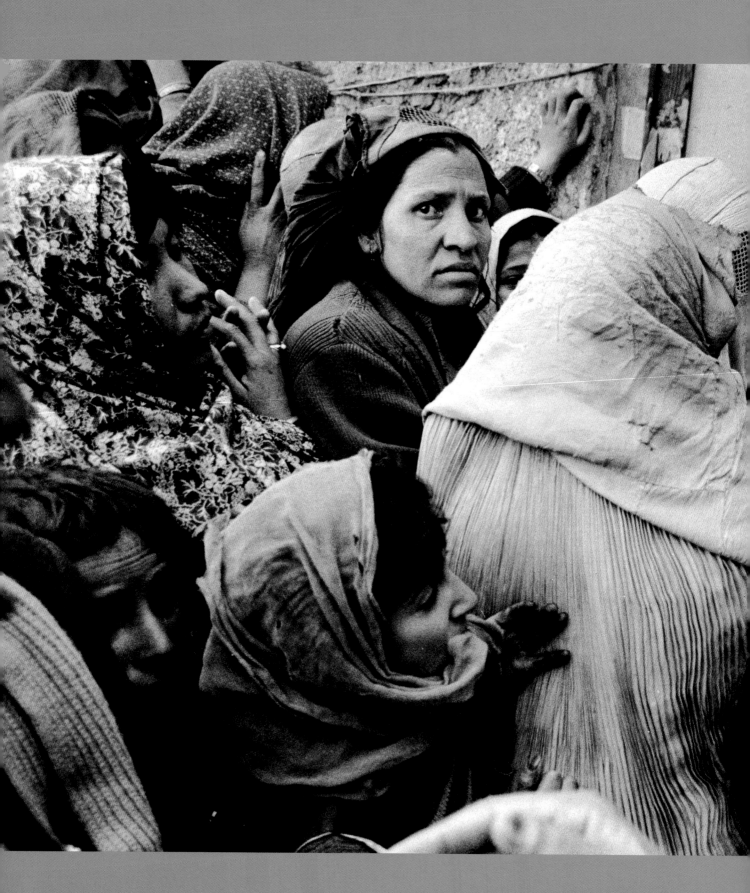

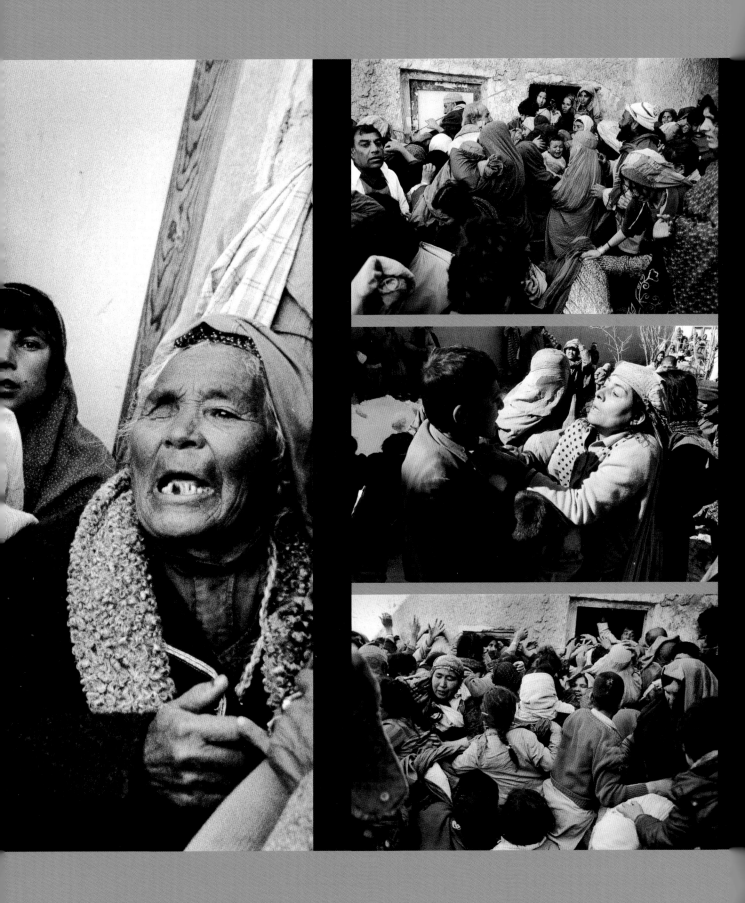

1989 JIHAD

BY STEVE MCCURRY

The conversion of the Afghan uprising into an international jihad for the entire Arab-Muslim world was a gradual process. In 1980, I ran across just one Pakistani. He was sort of a novelty at the time. By 1988, however, I noticed a lot of Arabs already hanging around together. They hated Americans, hated foreigners, hated journalists. They would refuse to shake your hand. They didn't want to talk to you. In fact, they even threatened me a couple of times. "You're a kafir! We're going to kill you."

During a huge offensive at Jalalabad, some Arabs were dragging one of their wounded colleagues down a path. It was in the midst of really heavy gunfire and shelling. They were dragging this guy by his feet. Each guy had a foot under his arm and they were dragging him and his head was bumping against the trail. When I jumped over to get a picture, one of these guys picked up a rock and glared at me wildly. I stared at him; he cursed me and eventually threw the rock down. But the idea was, "I'm going to kill you if you take any pictures." We were literally a foot and a half apart. I met him another time near Jalalabad, where he went to visit Osama bin Laden. The Arabs wanted us to leave and threatened to take our cameras, but the Afghans stood up and said we were their guests and refused to allow them to be aggressive with us. "This is our country. We've invited them to come here." It was a stand-off, and the Arabs backed down.

Although the Arabs were fighting absolutely alongside the Afghans, I don't think they ever really embraced them. Everyone knew that the Arabs distributed money in the camps. Afghans probably felt grateful for any help, but the Arabs were Wahabi types—very condescending and very hateful. If it weren't for the Afghans around, they would just take you out.

The Afghan peasants are an illiterate people, and they believe the scriptural command to follow the Qur'an and be a good Muslim because they don't want to go to hell. They buy into the whole idea. How deeply do they understand it or personalize it? I guess probably not very much, but they believe that this is the true faith. They believe the mullah (prayer leader). There's no discussion, no debate. They go through the five daily prayers, and are pretty good about observing Ramadan. In village life there's the mullah and the tribal elder: the tribal elder maintains political, social, and economic control, and the mullah exercises religious control. The tribal leader or the village leader only wants to control his village, and he doesn't want his power base messed with. The mullah is the spiritual leader only. The whole thing worked until the central government wanted to install their own guy in order to consolidate a Communist power base. They were not only coming into the villages and disrupting the secular order, but they were also being perceived as godless enemies of Islam.

WOUNDED MUJAHID EN ROUTE TO HOSPITAL ACCOMPANIED BY HIS MOTHER.

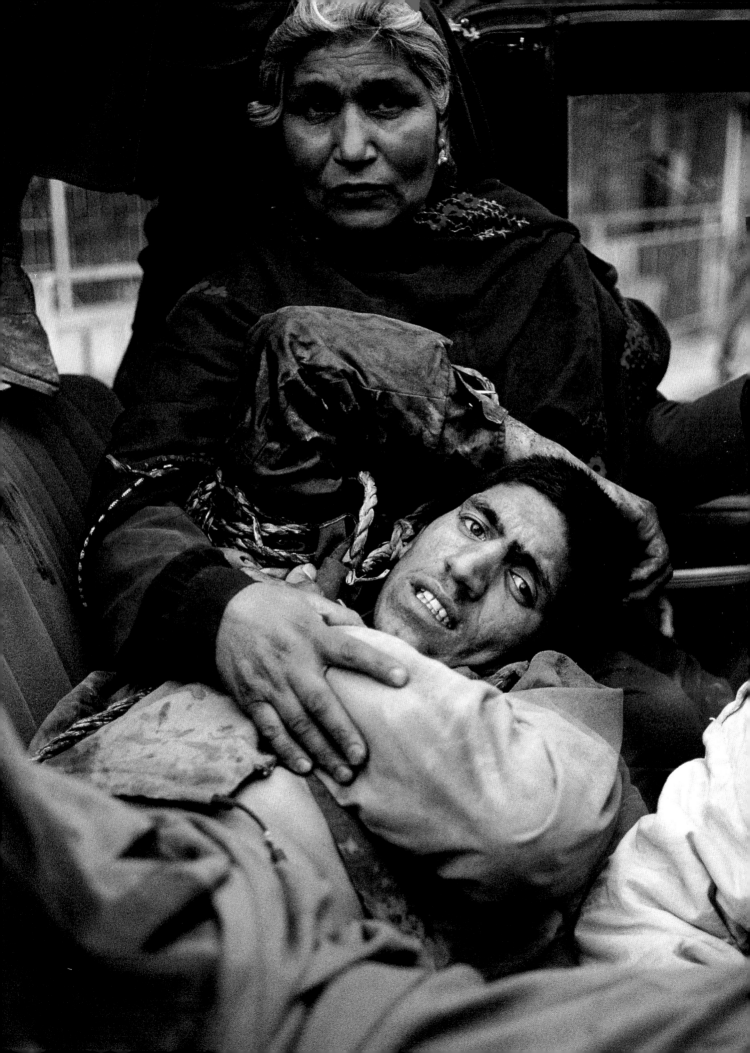

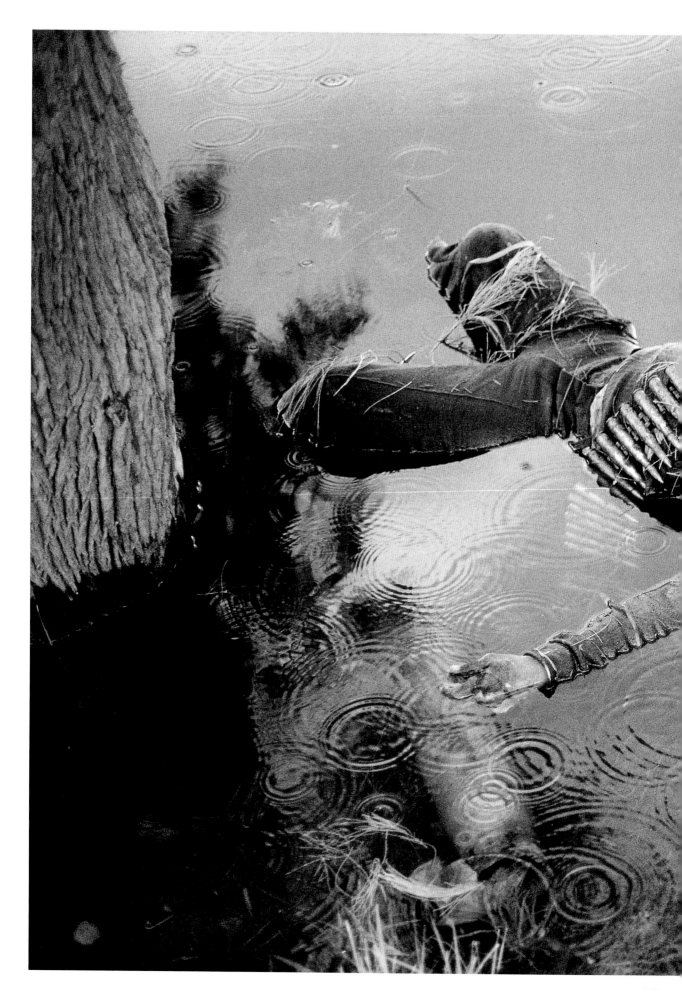

A GOVERNMENT SOLDIER KILLED DEFENDING THE MILITARY AIRPORT NEAR JALALABAD.

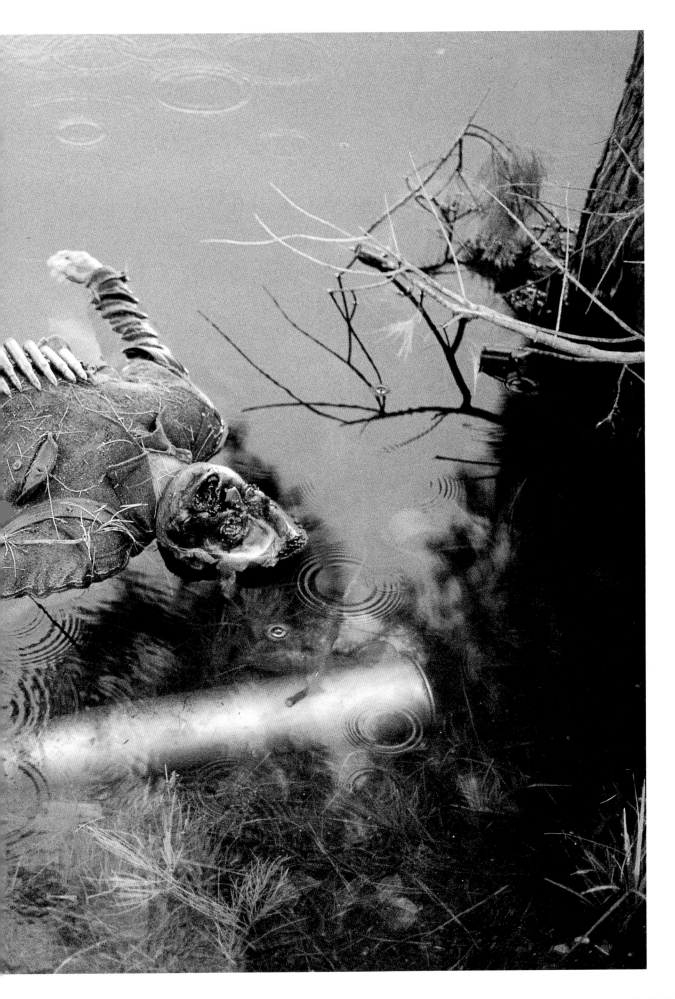

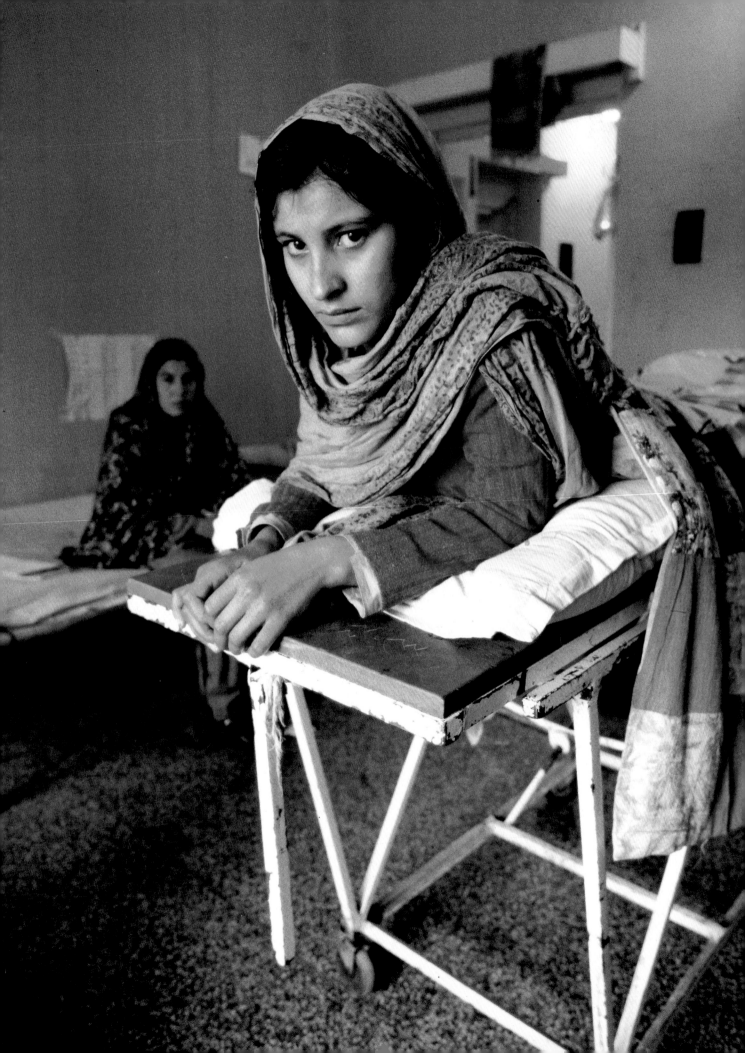

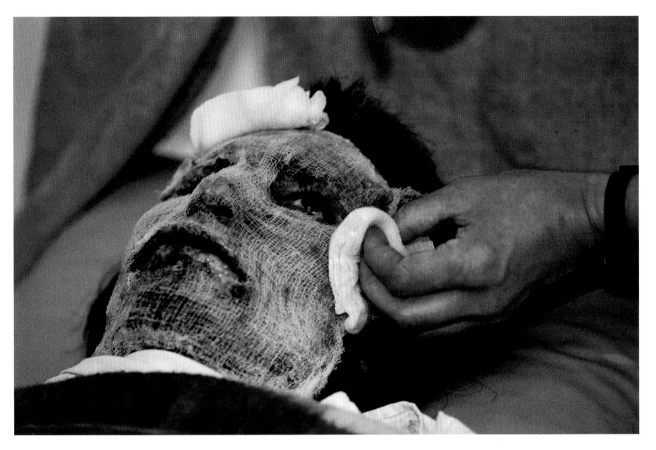

THIS MAN'S FACE WAS BURNED BY THE BACKFIRE OF A ROCKET.

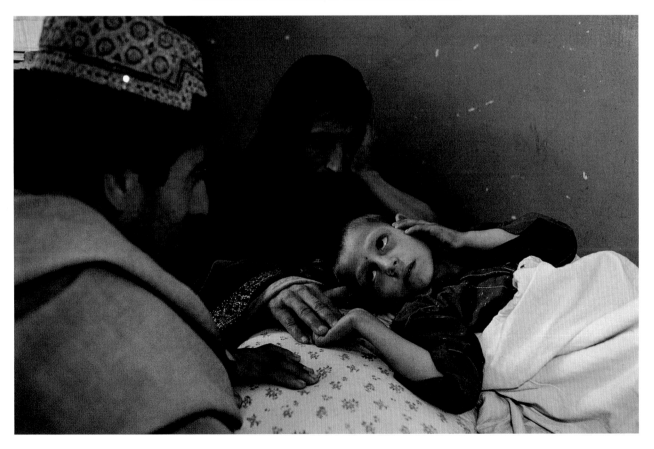

LEFT: A YOUNG WOMAN IN THE PARAPLEGIC WARD OF KABUL'S RED CROSS HOSPITAL; ABOVE:
A BOY INJURED BY THE EXPLOSION OF ONE OF THE MILLIONS OF SOVIET LAND MINES THAT LITTERS THE COUNTRY'S LANDSCAPE.

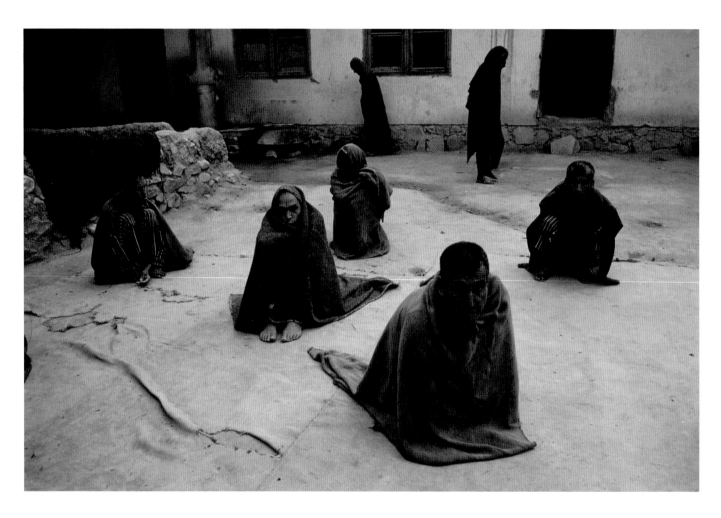

AMONG THE INVISIBLE VICTIMS OF A BRUTAL WAR WERE THOSE WHO SUFFERED MENTAL DISORDERS.
SOME WERE CONFINED TO THIS ASYLUM AT MAR-I-STOON NEAR JALALABAD.

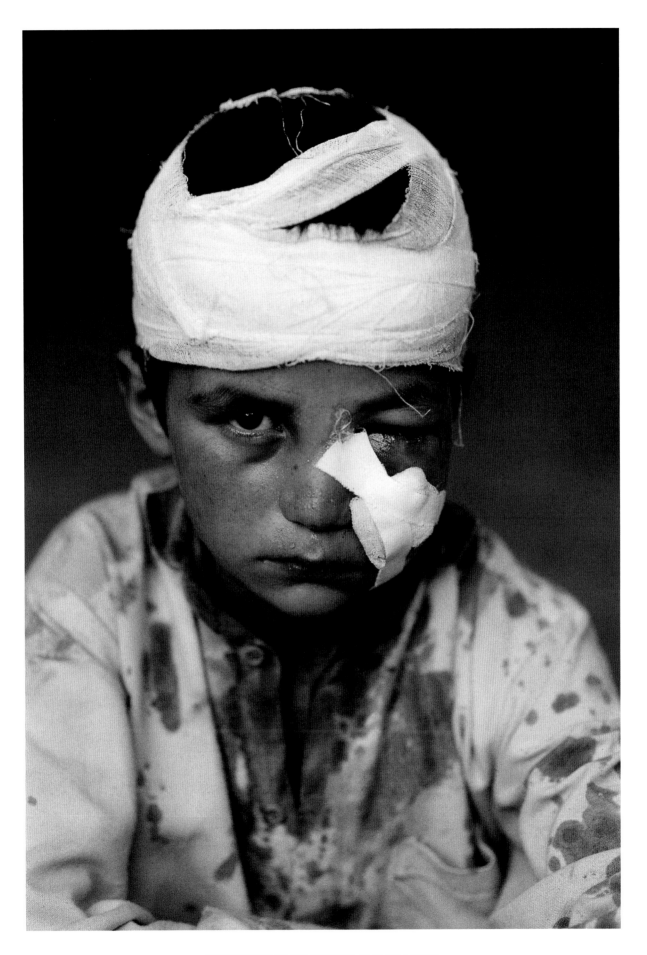

BOY WOUNDED BY HOT SHRAPNEL NEAR PUL-I-KUMSI.

1992
DEATH IN KABUL

BY ABBAS

So much has already been written about jihad that the term now means too many things to too many people. For twenty years now, I have led my own jihad against jihad.

Islam might be unique, in the way Allah is claimed to be One, but Muslims are many. What does a Javanese Muslim, heir to a great Hindu civilization, share with a Wolof of Senegal, whose grandfather was an animist, save the scripted rituals of faith?

Some Afghans remember they were once Buddhists, Zoroastrians, and probably animists before converting to Islam. In 1992, when I was covering the Red Cross hospital in Kabul, I could see that all of the wounded men, women, and children—there courtesy of the various Mujahidin factions fighting for control of the capital—had some sort of protection amulet hidden under their clothes.

Why do you think that the Taliban defaced paintings or destroyed up the giant Buddhas of Bamiyan? Not because these things were an offense to their puritanical morals, but because they wanted to erase anti-Islamic thoughts from the psyche of Afghans. In his novel *Shame*, which is about neighboring Pakistan, Salman Rushdie writes, "Men who deny their pasts become incapable of thinking of them as real."

A MUJAHID OF HEZB-I ISLAMI, GULBUDDIN HEKMATYAR'S GUERRILLA ORGANIZATION, GUARDING THE ROAD TO KABUL.

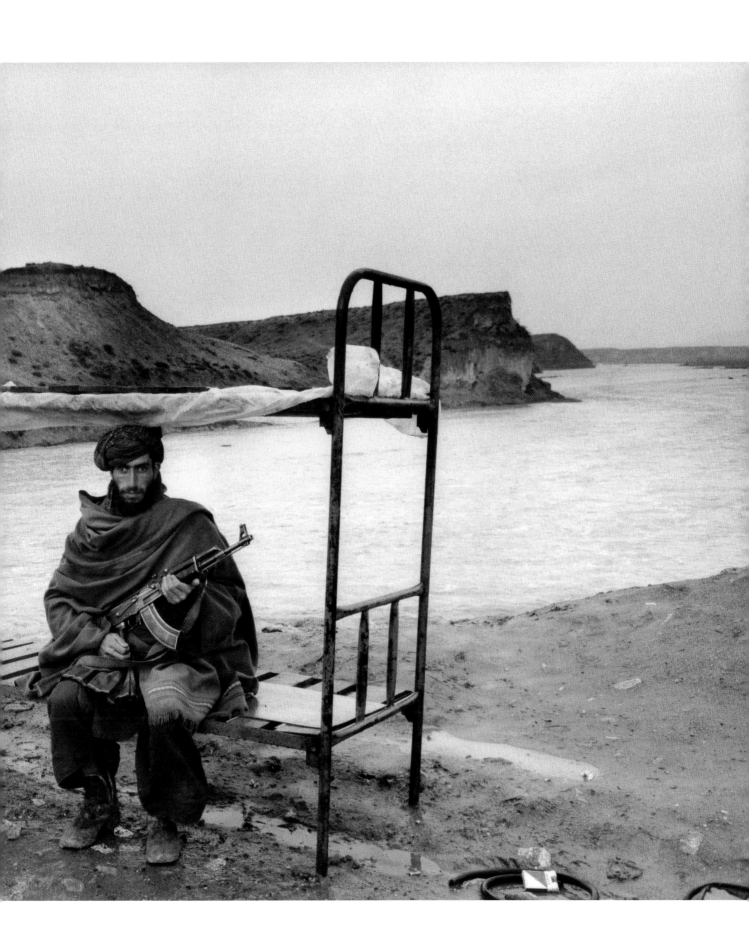

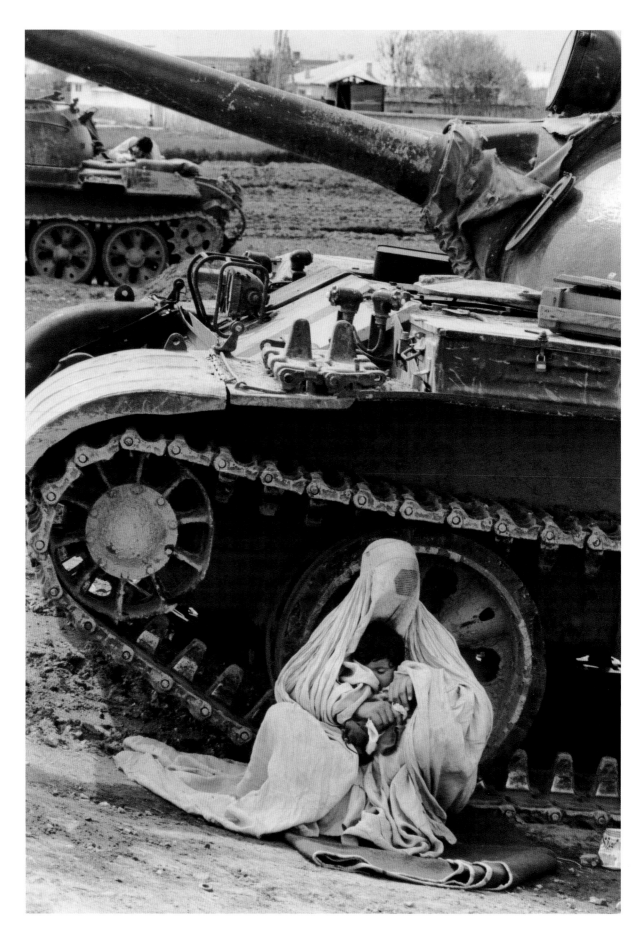

A WOMAN SHELTERING HER CHILD FROM FACTIONAL WARFARE IN KABUL.

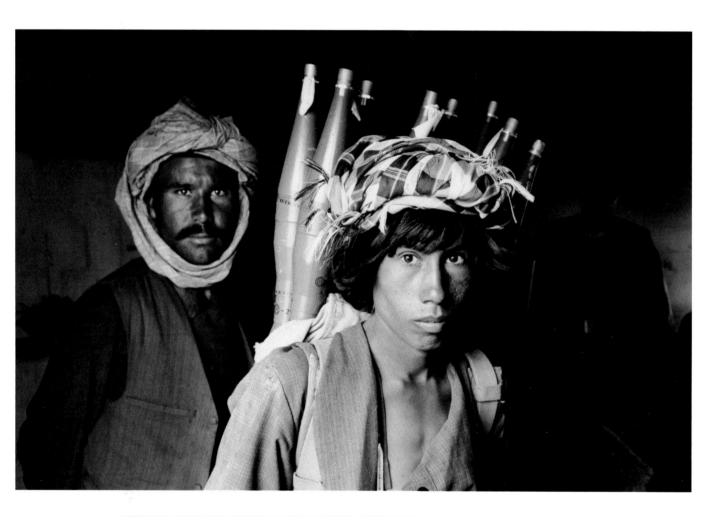

GUERRILLAS ALLIED WITH GENERAL RASHID DOSTUM'S UZBEK MILITIA, ANOTHER ORGANIZATION STRUGGLING
FOR A SHARE OF POLITICAL POWER IN POST-COMMUNIST AFGHANISTAN.

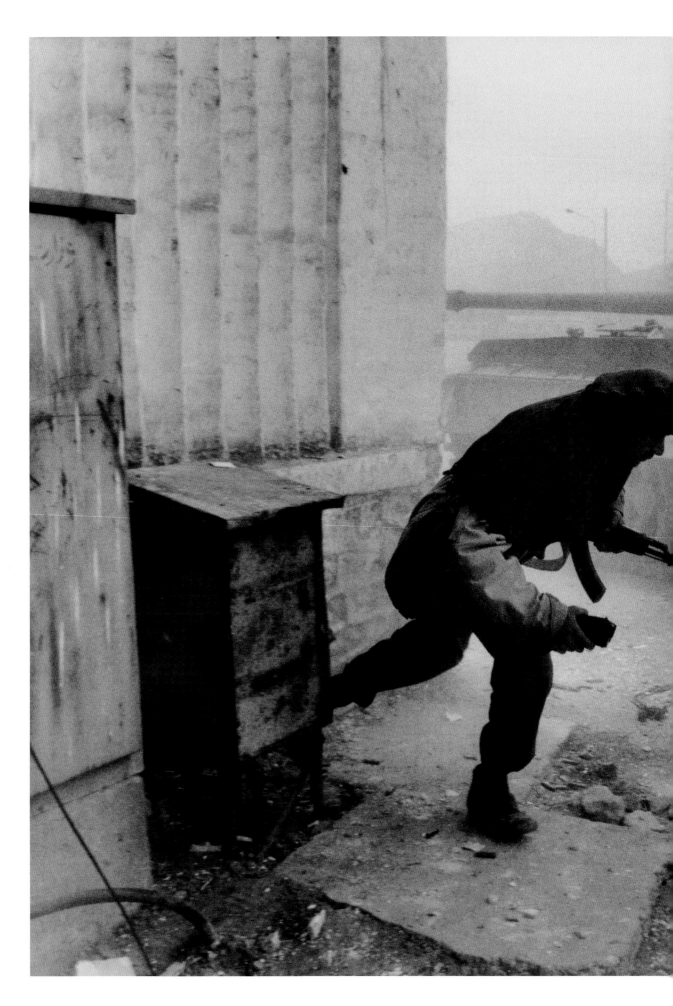

JAMIAT ISLAMI MUJAHID BATTLING THE HEZB-I ISLAMI FOR CONTROL OF KABUL. FIGHTING AMONG THE GUERRILLA FACTIONS ERUPTED AFTER

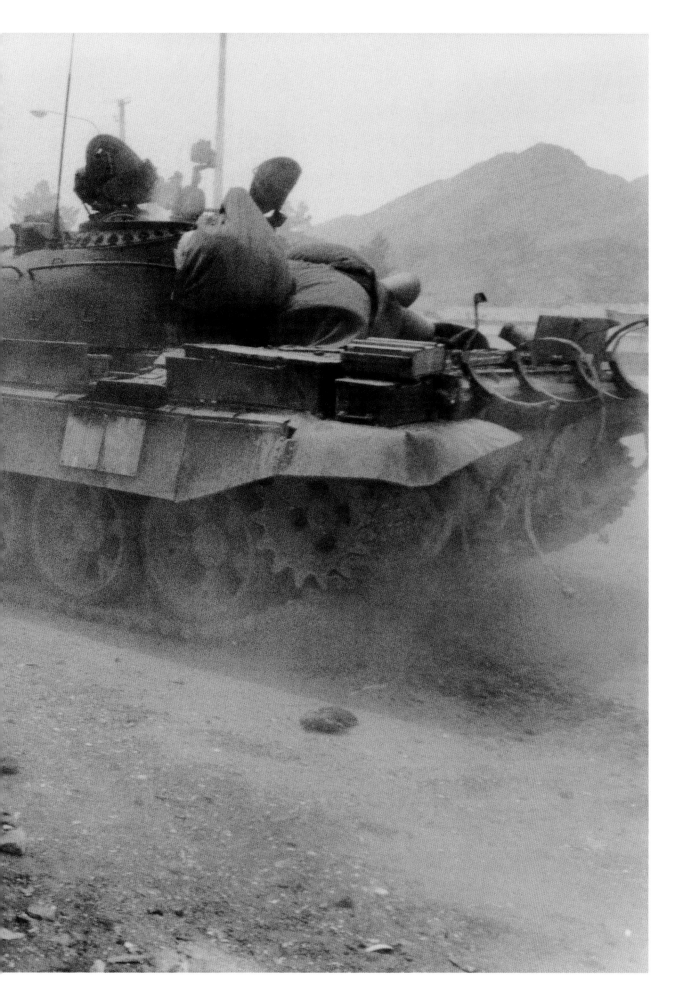

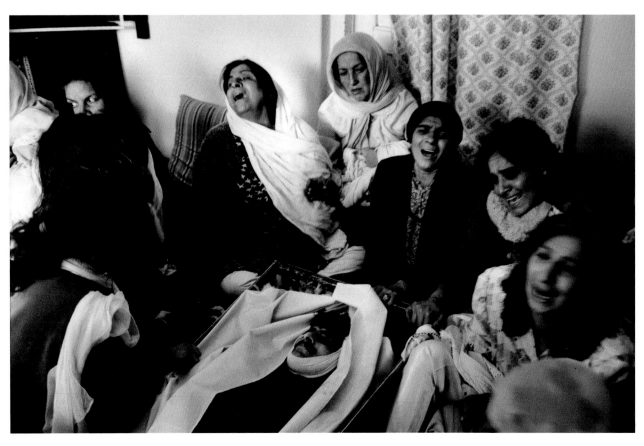

WOMEN MOURNING THE DEATH OF A CIVILIAN KILLED BY HEZB-I ISLAMI'S INCESSANT SHELLING OF KABUL.

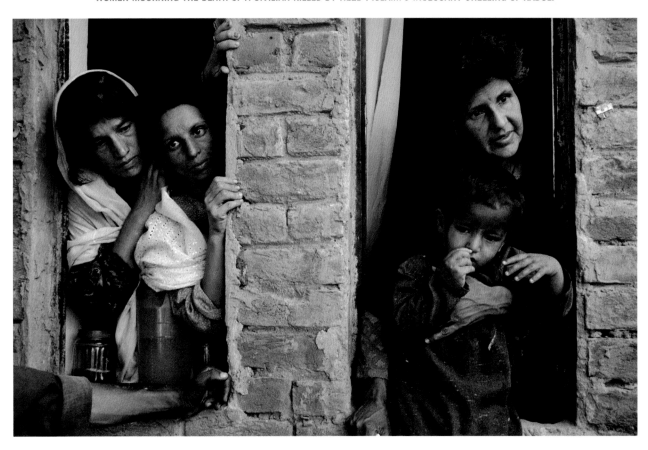

SOME KABUL RESIDENTS FLED ACROSS THE BORDER TO PESHAWAR TO ESCAPE THE SAVAGE WAR IN THEIR CITY.

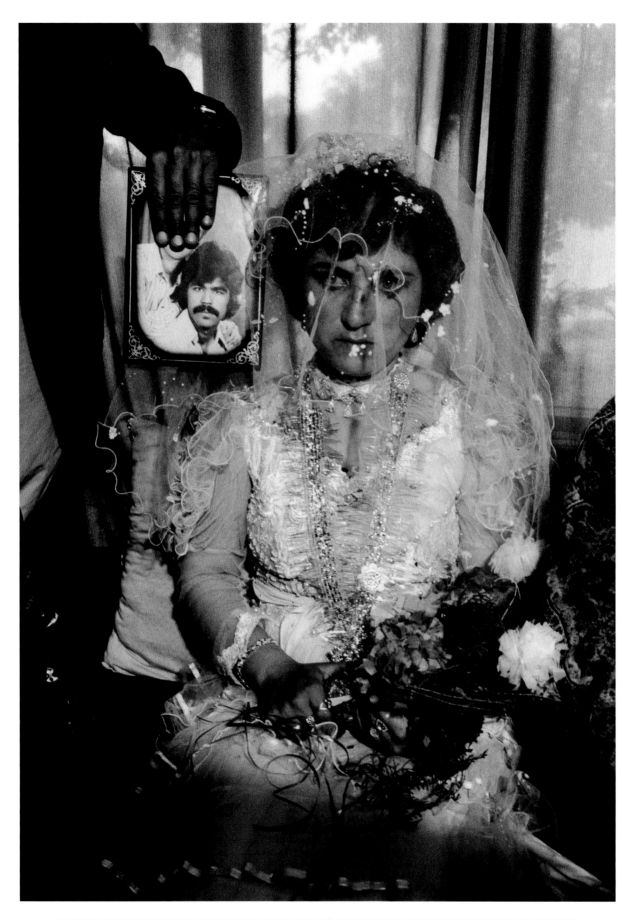

A YOUNG WOMAN EXCHANGING MATRIMONIAL VOWS WITH HER ABSENT GROOM (PORTRAIT) WHO WORKED IN GERMANY.

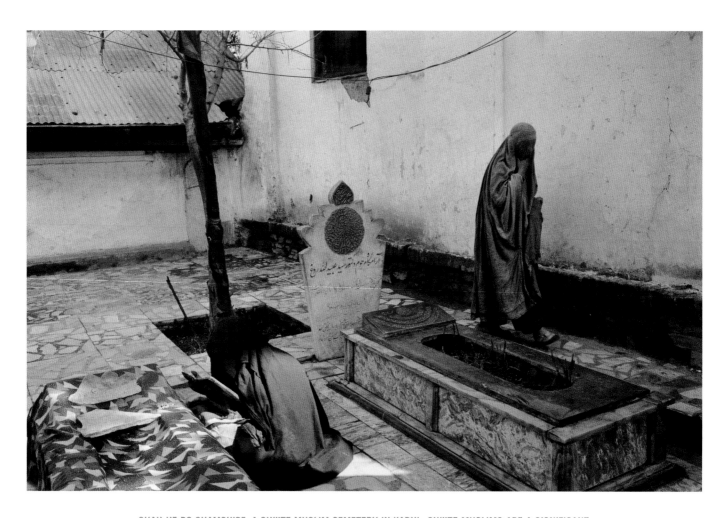

SHAH-HE DO SHAMSHIRE, A SHI'ITE MUSLIM CEMETERY IN KABUL. SHI'ITE MUSLIMS ARE A SIGNIFICANT
AND OFTEN PERSECUTED MINORITY IN A COUNTRY WHERE THE MAJORITY OF MUSLIMS FOLLOWS SUNNI DOCTRINE.

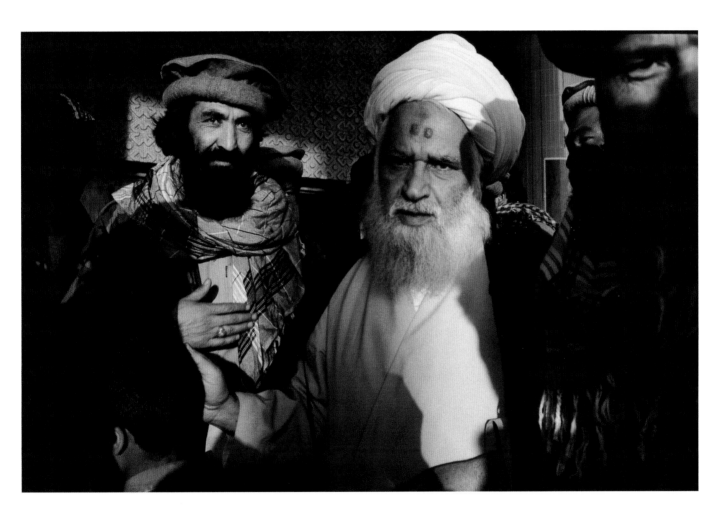

LEADER OF AFGHANISTAN'S SHI'ITE MUSLIMS, AYATOLLAH ASIF MOHSENI.

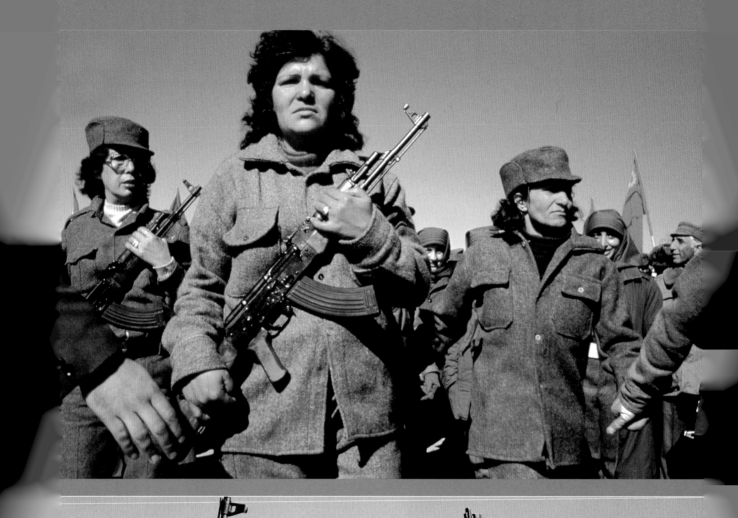

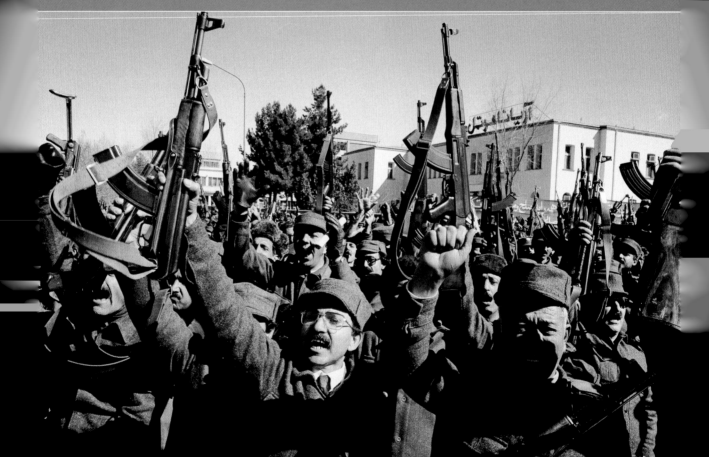

IN THE WAKE OF THE RED ARMY WITHDRAWAL IN 1989, PRESIDENT NAJIBULLAH CALLED UPON THOUSANDS OF PRO-GOVERNMENT MILITIAMEN AND WOMEN TO DEFEND AGAINST THE ENCROACHING MUJAHIDIN ARMIES. ARMORED TROOP CARRIERS SNAKING THEIR WAY OUT OF KABUL, RETREATING ALONG THE SALANG HIGHWAY TOWARD THE SOVIET BORDER 420 KM AWAY.

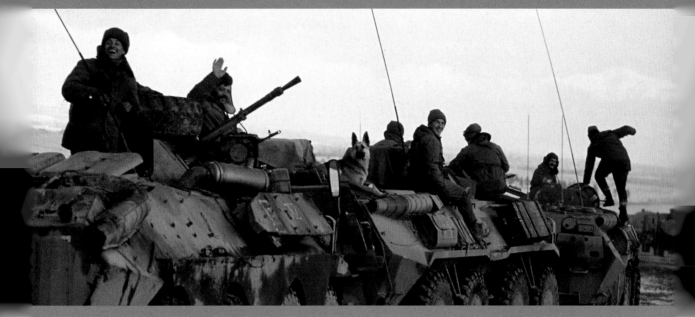

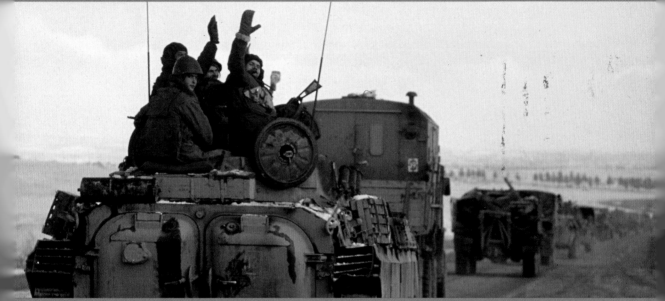

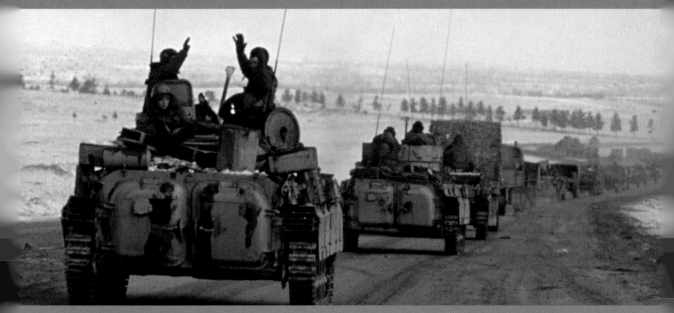

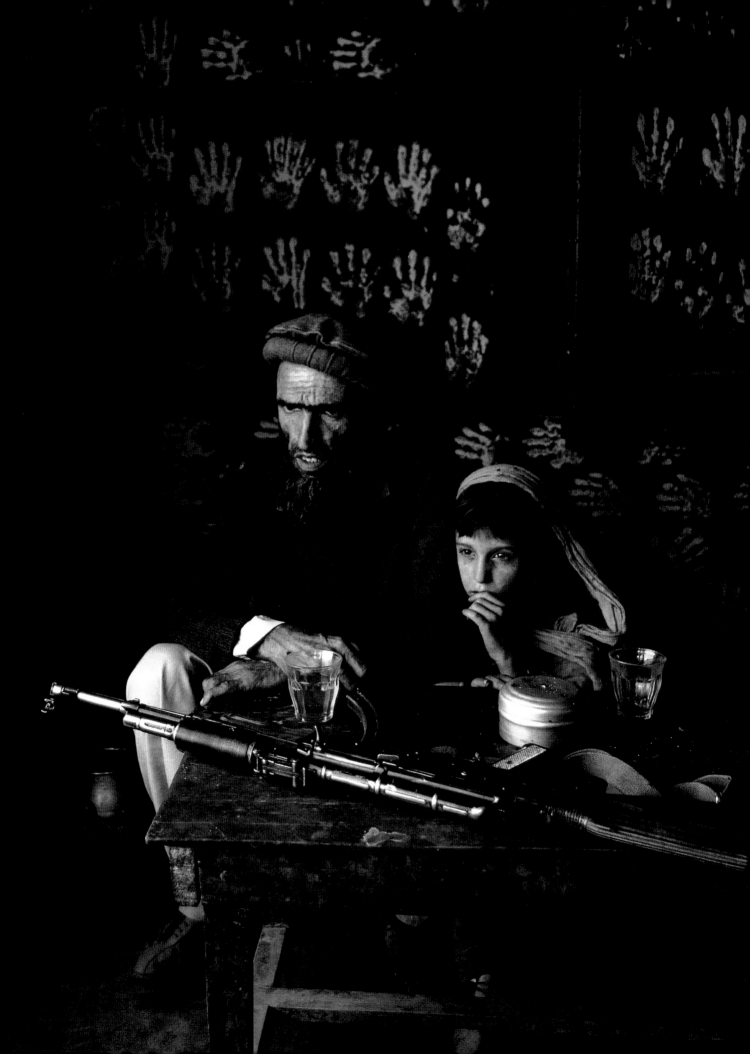

1992 THE DOMESTIC FORTRESS

BY STEVE MCCURRY

Afghans love walls. They want to be surrounded by big walls, high walls. Fortresses. You walk through some of these villages and the walls are twenty or thirty feet high. These huge walls are just amazing; they're impossible to scale. When entering a compound, you pass huge walls only to find a small houses within. There are lookout posts in order to survey the terrain. Down in the lowlands around Jalalabad and further south around Kandahar, you see very imposing fortified villages. All this is constructed of mud, except in the north, where it's all wood. Here the families and neighbors live close together, much like a beehive where the houses are all connected.

The whole idea is that of a domestic fortress. Afghans always want protection. It's the same with their women. They protect them fanatically. You wonder if this goes back to ancient times when women were kidnapped. There's something else going on apart from the Islamic doctrine about female modesty, because they are obsessed about their women. Just imagine another era, when the plundering horde sweeps in and takes away all the women. The burka was fully enforced back then.

You could never meet your best friend's wife, or even his sister. He could be your best friend, and you would never meet his wife. There was always a separate room in the house for guests, and I was never in contact on any level with the women. If you saw a woman in the village,

she would be working or caring for the children. You were allowed a single glance. In other words, you could look, but you couldn't look again. Obviously on the trail or something you might bump into somebody. However, if you were going to talk to a woman, ask for directions, you would have to position yourself a good distance away and standing off to the side. Theirs was a custom where you had to avoid all contact with women. There was no chance to take photographs. You could photograph a young girl running around playing with her friends in the village, but there was never any contact at all with adolescent and adult women. Just none. It's very interesting.

Back to the architecture. Afghans generally have big homes with lots of space. They are kind of affluent, I would say. Afghans always had a lot to eat. They always had a big house. They always had land. There were always sheep and goats around. I never got the idea that there was any poverty. Of course, they didn't have any running water or electricity, but they always seemed like they had a lot to eat. Maybe they didn't have education or medical facilities, but they had a great place to live, and shelter and food were abundant.

Life was pretty good. There were rooms everywhere, and there was great food, and you ate well all the time. Only when a village was destroyed were you just eating rice and bread.

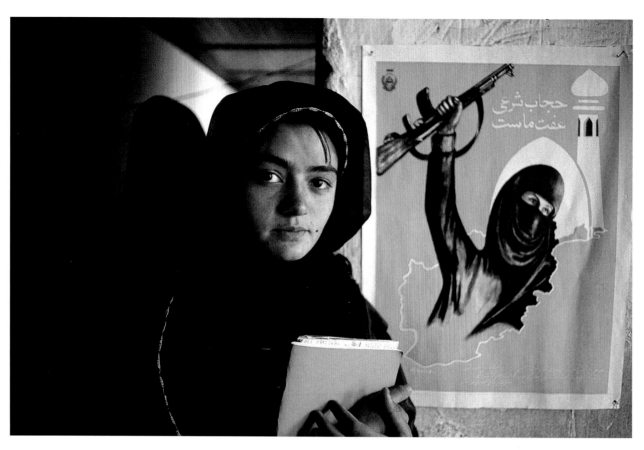

A POSTER DISPLAYED AT A GIRLS HIGH SCHOOL IN KABUL EXHORTING AFGHANS TO RESIST FOREIGN INVADERS.

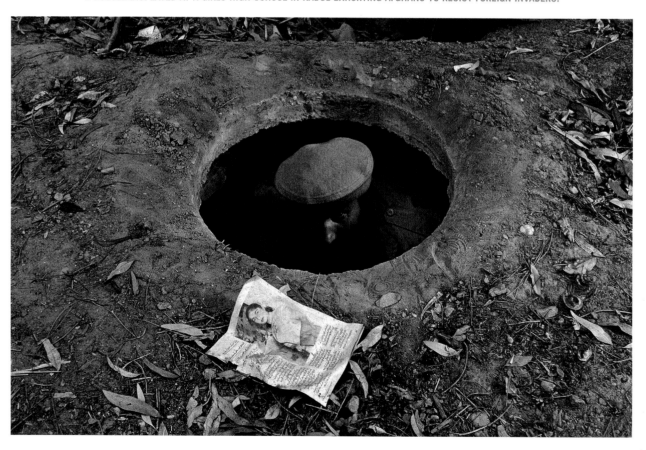

A MUJAHID TAKING COVER DURING A GOVERNMENT AIR RAID NEAR JALALABAD.

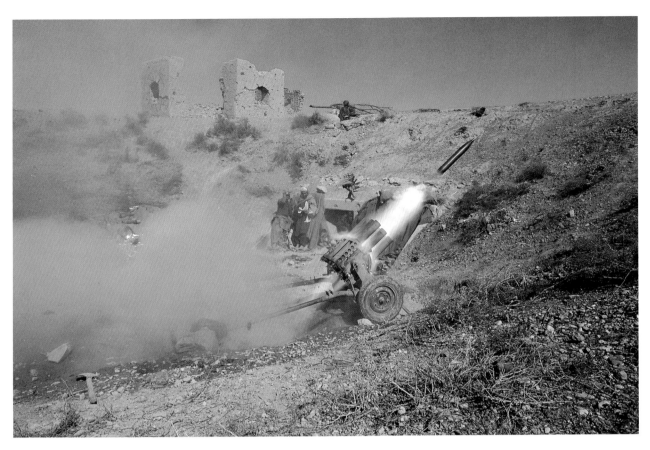

MUJAHIDIN FIRE ON GOVERNMENT POSITIONS NEAR KANDAHAR, 1989.

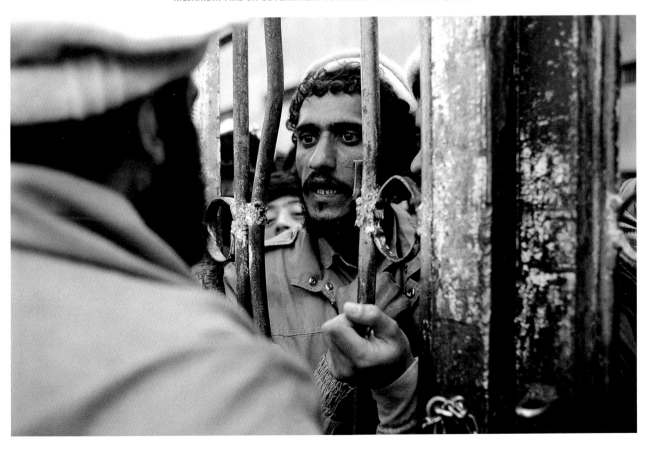

KABUL'S NOTORIOUS PUL-I-CHARKI PRISON. IMPRISONED MUJAHIDIN AWAIT LIBERATION AFTER THE FALL OF NAJIBULLAH'S COMMUNIST REGIME.

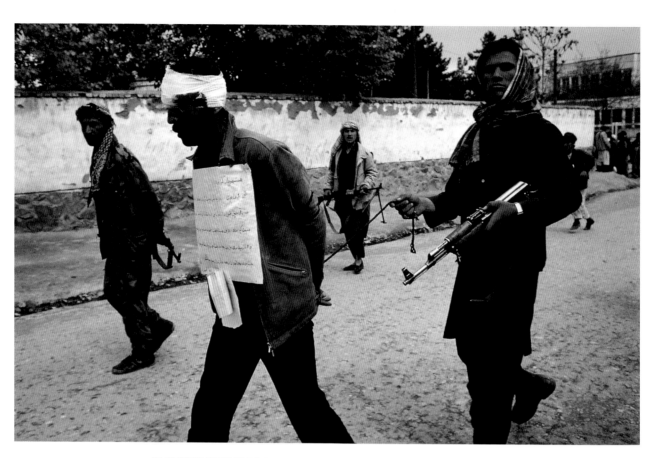

AN ACCUSED THIEF BEING ESCORTED TO HIS EXECUTION BY MUJAHIDIN IN KABUL.

COMMUNIST LITERATURE BURNED AS FUEL AFTER THE SOVIET RETREAT;
RIGHT: BUDDHISM WAS AN IMPORTANT PART OF AFGHANISTAN'S ANCIENT CULTURAL LEGACY.

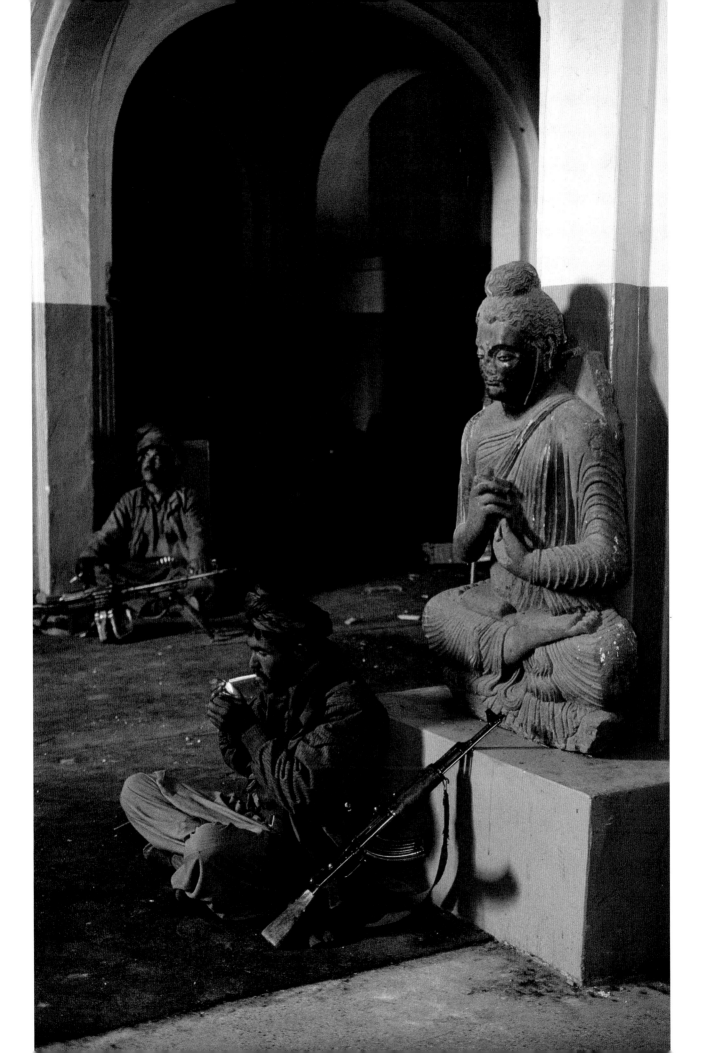

4

TALIBAN RISING

In 1992, a shifting coalition of Mujahidin groups known as the Islamic Jihad Council eventually swept the Communists from power, seized Kabul, and proclaimed themselves to be the legitimate government of Afghanistan. However, two of the principal leaders, Burhanuddin Rabbani and Gulbuddin Hekmatyar, quarreled over plans to share power. Hekmatyar's forces blockaded Kabul and used a seemingly endless supply of rockets to shell the city for months. Tens of thousands of residents were killed and wounded, and parts of the city were pulverized. The rest of Afghanistan, meanwhile, was divided into fiefdoms controlled by Mujahidin field commanders, mullahs, and clan leaders who remained deaf to a United Nations call for disarmament.

Competition among warring factions persisted for several years due largely to the enormous profits of the opium trade and intrigues sown by foreign sponsors. By 1994, a new force emerged called the Taliban. Composed of a younger generation of holy warriors, the Taliban were armed with an uncompromising agenda and a fatalistic resolve to prevail. Soon, they controlled two-thirds of the country. They established a political base in the southern city of Kandahar and set out toward Kabul, which they eventually captured in 1996.

While they were initially greeted by war-weary Afghanis with a sense of relief, the Taliban proved to be even more intolerant than previous Muslim fundamentalists. Their strict enforcement of the sharia included amputation, death by stoning, the absolute suppression of women's rights, compulsory prayer, and the suppression of all forms of recreation and entertainment. Such lack of concern for human rights even produced mass executions of members of the Shi'ite Muslim minority.

The Taliban's rise to power can be linked to the collaboration of Pakistan, Saudi Arabia, and the United States—each of which, for radically separate reasons, desired more predictable clients as arbiters of Afghanistan's future.

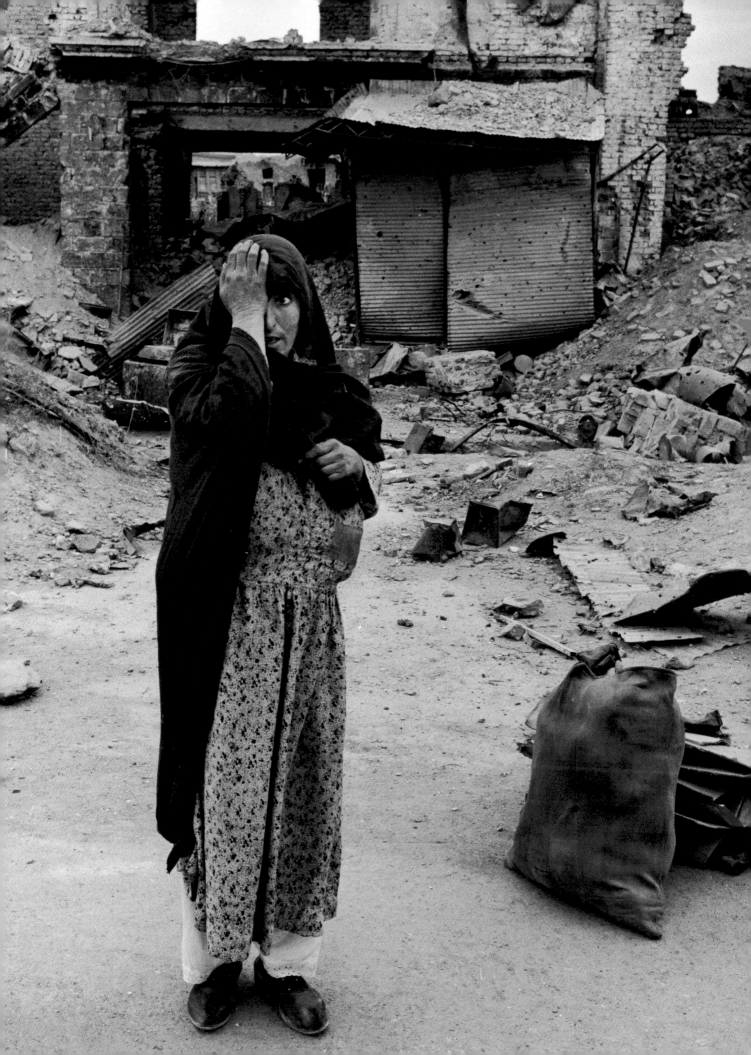

1996
ONE-LEGGED
BICYCLE RACE

BY CHRIS STEELE-PERKINS

I was drawn to Afghanistan after having visited it for the first time on assignment for Doctors Without Borders in 1994. Who knows why one place fascinates and absorbs you and another leaves you relatively indifferent? All I know is that Afghanistan and its people got into my bloodstream like a virus, and drew me back three more times. My last photographs were taken in 1998.

I have always been fascinated by that which is different, far removed from the life and ways I have known as a middle-class Englishman. Photography has been my tool for exploring these different worlds, and Afghanistan was a very different world: wild, medieval, cruel, clever, beautiful, gracious, generous, and extraordinary. In my book of photographs, *Afghanistan*, I wrote, "It is impossible to be indifferent to Afghanistan. Its magic and madness rip through any posture of detachment. I know of nobody who has been there who does not have strong feelings generated by the encounter."

Recent events in Afghanistan have given my work there a new relevance, as my interest and concern with that country has become shared by the whole world. People who never knew Afghanistan existed certainly do now. People who knew it existed, but never knew where it was, do now. Yet people still know so little.

AMPUTEES EQUIPPED WITH PROSTHETIC DEVICES AT A RED CROSS CENTER IN KABUL.

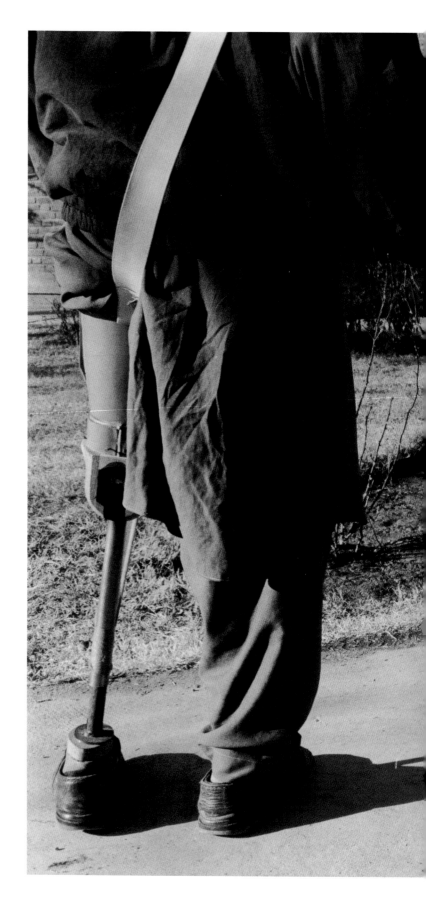

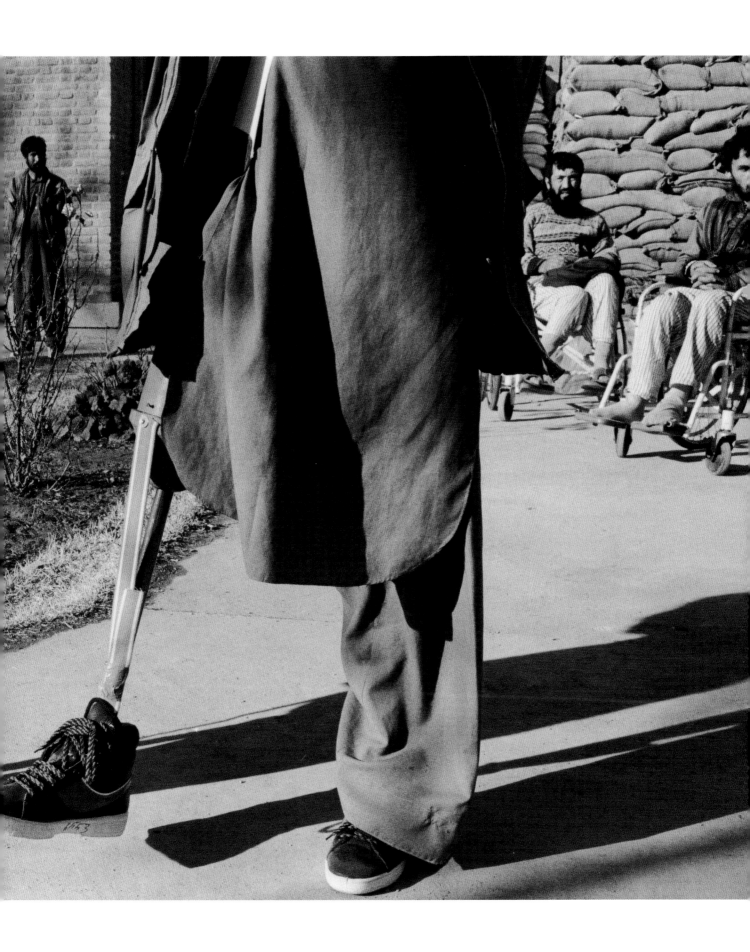

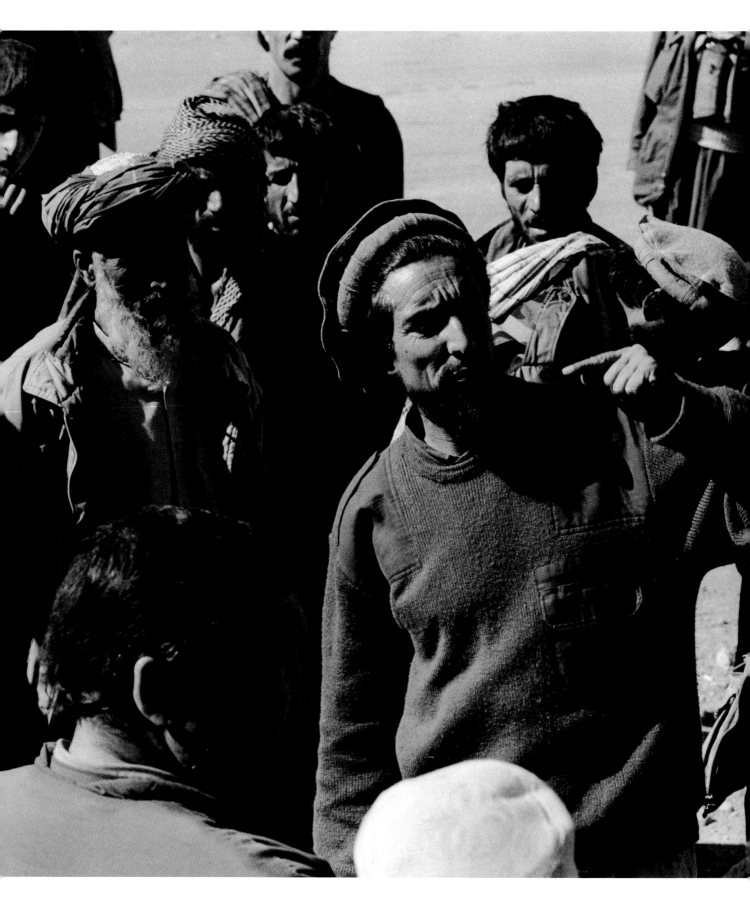

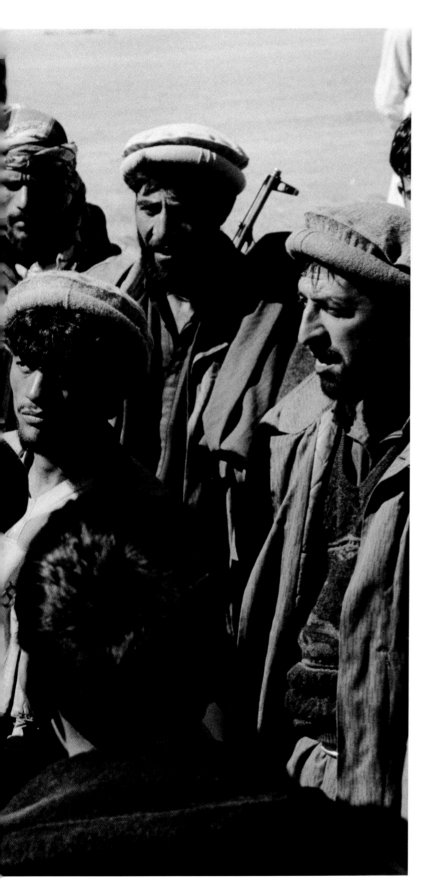

What people do know about Afghanistan is that it is a troubled place, and indeed it has been for a long time, and it is further troubled now. Inevitably, the trouble is the focus of most reporting; that is the nature of journalism. It is what first brought me there, too. But I felt it necessary to look beyond the troubles, the war, the destruction; I wanted to photograph the wider culture: to look at the way people worked and lived their lives, and the rhythms of the year. To capture at their joys as well as their sorrows. To try to build a picture of a whole people, not simply to reinforce the stereotype of war.

On my first visit to Afghanistan, I went to a one-legged bicycle race. It seemed a strange event to me, but then I realized how many of the people are one legged due mainly to land mine explosions. It was a joyful occasion, a rejection of self-pity for an affirmation of life. Afterwards people moved to a nearby mosque. They prayed, and they read poems. Afghans love poetry, as they love flowers. A young man, maybe twenty years old, limped up to the microphone and read his own poem:

This war has taken my legs
Only my hands remain to me.
Like me there are many others;
Some without legs, some without hands.
Day and night I cry for what has happened.
I ask if peace will ever come again.
I want this country to rise from its ashes.
We do not want to dig more graves
But we are powerless.
God save us from further destruction.
In God's name, In God's name, In God's name.
We are tired of this war.
Let us forget war and speak of peace.
Let us be happy again.

AHMAD SHAH MASSOUD ORGANIZING RESISTANCE ON THE NORTHERN FRONT; FOLLOWING PAGES: TALIBAN FORCES CARRYING ROCKET GRENADES INTO BATTLE AGAINST MASSOUD'S NORTHERN ALLIANCE; MEMBERS OF GENERAL RASHID DOSTUM'S UZBEK MILITIA EN ROUTE TO BATTLE THE TALIBAN ON THE NORTHERN FRONT.

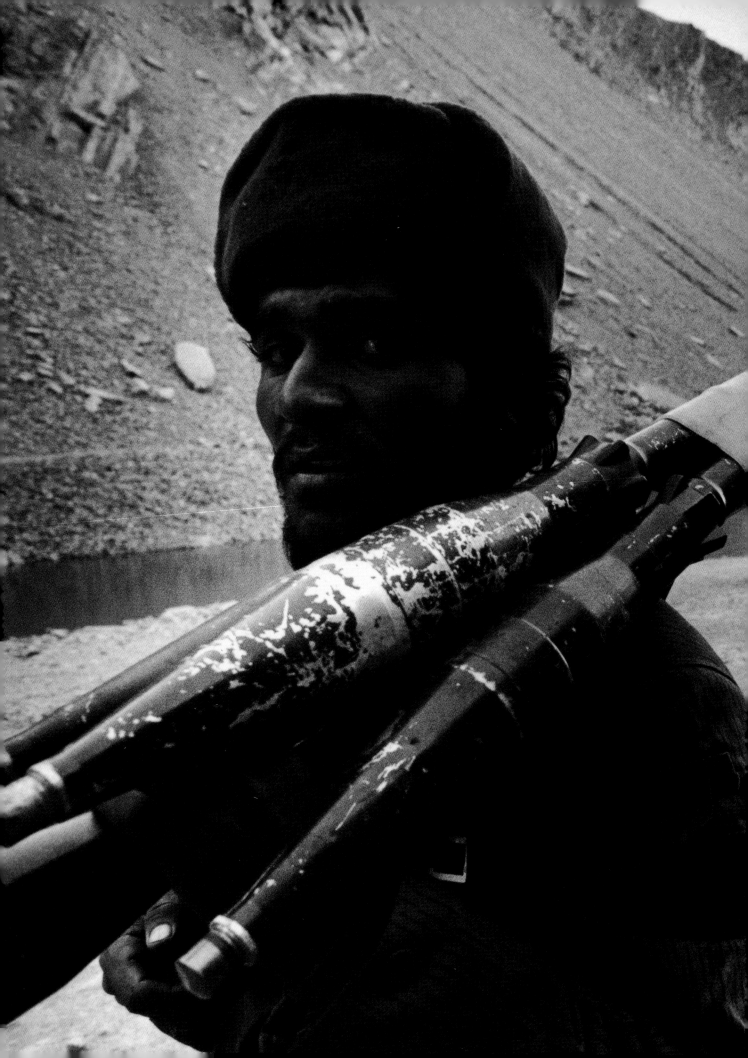

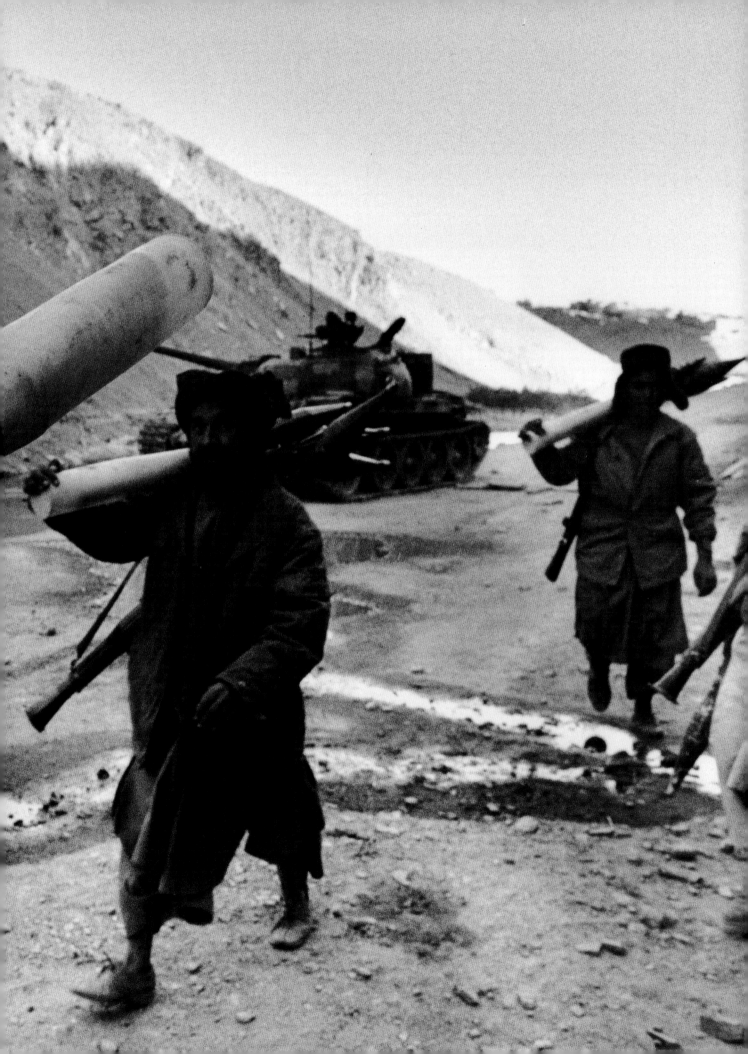

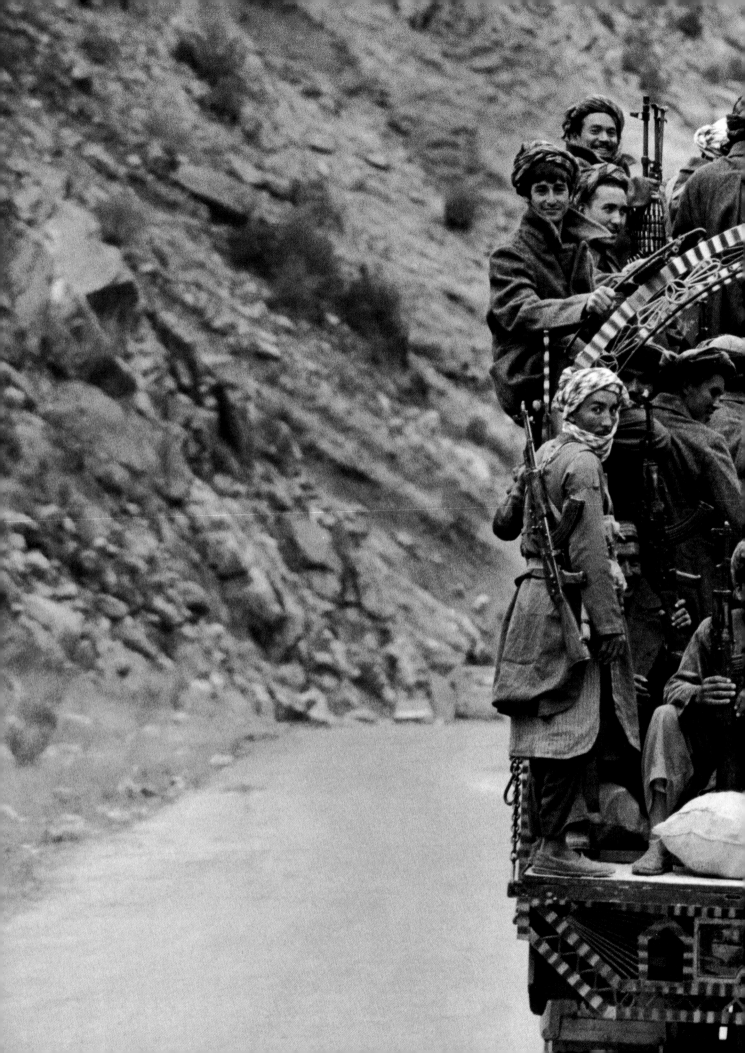

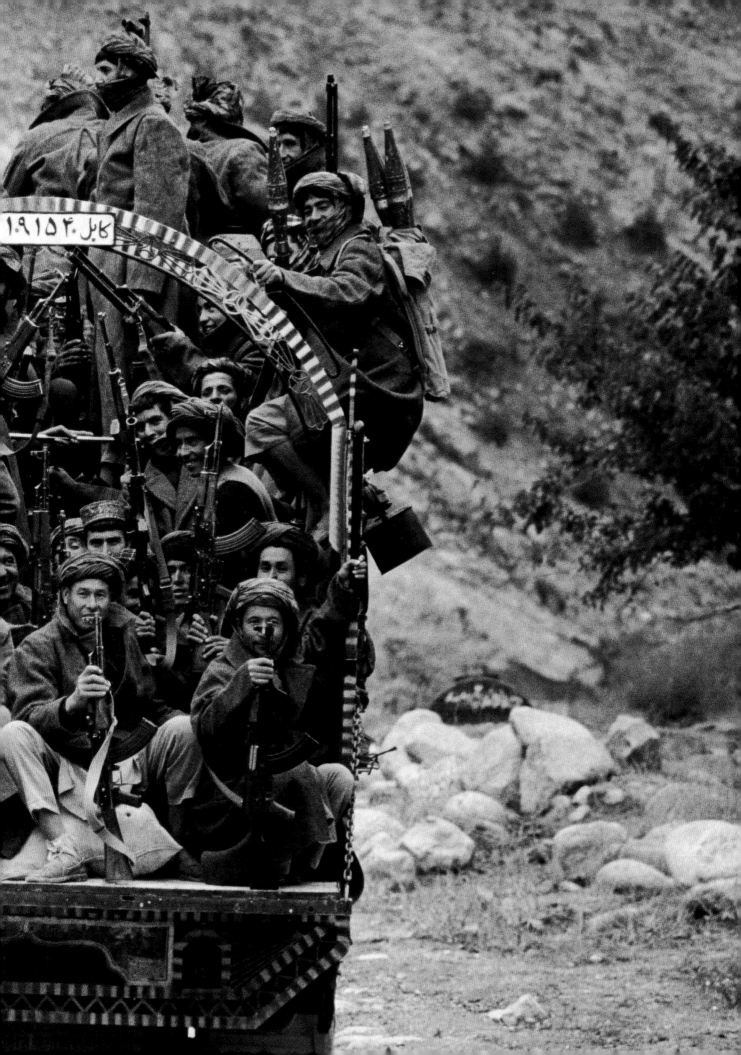

CARING FOR THE ORPHANS OF WAR, THIS WOMAN WAS EVENTUALLY BEATEN BY THE TALIBAN FOR REFUSING TO ABANDON HER YOUNG CHARGES.

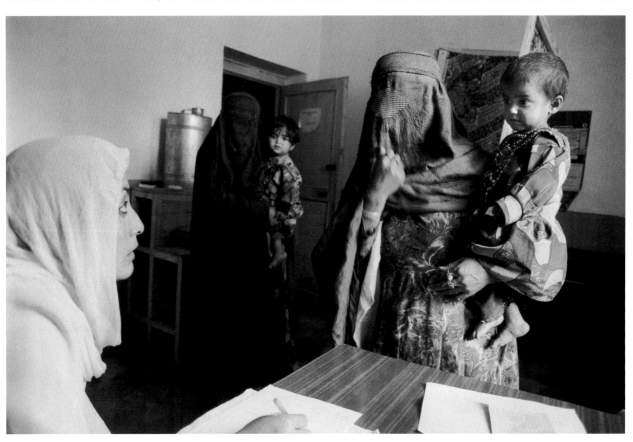

DESTITUTE PATIENTS VISITING A CLINIC RUN BY A FEMALE DOCTOR IN MAZAR-I-SHARIF.

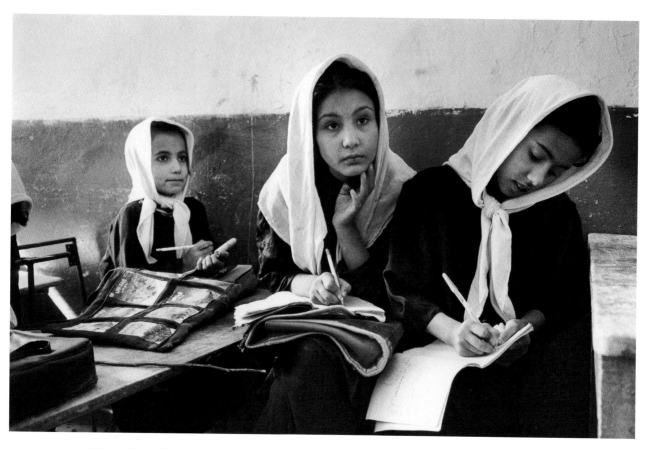

GIRLS WERE PERMITTED TO ATTEND SCHOOL IN MAZAR-I-SHARIF BEFORE ITS CAPITULATION TO THE TALIBAN.

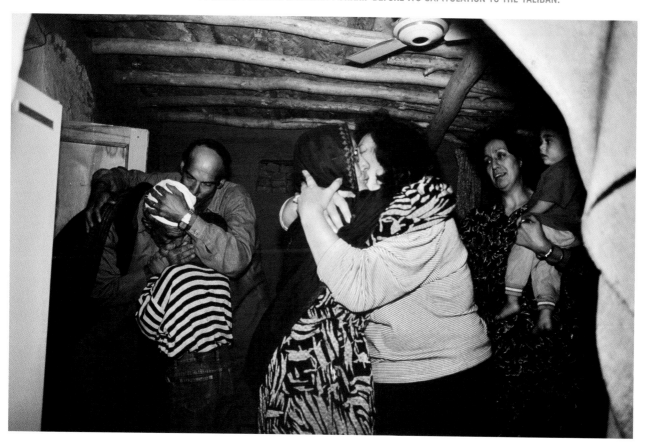

AFTER FIVE YEARS OF SEPARATION, THIS FAMILY REJOICED IN BEING REUNITED AT A REFUGEE CAMP IN MAZAR-I-SHARIF.

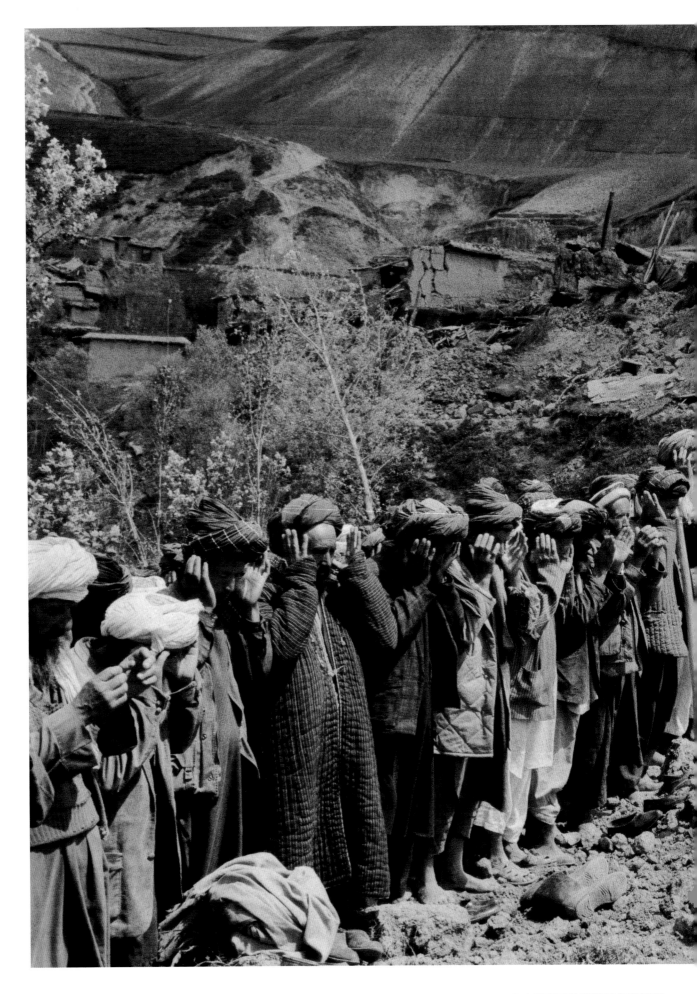

CONSECRATION OF A VILLAGE GREEN AS A CEMETERY FOLLOWING THE 1998 EARTHQUAKE THAT KILLED OVER 250 PEOPLE IN TAKHAR PROVINCE.

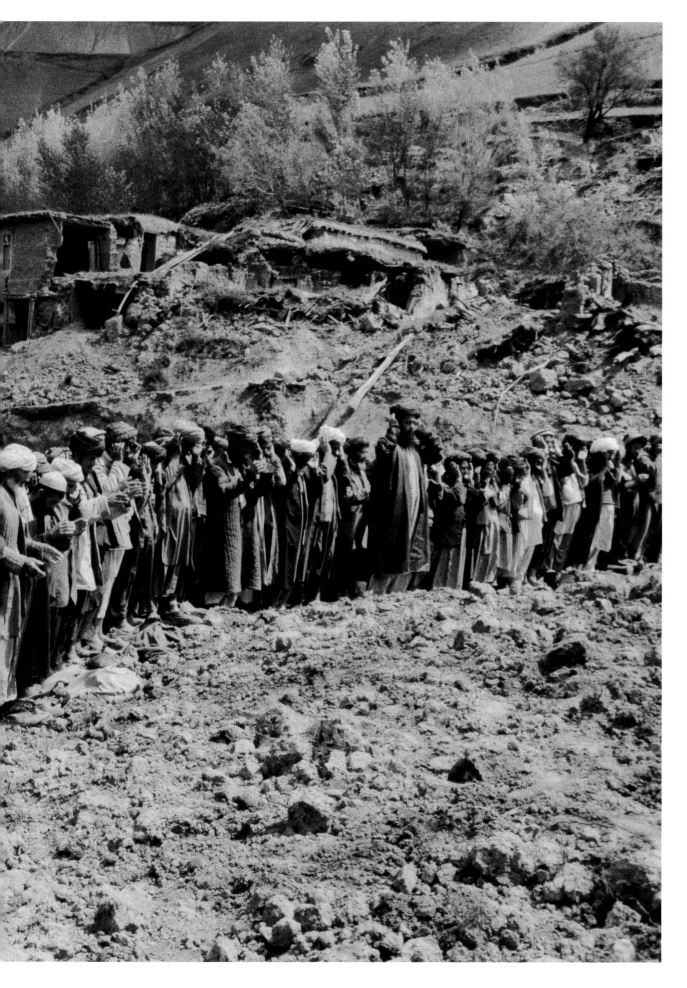

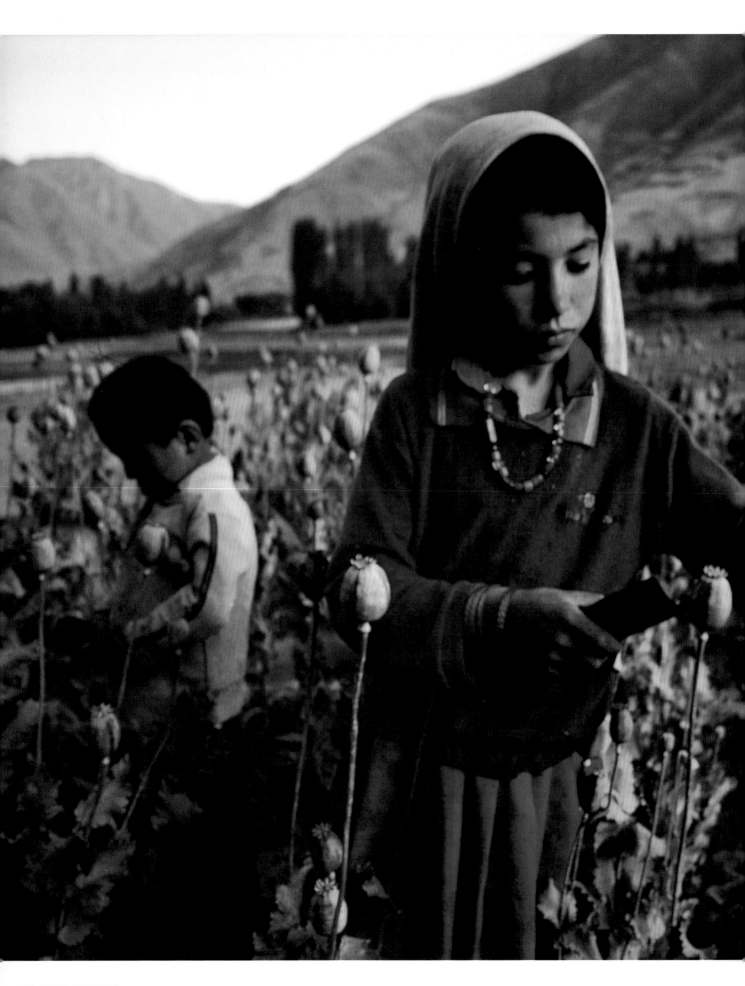

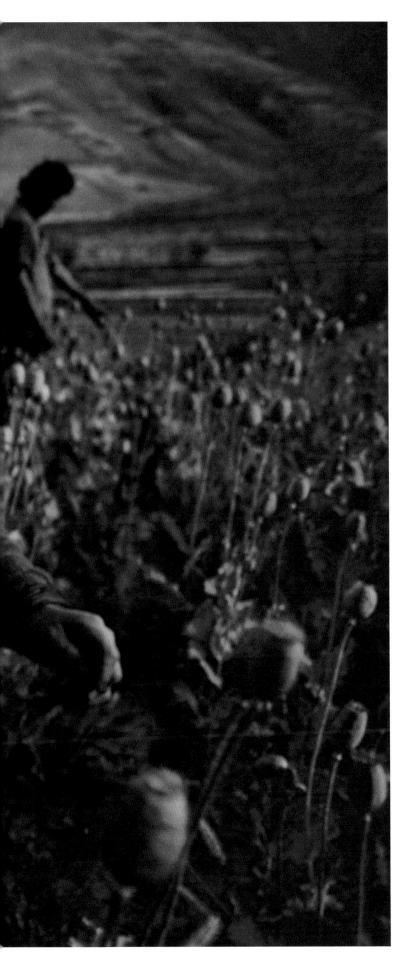

1996
NARCOTICS AND WAR

BY STEVE MCCURRY

I remember several Afghans; they would always get stoned before they went to fight. They smoked hashish. I didn't really see opium being used that widely. I'm sure they all had it, because that was another kind of local medicine. If nothing else, it would just kind of relieve the pain if you were severely wounded.

In the 1990s, I started seeing very serious opium production. Everybody was in cahoots. A square kilometer of opium poppies was a very big crop. I saw them being grown around Jalalabad; huge fields of poppies. It was a major crop—like the wheat fields in Kansas. As you were walking you would be passing poppy fields for hours.

They cut the pods with a kind of blade, scraping the tar. It looks like fudge. It was not an illegal thing. It was like growing corn or wheat or any other kind of cash crop.

I think the local people were just subsisting on it. They would get clothes and maybe a pair of shoes, and maybe they would save up money for a radio or a bicycle or something. The big profits probably went back to the Pashtun tribal leaders, who were in charge of transporting or refining it. A lot was being refined in tribal laboratories in the North-West Frontier Province; the profits were channeled through Pakistan.

A grower might live in the tribal area, and his cousin probably in Afghanistan; they speak the same language, share the same culture, and he's giving his cousin a piece of the pie. Maybe he has a bigger piece of the pie, so the profits and money trickle into the tribal area on the Afghan side.

AFGHANISTAN REMAINS ONE OF THE WORLD'S LEADING OPIUM PRO-
DUCERS, EXPORTING NEARLY 2,000 TONS PER YEAR. THE DRIED OPIUM
IS MANUFACTURED INTO HEROIN WORTH ABOUT 50 BILLION DOLLARS.
PRODUCTION FELL DRAMATICALLY DURING THE SOVIET OCCUPATION
AND ALSO UNDER THE TALIBAN.

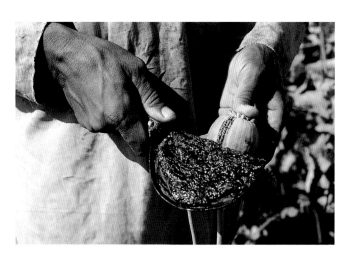
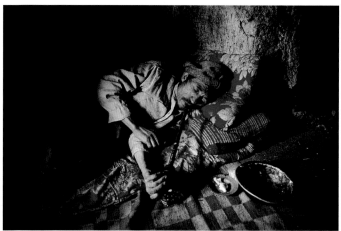
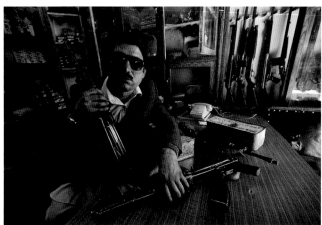
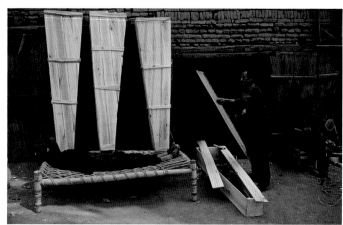

TOP LEFT: OPIUM TAR; TOP RIGHT: OPIUM SMOKER AT A "REHABILITATION" CENTER IN KAYAN; BOTTOM LEFT: ARMS MERCHANTS
IN THE LAWLESS TRIBAL AREA NEAR THE PAKISTAN BORDER REAPED HANDSOME PROFITS THROUGHOUT THE DECADES OF WAR; BOTTOM RIGHT AND
OPPOSITE: CARPENTERS IN KABUL HAD PLENTY OF WORK MANUFACTURING COFFINS AND CRUTCHES.

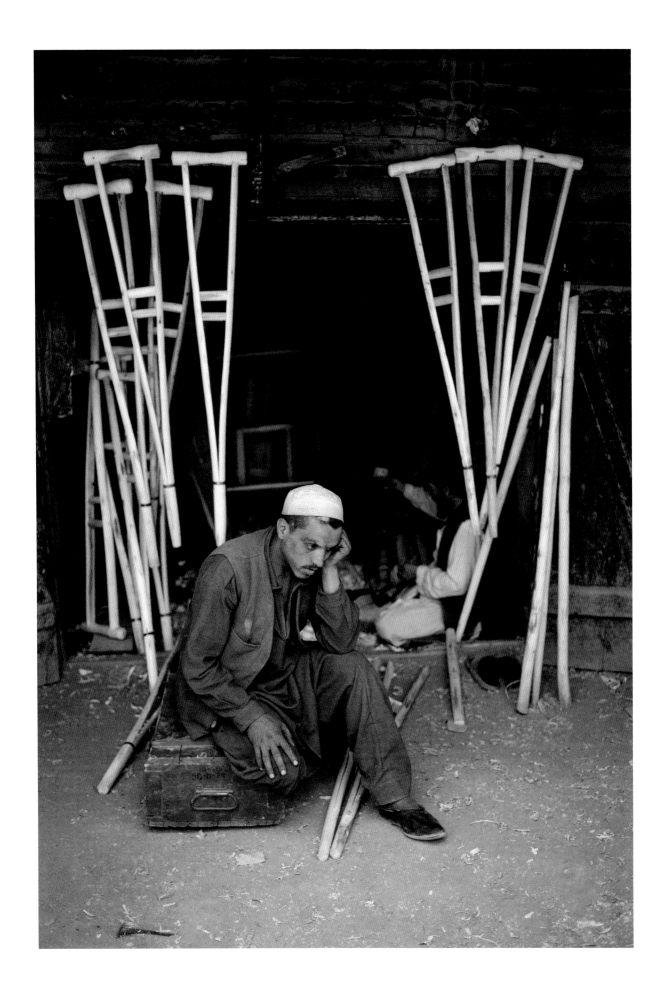

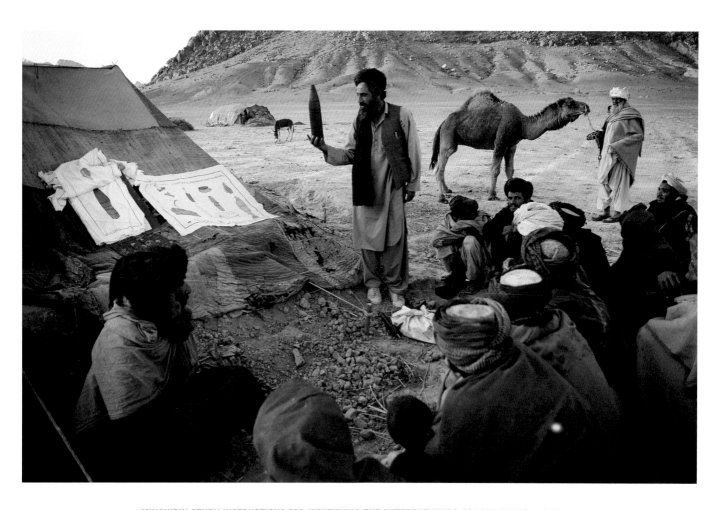

MUJAHIDIN STUDY INSTRUCTIONS FOR IDENTIFYING THE DIFFERENT KINDS OF LAND MINES DEPOSITED
BY THE SOVIET RED ARMY AND THEIR AFGHAN ALLIES.

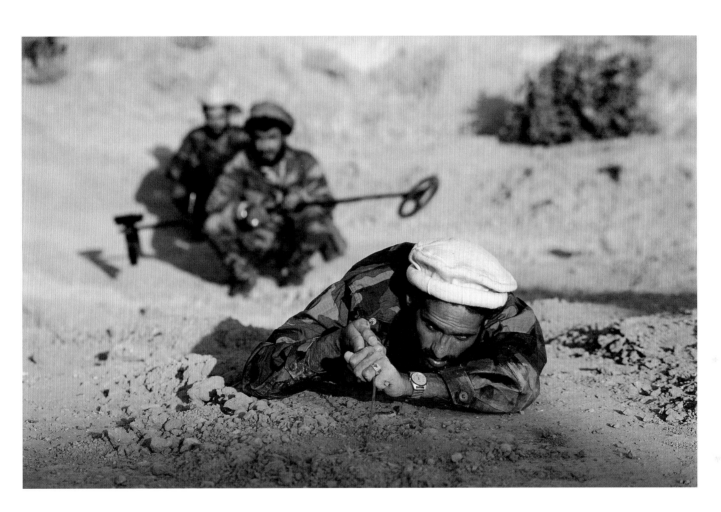

DE-MINING NEAR HERAT.

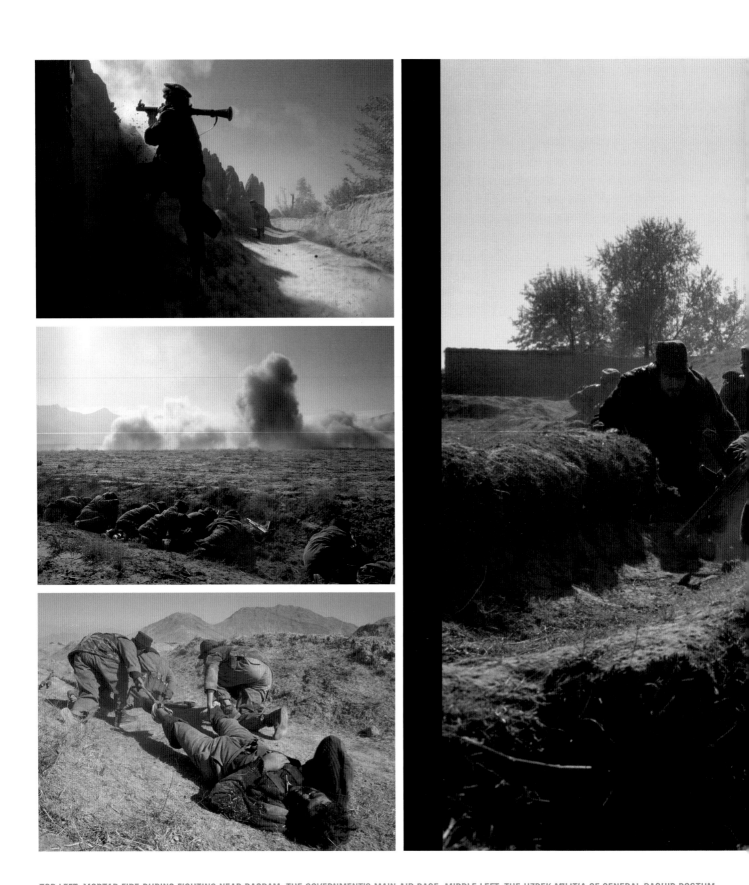

TOP LEFT: MORTAR FIRE DURING FIGHTING NEAR BAGRAM, THE GOVERNMENT'S MAIN AIR BASE; MIDDLE LEFT: THE UZBEK MILITIA OF GENERAL RASHID DOSTUM TOOK COVER AS THE BATTLE RAGED AGAINST TALIBAN FOR CONTROL OF A HIGHWAY LEADING TO KABUL; BOTTOM LEFT: RESCUING A WOUNDED COMRADE NEAR BAGRAM. RIGHT: FORCES COMMANDED BY AHMAD SHAH MASSOUD BATTLED THE TALIBAN AT HUSSEIN KOT, A VILLAGE NEAR KABUL; FOLLOWING PAGES: MORTAR FIRE DURING THE STRUGGLE FOR HUSSEIN KOT. ALL PHOTOS, 1996.

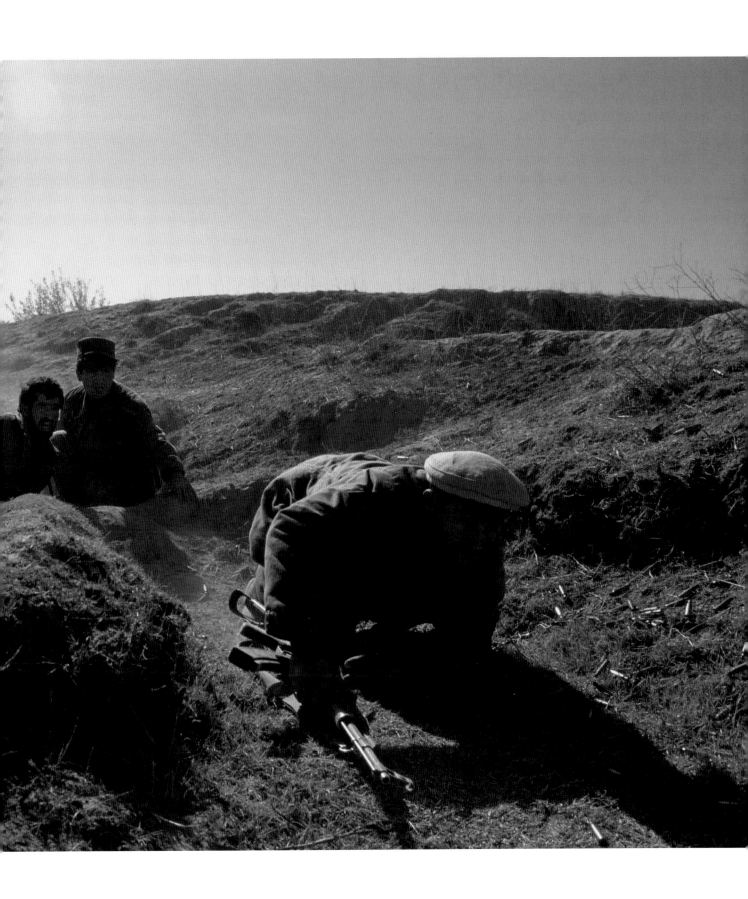

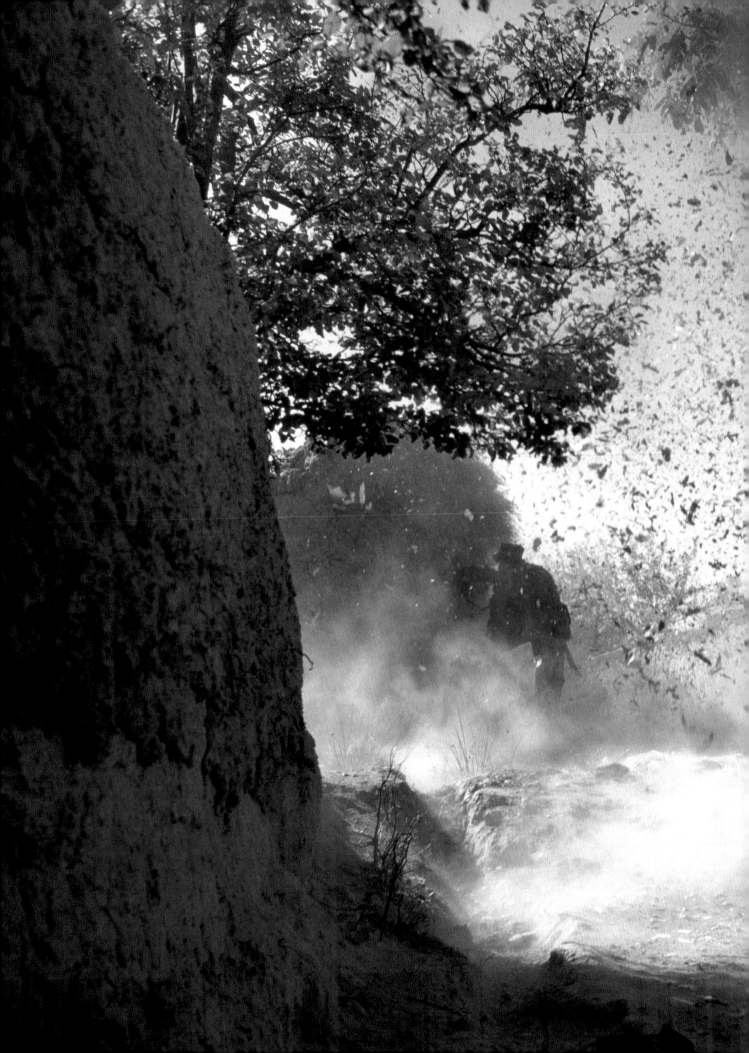

1996
ISLAMISTS DIG IN

BY BARNETT RUBIN

In January 1996 Susan Meiselas accompanied Prof. Barnett Rubin of the Center for Preventive Action, U.S. Council on Foreign Relations on a visit to Tajik refugee camps inside northern Afghanistan. Thousands of Tajiks were fleeing a civil war in their country, which opposed partisans of the Islamic Resistance Movement of Tajikistan of the post-Soviet regime of President Imomali Rakhmonov. Their presence in Afghanistan was an opportunity for regional and international forces to further their ambitions on both sides of the border. As their narrative seems to indicate, radical Islamists were already using refugee camps to exercise their influence on regional politics.

We visited two refugee camps. The first one, Bagh-i-Sherkat, was run by charity from the Arab world. In this refugee camp. a few of the women wore traditional, all-black, full-face veils, the kind usually associated with Arabia and seldom seen in Afghanistan.

Some Medecins Sans Frontières doctors there explained that the United Nations High Commissioner for Refugees had conflicts with the Arabs and were forced out of the area in 1993. One reason for the conflict was that the UNHCR tried to apply U.N. rules to the camp, separating armed combatants from refugees. About the same time, two UNHCR international contract employees and their Afghan driver were assassinated near Jalalabad by Arabs.

AMIRABAD REFUGEE CAMP, LOCATED BETWEEN KUNDUZ AND TALOQAN, RUN BY THE IRANIAN RED CRESCENT.

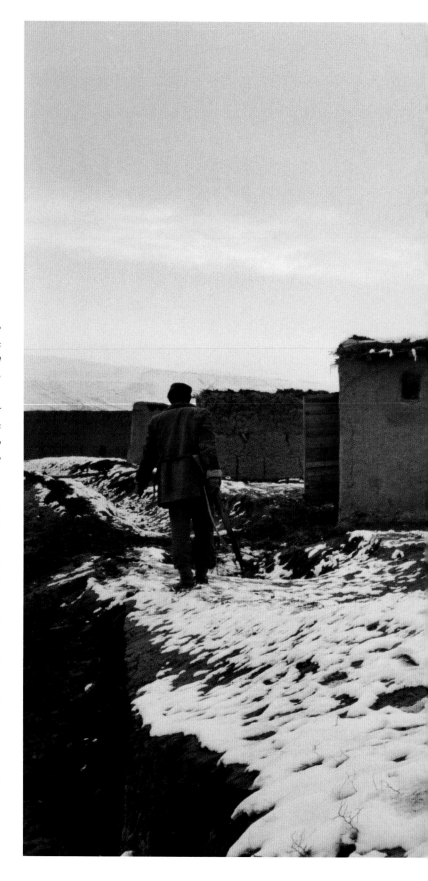

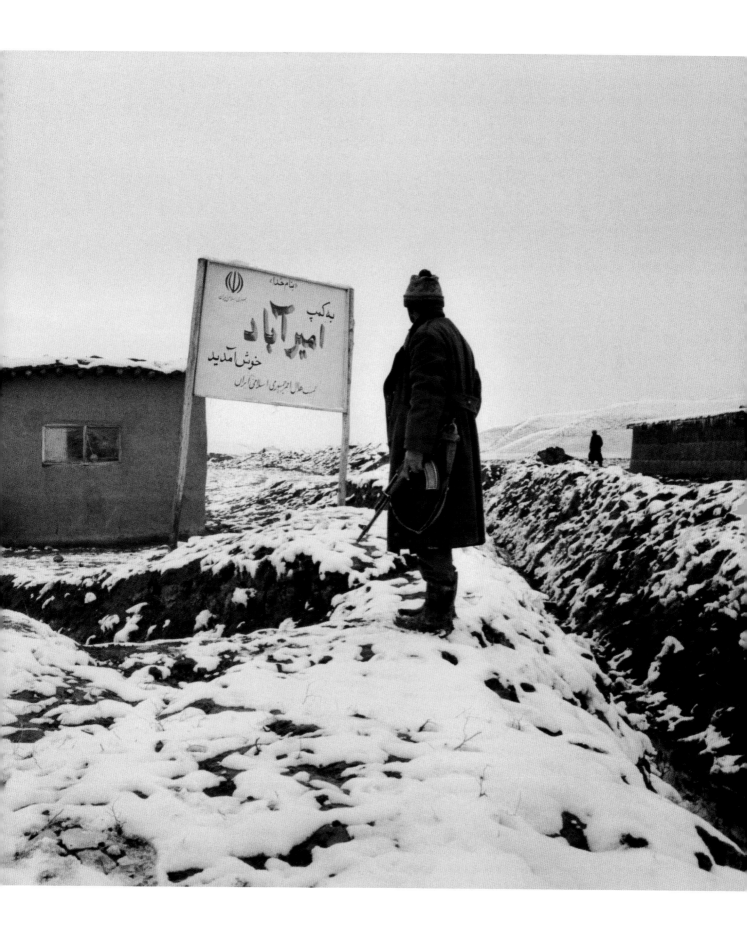

The UNHCR subsequently withdrew all international staff from Afghanistan. In March 1993 the head of the Pashtun Shura expelled the UNHCR team leader from Kunduz, leaving the UNHCR with just a small office in Kunduz. Afterwards, refugees received food assistance only from Arab-Islamist groups (which we know now were affiliated with al-Qaeda), which maintained an office there. Money was now coming in from Saudi Arabia, and from elsewhere in the Persian Gulf—not officially, but through collections in mosques.

Our trip occurred in January 1996. By September, the Taliban had taken Kabul, and Massoud had returned north to Taloqan. The Taliban then captured Kunduz in May 1997 and briefly held Mazar-i-Sharif. The Taliban took complete control of that area in 1998. That's why there was such a huge battle in Kunduz in November 2001. Many Taliban leaders were there, and apparently top Pakistani military advisers too.

Also located in the Bagh-i-Sherkat refugee camp was an office of the Islamic Resistance Movement of Tajikistan, where we watched a guerrilla training video. It was called

something like "On the Barricades." They showed it to us while we discussed the nature of the war in Tajikistan. Was it ethnic or ideological? They pointed to the Uzbeks in the video to illustrate that it was not just an ethnic war of Tajik nationalists against Uzbeks or the Dushanbe regime. It was something larger.

The other refugee camp was called Amirabad, named after the chairman of the Kunduz Shura, who was killed in a battle with troops loyal to General Rashid Dostum in one of their periodic battles for control of the area. Amirabad was located on the way between Kunduz and Taloqan. The sign declared that it was run by the Iranian Red Crescent. At the time, Kunduz was controlled by the predominantly Pashtun Shura. Taloqan was the headquarters for Ahmad Shah Massoud's Northern Alliance in the northeast. The people in the camp were dressed in the traditional Tajik way. The Tajik women were baking bread out in the open on a very cold day. The Iranian Red Crescent seemed to be doing a very professional job. There was no evidence of radicalization or politicization of the refugees, no guerrillas or anything of the sort—as opposed to the situation at the camp Bagh-i-

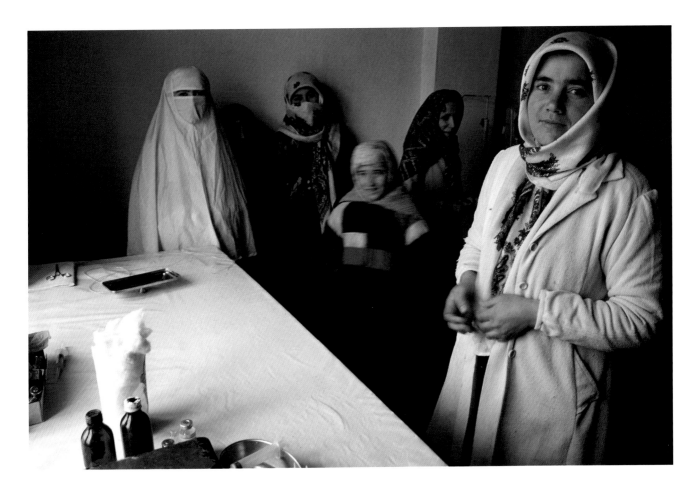

Sherkat, which was very clearly a militarized refugee settlement with an ideological agenda supported by the Arabs.

These pictures offer evidence that what once a local Tajik conflict had acquired international dimensions. The Taliban rise to power in Kabul caused a realignment of political forces in this border region.

The most important change was an unlikely alliance of the Iranians and Russians, who had previously opposed one another over the Tajik civil war, but who now desired to collaborate in supporting Massoud and Rabbani in holding off the Taliban. If they continued fighting with each other over Tajikistan, it would have been more difficult achieve a United Front. So they quickly decided that the Tajiks had to end their war, and thus pushed the warring parties to sign a final agreement in June 1997.

This was just nine months after the Taliban took Kabul.

LEFT: JIHAD TRAINING VIDEO DISPLAYED AT BAGH-I-SHERKAT CAMP THAT ALSO SERVED AS THE HEADQUARTERS FOR THE ISLAMIC RESISTANCE MOVEMENT OF TAJIKISTAN; RIGHT: NURSES IN THE CLINIC AT BAGH-I-SHERKAT REFUGEE CAMP, SUPPORTED BY DONATIONS FROM PAN-ISLAMIC CHARITIES MOSTLY IN SAUDI ARABIA.

It was clearly in Massoud and Rabbani's interests to settle the war; they could then get more aid. So they too played a role in delivering the Tajik opposition. The Taliban wanted to disrupt these diplomatic moves. They forced down the plane of the leader of the United Tajik Opposition, Said Abdullah Nuri, on his return from Teheran, and tried to convince him to continue the jihad. He refused.

These photographs illustrate the internationalization of regional conflict in Tajikistan and Afghanistan—one influenced by Arabs and Pakistanis, evident in the flows of money from Saudi Arabia, and the expulsion of the UNHCR. Kunduz was the site of the biggest battle of the American-led war in Afghanistan, where the Northern Alliance, supported by the U.S., was fighting not only against the Taliban, but against Arabs, Uzbeks, and other nationalities, too, who were then backed into going to Mazar-i-Sharif, where they staged the infamous uprising in the prison camp resulting in the first American casualty. The Tajik war was settled because of events in Afghanistan, when Russian and Iran settled their differences. It shows the way these conflicts are interrelated throughout a region.

5
THE FUTURE UNRAVELS

Two separate wars occurred in the fall of 2001. One was a furious campaign waged by the United States government against the Taliban government and its ostensible guests, the al-Qaeda terrorist army. It was directed from a secretive bunker in Florida with "intelligent" bombs, guided by a complex array of digital hardware. In this first truly global military assault, the presence of human soldiers, and thus American casualties, was minimized. Also, masses of dense rock were vaporized, and while thousands of Afghans died, only a handful were enemy fighters. Ground-coordinated management of the war centered on extensive censorship and virtual reality propaganda showing familiar television narrators in an environmental context. No infantry or mechanized operations were allowed to be televised.

Simultaneously, a hastily-assembled and motley conglomeration of Mujahidin diehards, desperate farmers, bandits, and other actors drove across Afghanistan's northern steppes, which they already owned, and headed south to conquer the cities and towns abandoned by fleeing radicals. Some of the international "terrorist" brigades offered them fierce initial resistance, and then quickly faded away to avoid the subatomic bombs. Journalists were permitted to travel and enter the exposed areas of violence at their own risk. But the images they sought were no longer free. Rather, they were constrained by unbridgeable language differences, battlefield profiteering, and the ambivalence of "friendly" fighters.

In a sense, everyone on the ground in Afghanistan was a potential victim of the primary war. Danger was ubiquitous. Consequently, the images of the secondary war occurred in a very narrow margin of public space, a reality so diminished that only photographers of considerable talent were able to depict it in a meaningful way.

A NORTHERN ALLIANCE FIGHTER RELAXES UNDER A TREE INSCRIBED WITH PRAYERS MEMORIALIZING MUJAHIDIN COMMANDER MASSOUD AT KALAKATA, NEAR THE FRONT LINES.

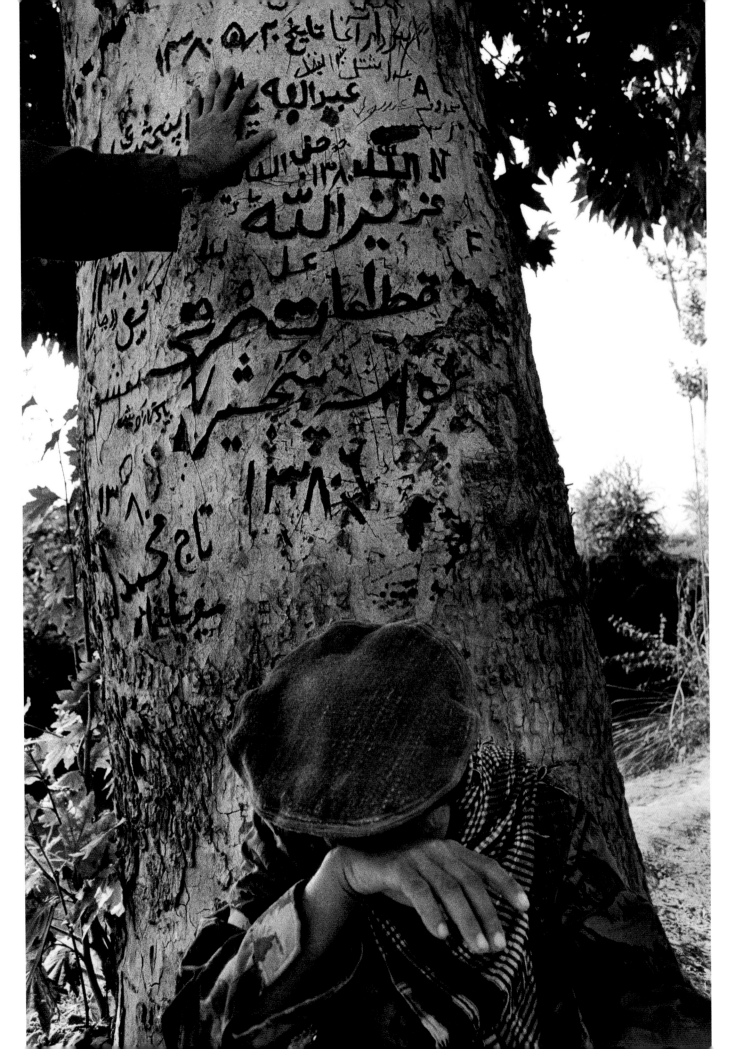

2001
POWER SHIFTS
TO THE ALLIANCE

IN LATE NOVEMBER 2001, THE TALIBAN YIELDED THEIR
POSITIONS TO THE NORTHERN ALLIANCE NEAR THE
TOWN OF KUNDUZ. THESE MEMBERS OF THE TALIBAN
JOINED THEIR COMRADES IN SURRENDER.

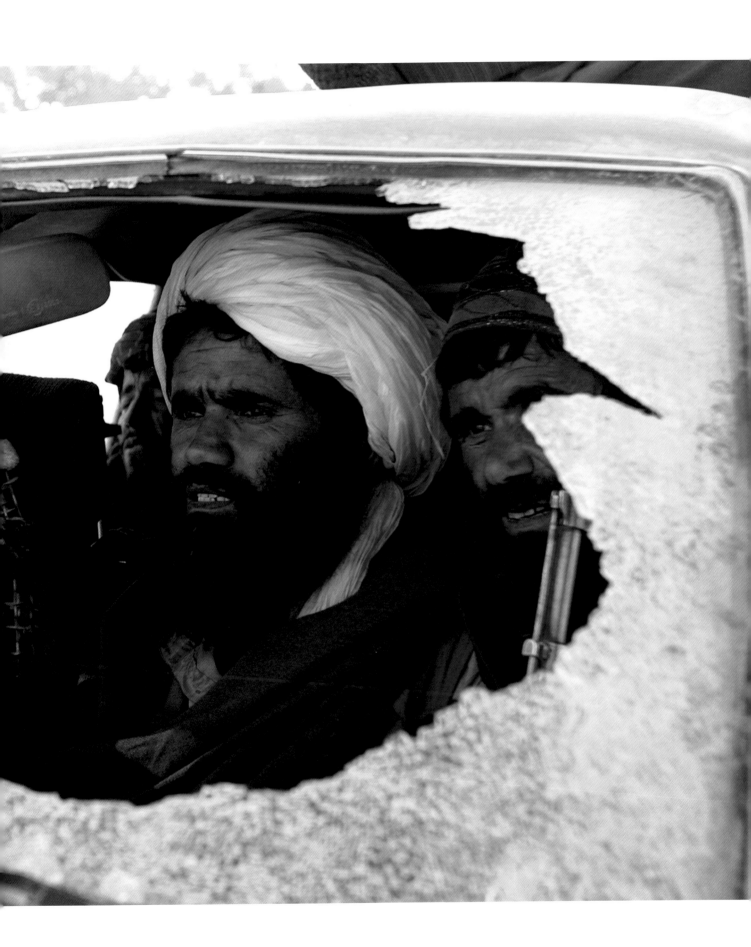

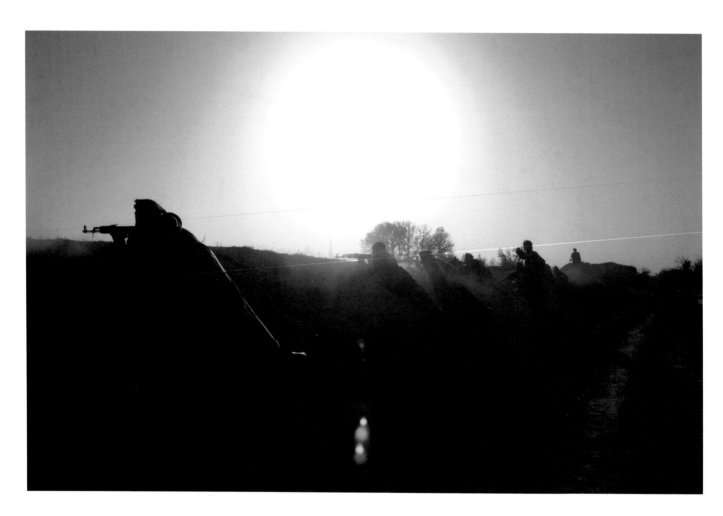

FIGHTING RAGES FOR KUNDUZ.

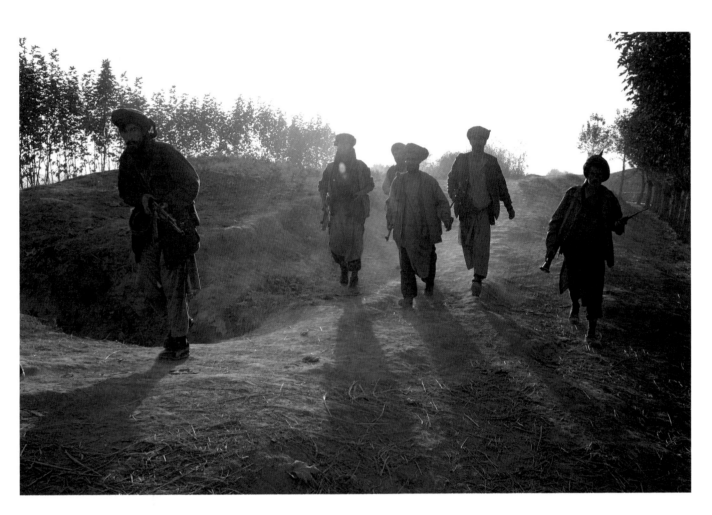

TALIBAN SURRENDER.

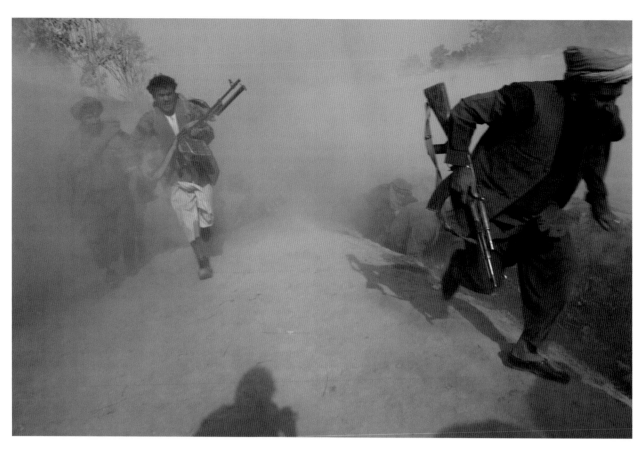

STREET FIGHTING IN KUNDUZ.

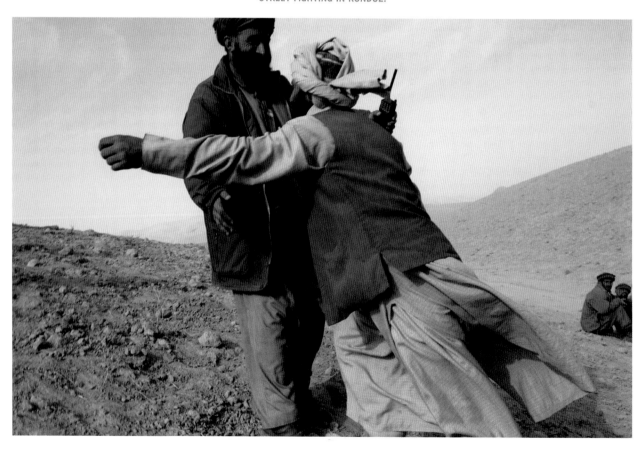

A TALIBAN FIGHTER, RIGHT, SURRENDERING TO AN OLD FRIEND NOW WITH THE NORTHERN ALLIANCE.

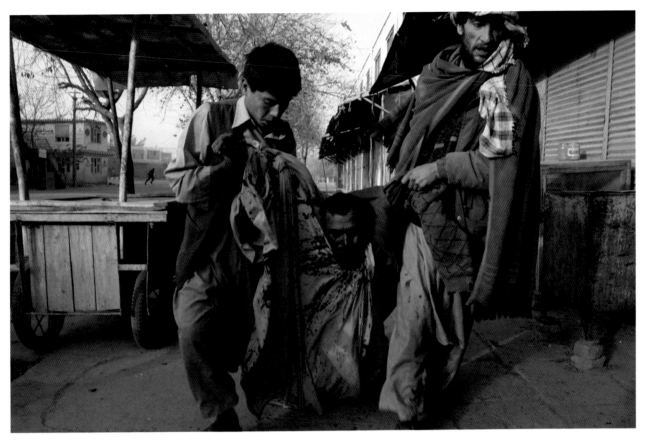

ALLIANCE FIGHTERS CARRY A COMRADE WOUNDED IN THE BATTLE FOR KUNDUZ.

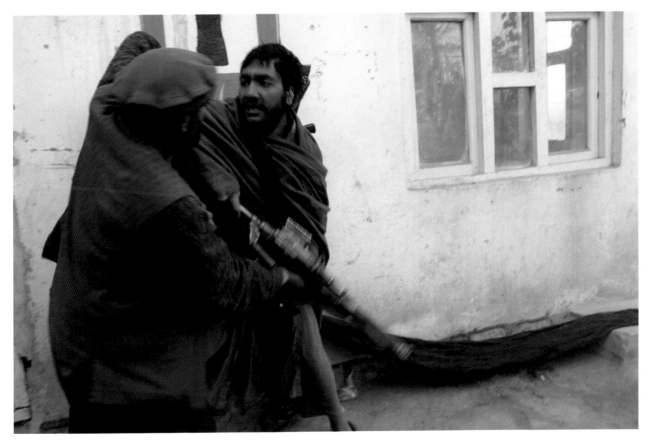

A NORTHERN ALLIANCE SOLDIER STRUGGLES TO DISARM A TALIBAN IN KUNDUZ.

ABOVE: ABANDONED TALIBAN BARRACKS SOMETIMES CONTAINED
EVIDENCE OF PLANNED TERRORIST ACTIONS; RIGHT: A HOUSE
MISTAKENLY DESTROYED BY U.S. BOMBS LOCATED NEAR THE
KABUL FRONT LINE.

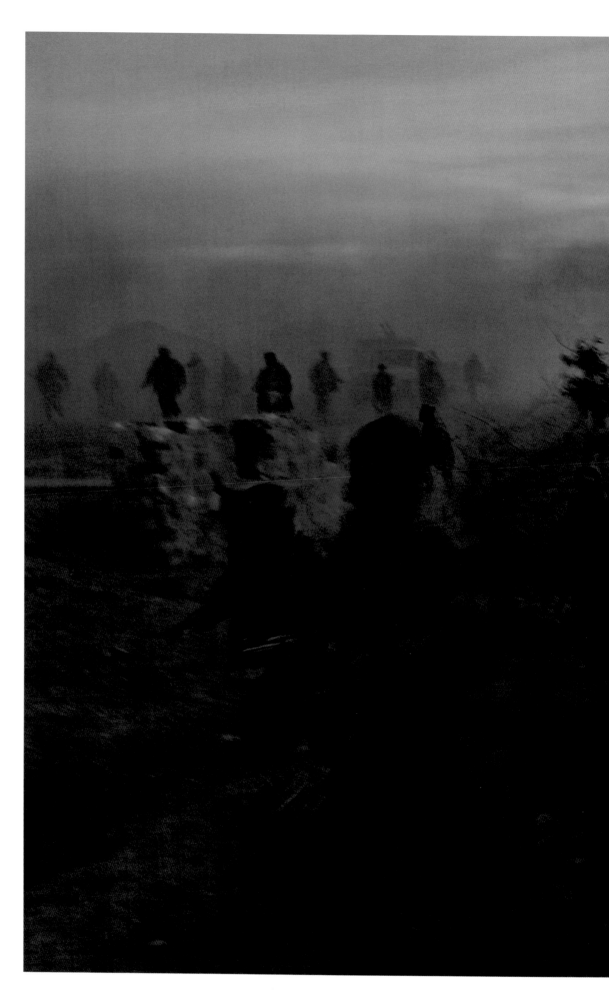

ALLIANCE SOLDIERS AMBUSHED BY THE RETREATING TALIBAN 25 KM FROM KABUL.

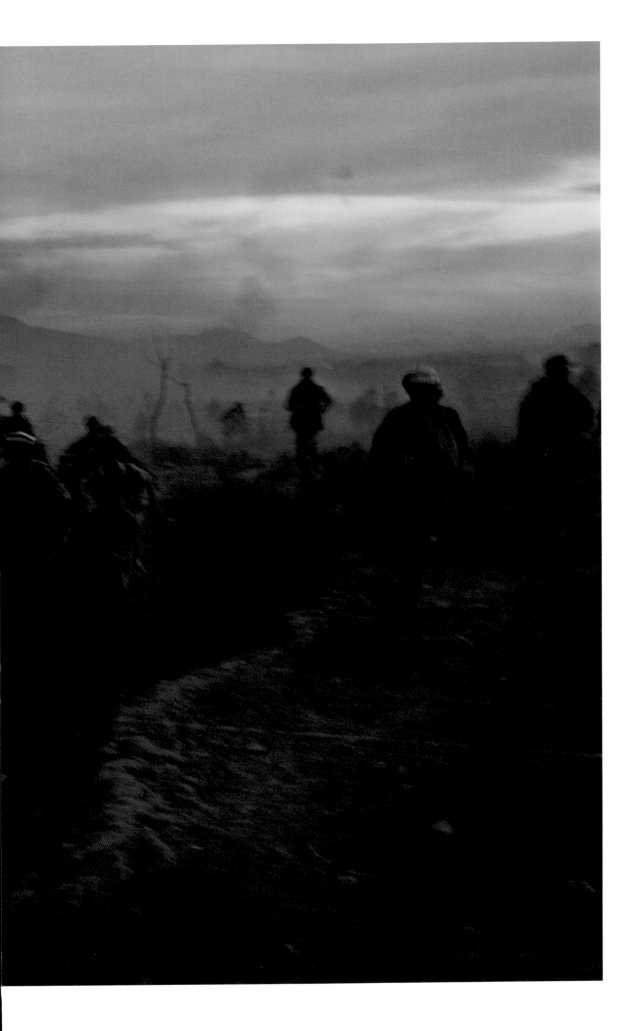

ALLIANCE FIGHTER SEARCHING FOR IDENTIFICATION PAPERS TO DETERMINE THE NATIONALITY OF A DEAD TALIBAN. MUJAHIDIN FROM PAKISTAN AND OT

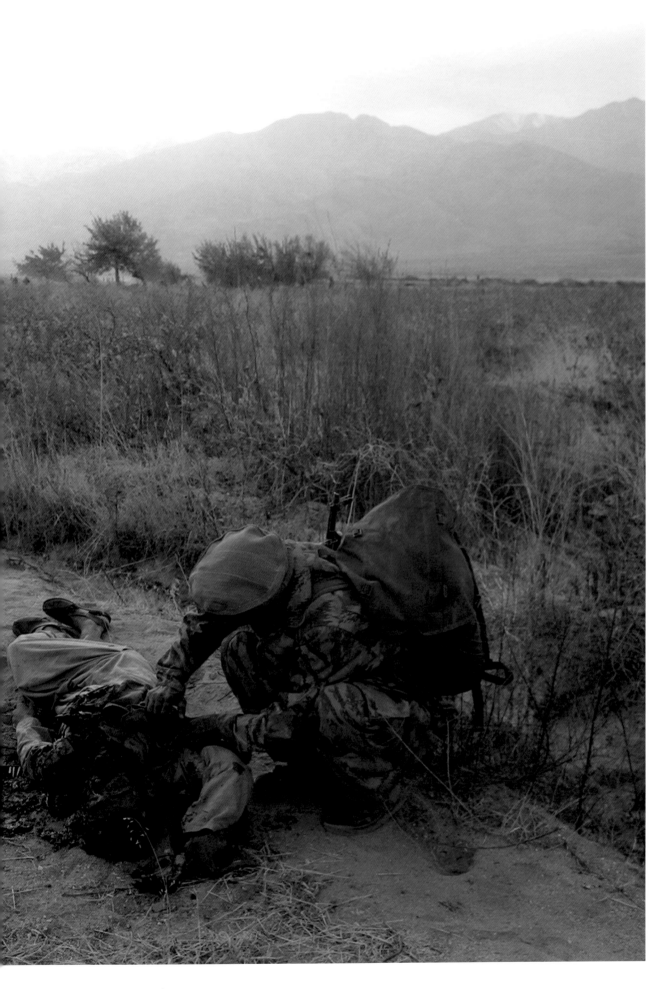

LIM NATIONS ANSWERED THE CALL FOR A HOLY WAR AGAINST THE UNITED STATES AND THEIR AFGHAN ALLIES.

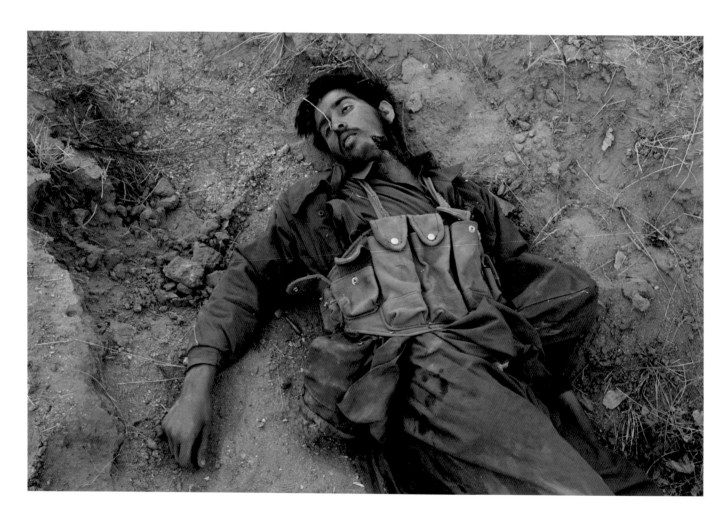

A TALIBAN SOLDIER LAY DEAD NEAR THE KABUL FRONT LINE.

ALLIANCE SOLDIERS TRACK DOWN FLEEING TALIBAN.

ALLIANCE VEHICLES PREPARED THE FINAL ASSAULT ON KABUL. FOLLOWING PAGES: ALLIANCE TROOPS CAMPED FOR THE NIGHT ON THE OUTSKIRTS OF KABUL

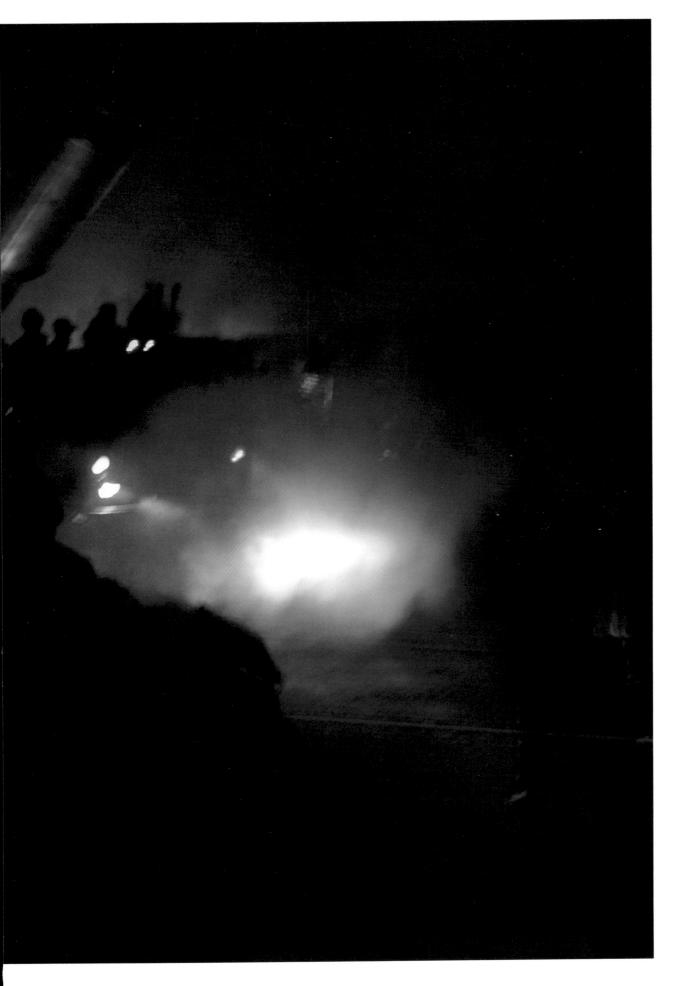

AFTER THE FIGHTING FOR KABUL, MARKET ACTIVITY RESUMED.

 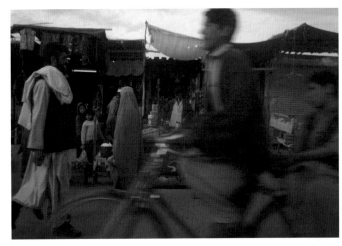

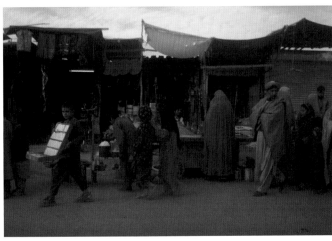 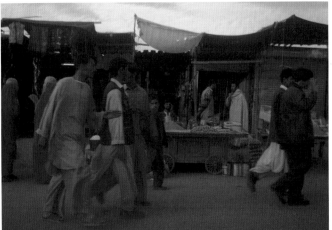

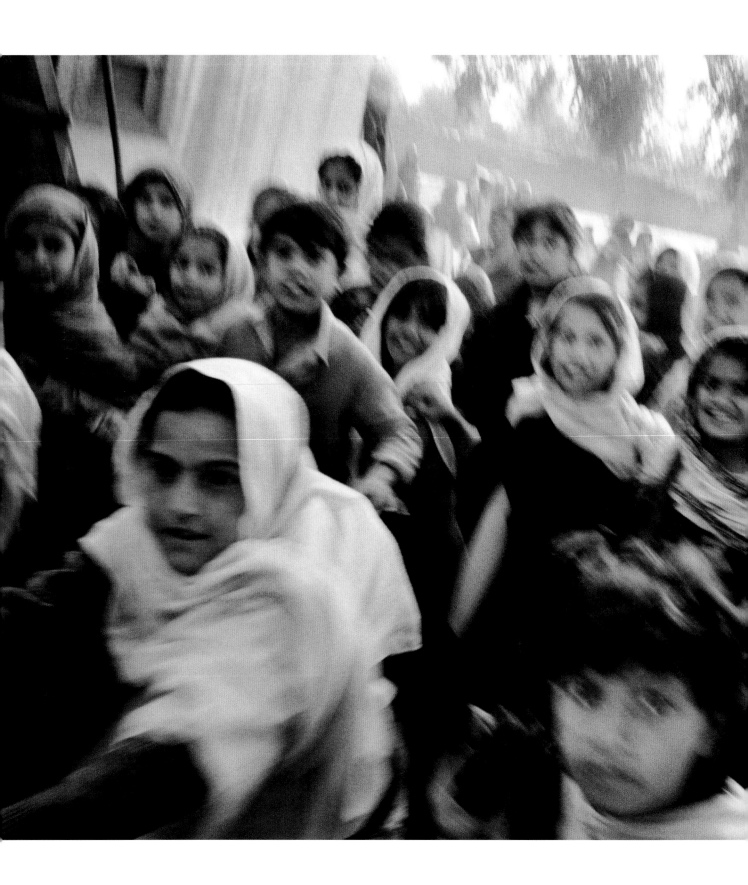

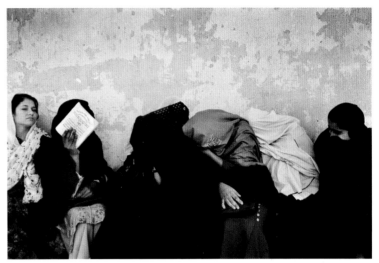

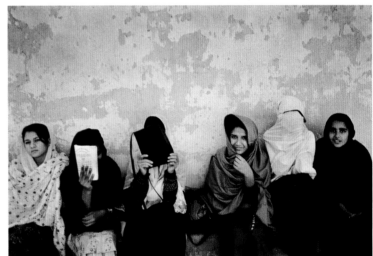

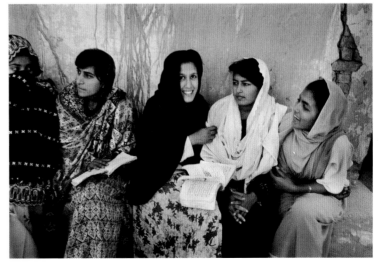

SCHOOLGIRLS RUSHING INTO THE STREETS TO REGISTER FOR CLASSES A FEW DAYS
AFTER THE LIBERATION OF KABUL IN NOVEMBER 2001.

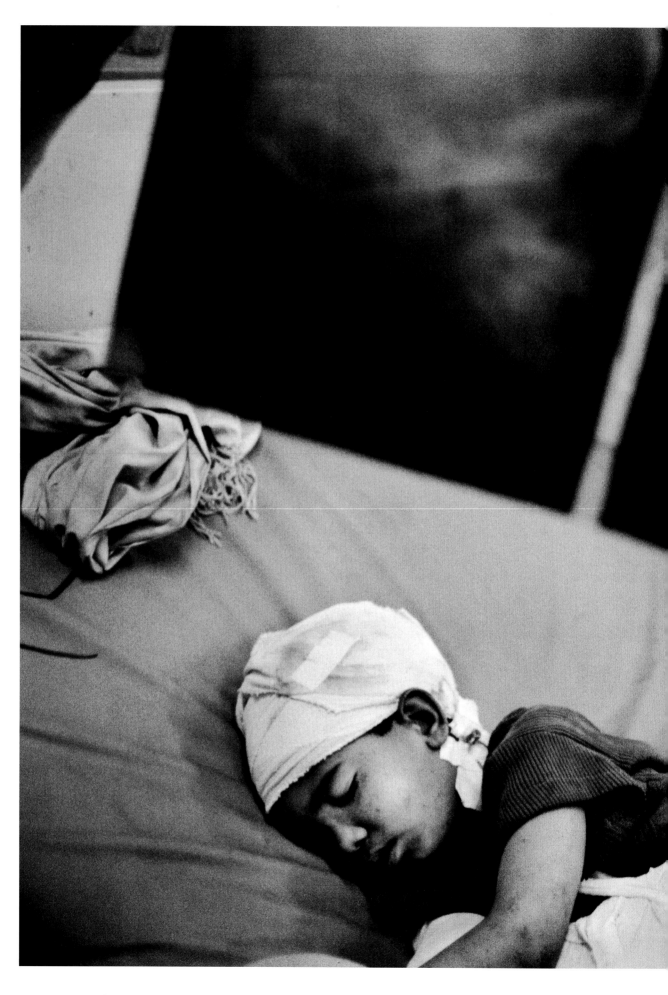

A PHYSICIAN AT JALALABAD'S HOSPITAL EXAMINES THE X-RAYS OF A CHILD INJURED BY A U.S. BOMBING RAID THAT MISTAKENLY KILLED 153 CIVILIAN

2001 BACK IN TIME

On my latest trip of December 2001, I was tempted to think I entered the Iran of five hundred years ago. Afghanistan has hastened to move backward in history during the rule of the Mujahidin and the Taliban. The state just dissolved. In the Kabul of December 2001 I lived the utopia of a country returned to its tribal days. When the burkas were lifted and the full beards shaved off, the faces revealed total despair.

The Taliban were able to control most of the country the way Afghan tribal chiefs have always gained the upper hand over their enemies, by shifting alliances. One writer has noted that no contemporary war was ever won on the battlefield. I guess this is also how most nation-states were built in Europe...five hundred years ago.

An Iranian mullah, whose politics were far from liberal,

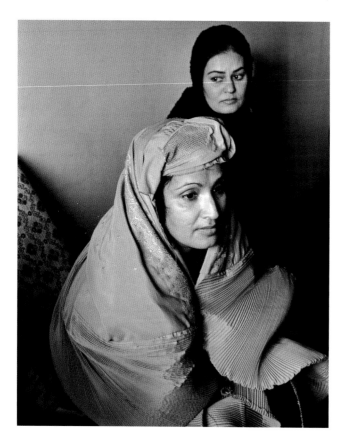

ABOVE: UNVEILED WOMAN AFTER THE LIBERATION OF KABUL FROM FIVE YEARS OF RULE BY THE TALIBAN; RIGHT: SHI'ITE MUSLIM CEMETERY NEAR SHKAI-JAN-SHEN NEAR KABUL. SHI'ITES WERE BRUTALLY PERSE-CUTED BY TALIBAN WHO REGARDED DEVIATION FROM SUNNI ORTHODOX WORSHIP AS HERESY.

once told me, "These idiot Taliban, they give such a bad name to Islam." Edward Said is right to think that there is an inherent bias in covering Islam. But then, without going back to the Crusades, what do you expect when in our own generation bombs explode in Nairobi, killing hundreds of bystanders; when American diplomats are held hostage in Tehran, French journalists in Beirut, and German tourists in the Philippines; when women are forced into burkas and girls out of school; when bearded mullahs, their faces distorted by fanatical hate, appear daily on TV screens, shouting, "Death to this!" and "Death to that!"; or when a great novelist is condemned to death for apostasy by a cleric whose only contact with the West was a forced exile to a village near Paris, where he spent his time seated under an apple tree; when homosexuals are beheaded in Saudi Arabia, adulterers stoned to death in Somalia, and thieves have hands and feet cut off in the Sudan; and last but not least, when two landmark towers of the world are just erased by commercial jets, hijacked with passengers on board....Is it not human to develop a bias against such a religion in whose name all this is committed?

To pretend that violent Islamists are acting outside of Islam is to engage an illusion. Terrorists and clerics alike justify every fatwa with quotations from the Qur'an and the Sunna. Muslims who claim to be peaceful citizens of their respective countries too often are hostage—sometimes willingly—to the rhetoric of Islamists with whom they share common values and an equal belief in the Qur'an as sacred as the word of God.

Where were they, these kindred souls of "good Muslims" who now claim to be horrified by the massacre of New York, when Islamism was being violently defined as an alternative model in their own societies, an alternative they were encouraging either actively, or passively by not resisting it? Does Islamism not feed on Islam? Is Edward Said aware of the inherent bias of Muslims covering the West? If one read learned columns in the Pakistani press or academic dissertations by Egyptian scholars, the West's "inherent" bias would sound more like a pleasant diversion compared to the gross misrepresentation of Western values by many Muslims!

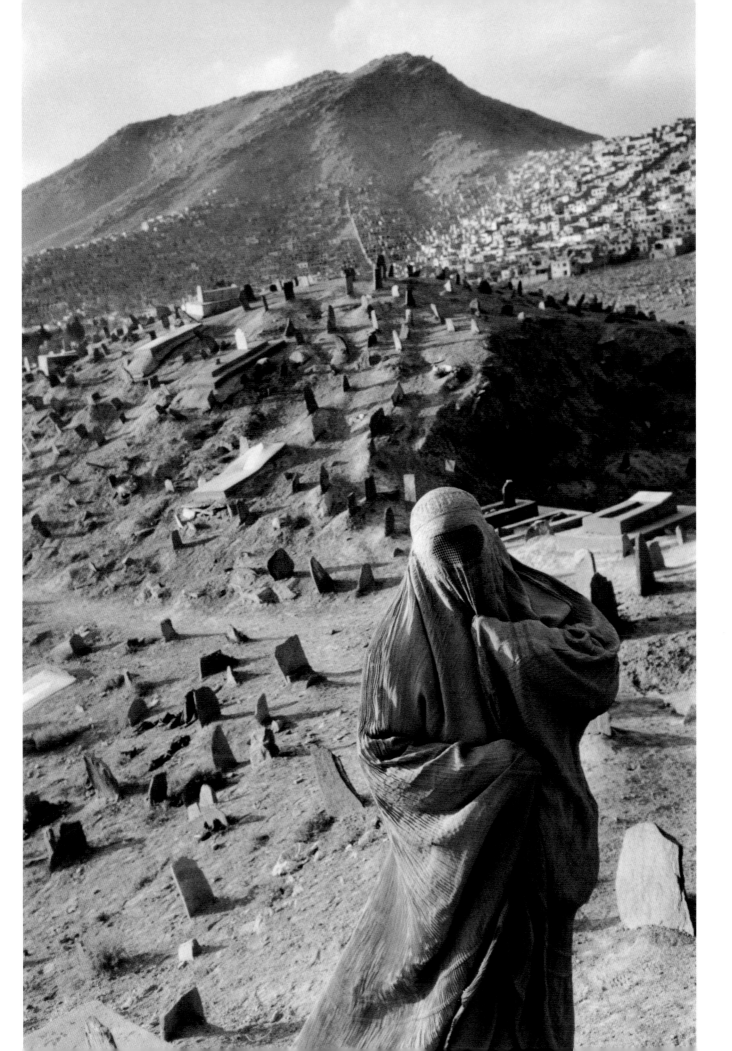

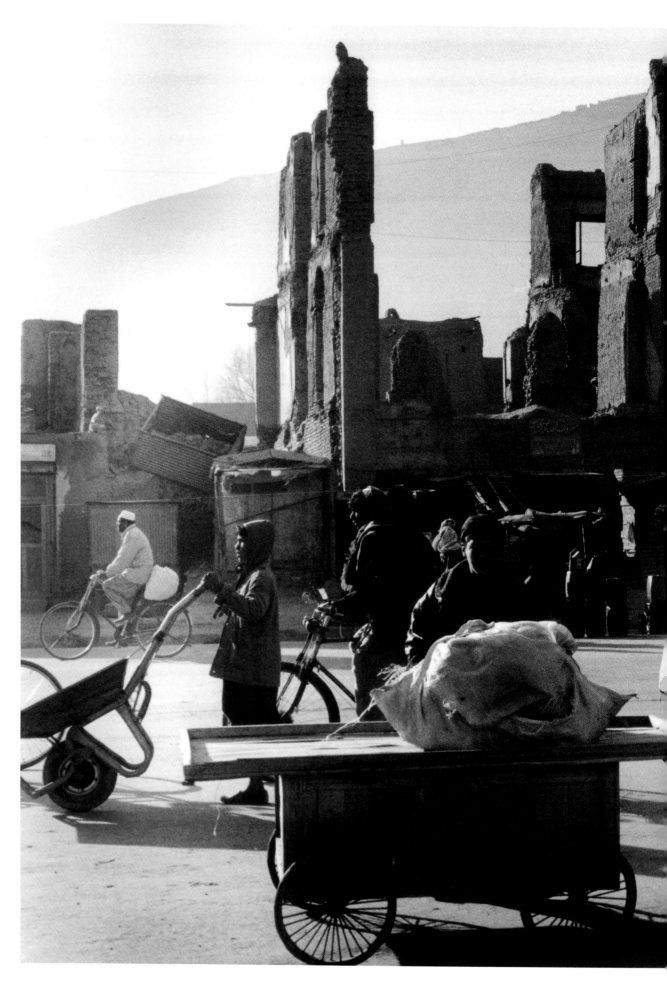

BAZAAR AMONG THE RUINS OF KABUL. THE CAPITAL WAS PARTIALLY DESTROYED IN FIGHTING AMONGST SEVERAL MUJAHIDIN FACTIONS FROM 1992-199

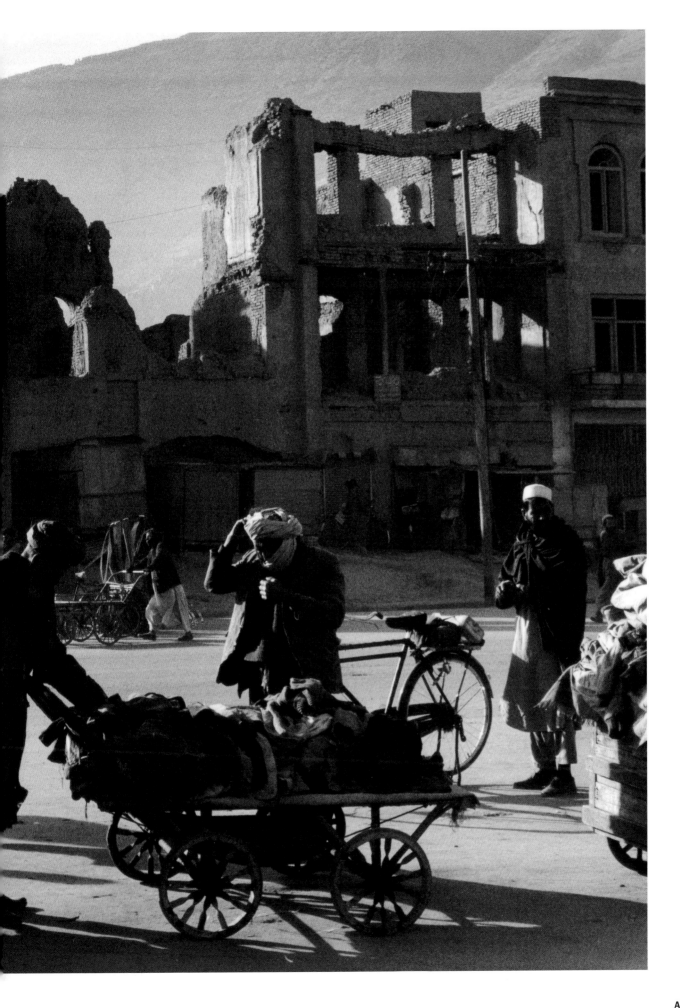

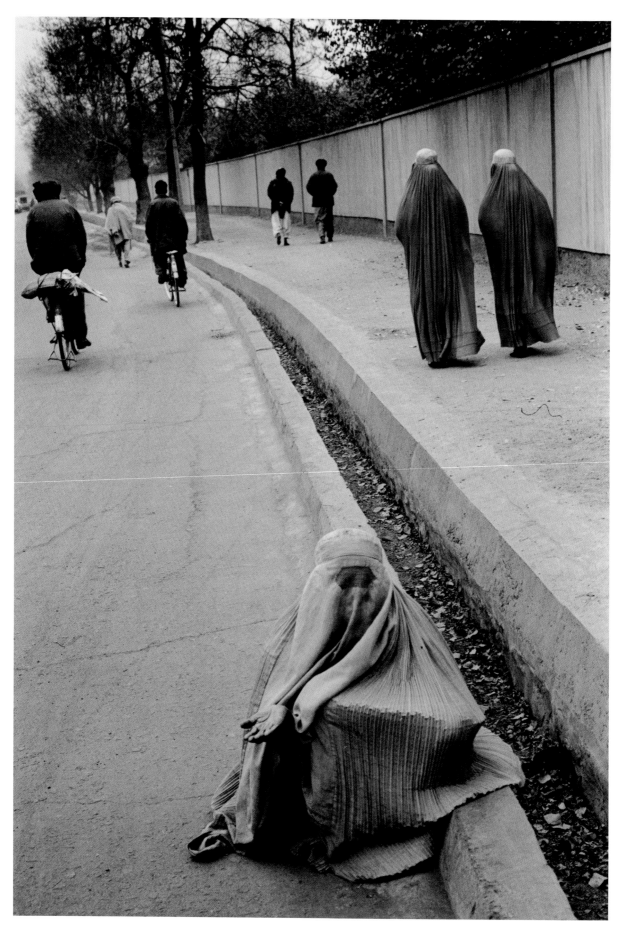

A BURKA-CLAD WOMAN BEGS IN THE STREET OF NEWLY LIBERATED KABUL.

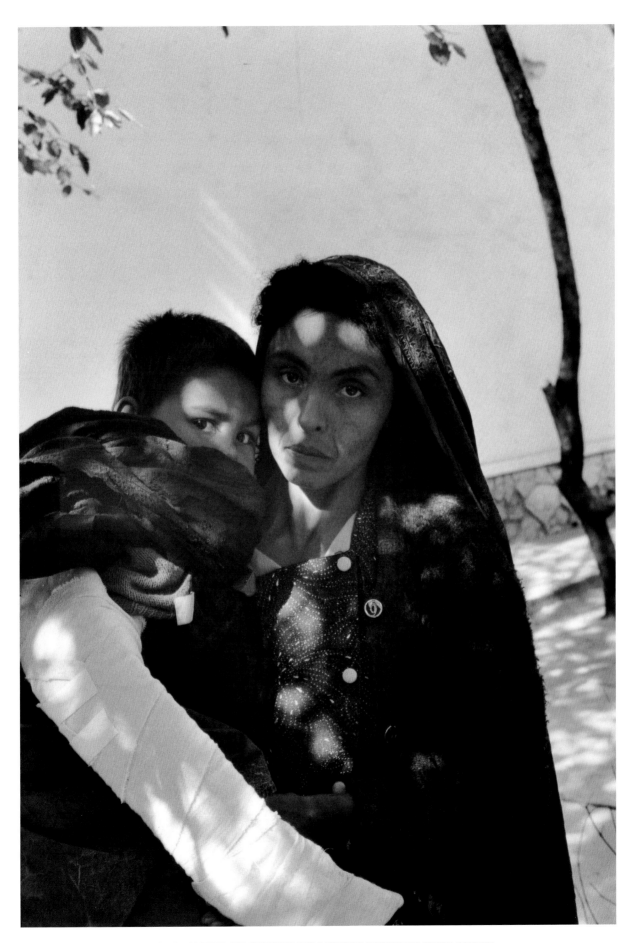

A MOTHER CRADLES HER WOUNDED CHILD OUTSIDE KABUL'S RED CROSS HOSPITAL.

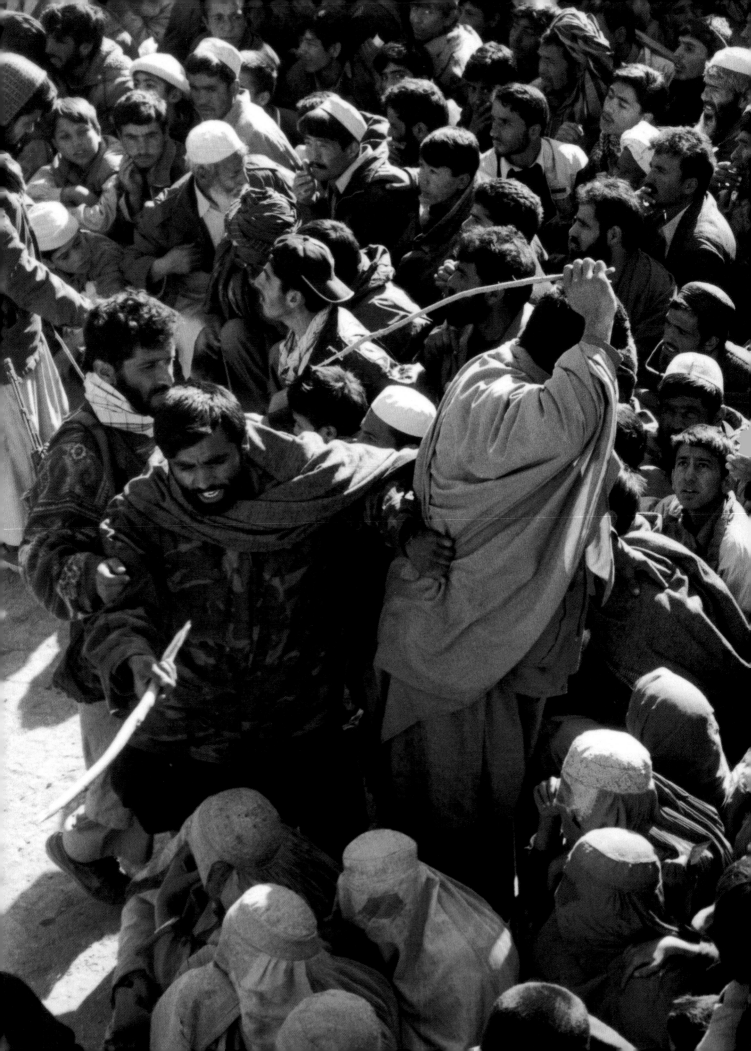

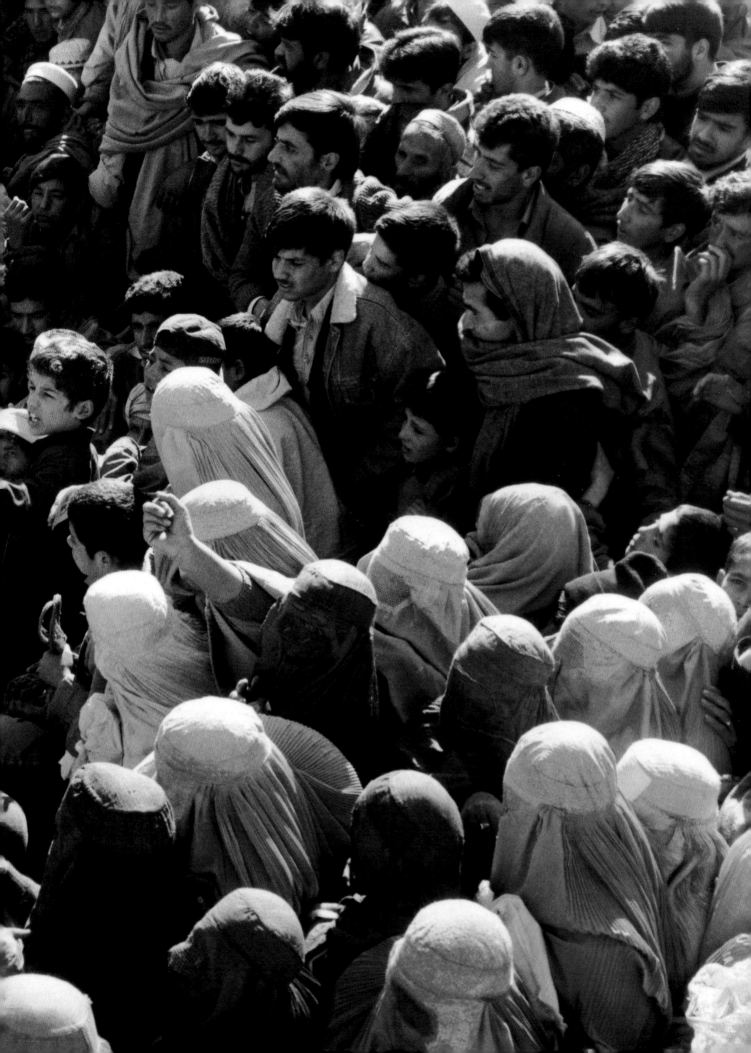

PREVIOUS PAGES: A STICK-WIELDING MILITIAMAN TRYING TO MAINTAIN ORDER IN A CROWD AWAITING A UNITED NATIONS
FOOD DISTRIBUTION; ABOVE: A WOMAN BEING GROOMED AT ONE OF KABUL'S CLANDESTINE BEAUTY PARLORS.

LADEN WITH SUPPLIES, A WOMAN HURRIES ALONG KABUL'S STREETS.

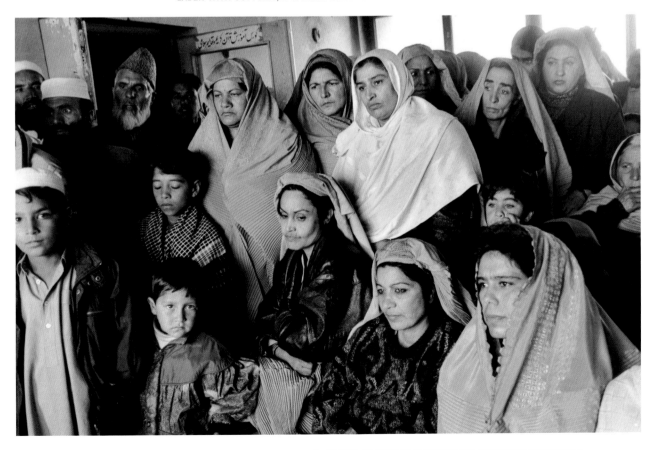

FOLLOWING THE ABDICATION OF THE TALIBAN, TEACHERS WASTED NO TIME IN PLANNING THE REOPENING OF SCHOOLS.

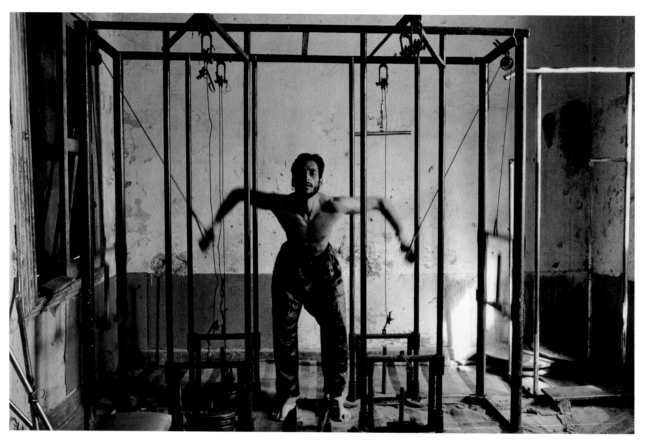

EXERCISING WITH LOCALLY-MANUFACTURED EQUIPMENT AT A GYMNASIUM IN KABUL.

THE TALIBAN HAD BANNED BOXING AND MOST OTHER ATHLETIC PURSUITS AS DISTRACTIONS FROM RELIGIOUS WORSHIP.

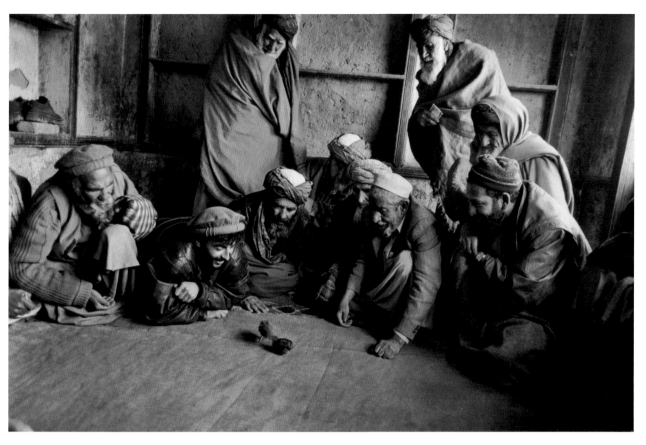

AFGHAN MEN WATCHING A FIGHT BETWEEN TINY QUAILS. THE WINNER IS THE ONE FRIGHTENING ITS OPPONENT INTO RETREAT.

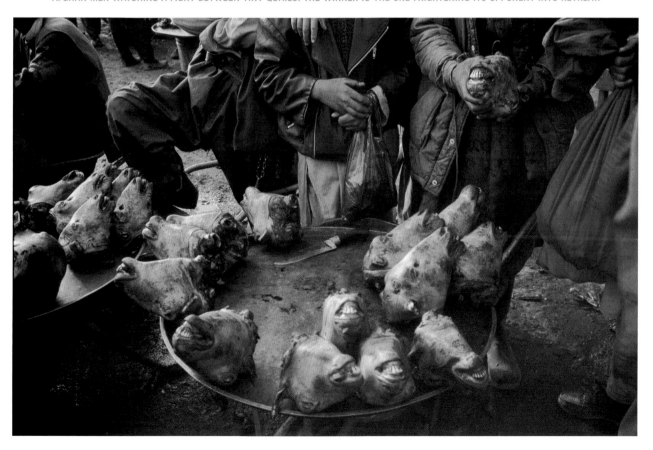

MARKET SCENE IN KABUL.

PIECES OF BUDDHIST STATUES.

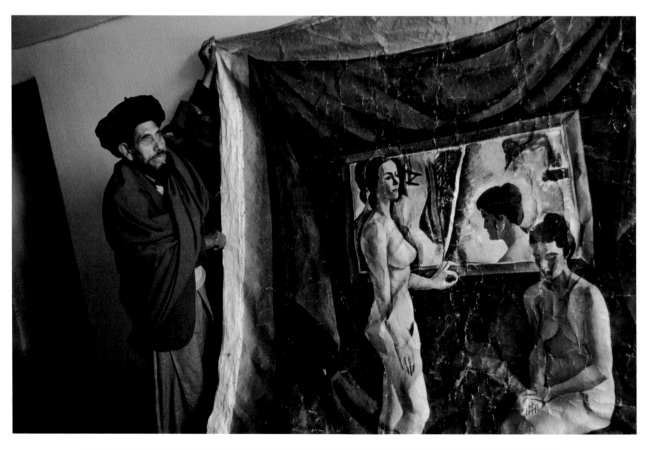

A GUARD SURVEYED REMNANTS OF THE NATIONAL MUSEUM'S ART COLLECTION SEQUESTERED BY THE TALIBAN.

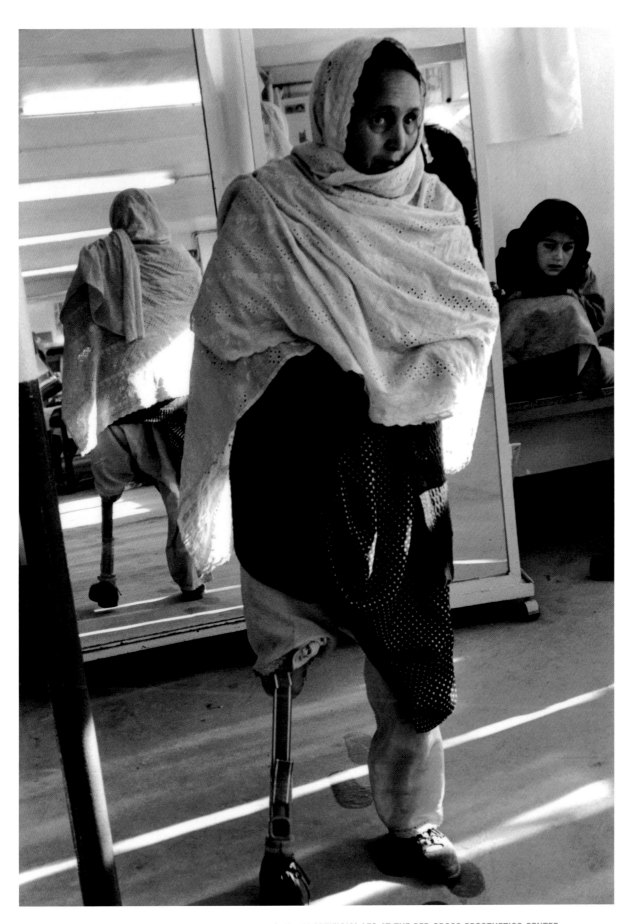

A WOMAN DISFIGURED BY A LAND MINE TRYING ON AN ARTIFICIAL LEG AT THE RED CROSS PROSTHETICS CENTER.

2001
INVISIBLE WAR

BY FRANCESCO ZIZOLA

Force, and fraud, are in war the two cardinal virtues.

—Hobbes, *Leviathan*

The U.S. Secretary of Defense Rumsfeld, citing Churchill, recently declared, "We will not report anything that might compromise our sources or methods." Then he authorized the Pentagon to lie to journalists whenever necessary.

In response to questions concerning proof of bin Laden's responsibility for the September 11 attacks, the White House press secretary stated, "You may have the right to ask that question, I have the right not to answer."

The first war of the twenty-first century is an invisible war, hidden from journalists and the public. It is obscene in the original sense used by the Greeks to denote things so malevolent that they should not be depicted on the stage.

Censorship and manipulation are the only rules that apply to the press in this war. It is a war conducted on behalf of global governments, and it has been declared incompatible with an open press. We are told that this is a struggle for "civilization" and "freedom from fear." Yet we are asked to sacrifice freedom of the press, which constitutes, together with the market and science, one of the pillars of liberalism.

After ordering the bombing of Afghanistan, President George Bush said, "It is the duty of

A CAMP FOR INTERNAL REFUGEES FLEEING THE AIR RAIDS NEAR THE KHOJA BAHAUDDIN IN TAKHAR PROVINCE.

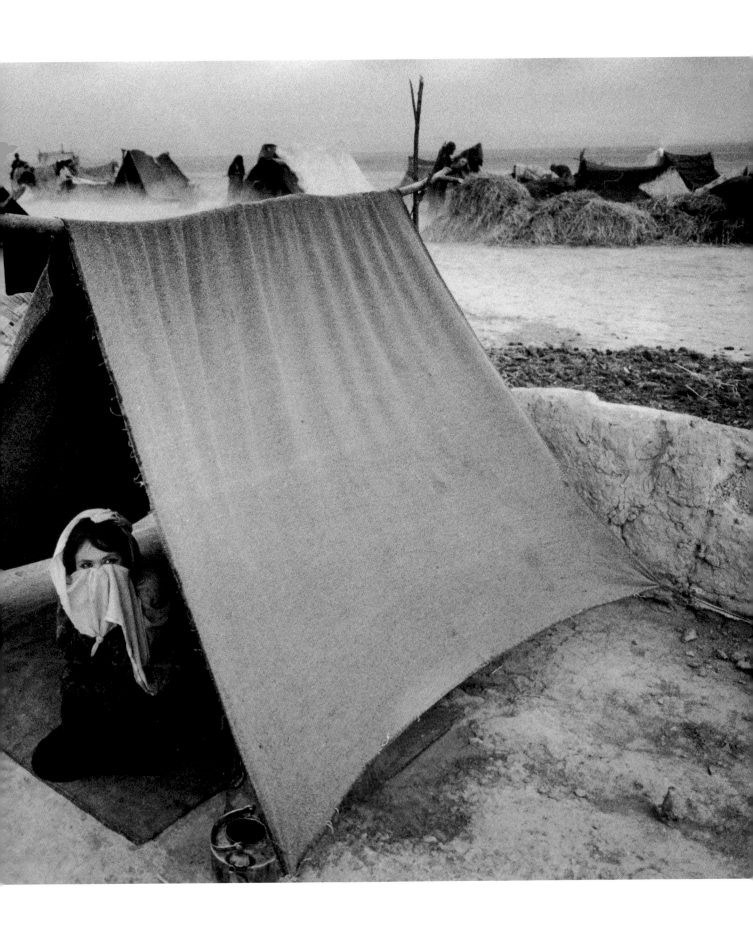

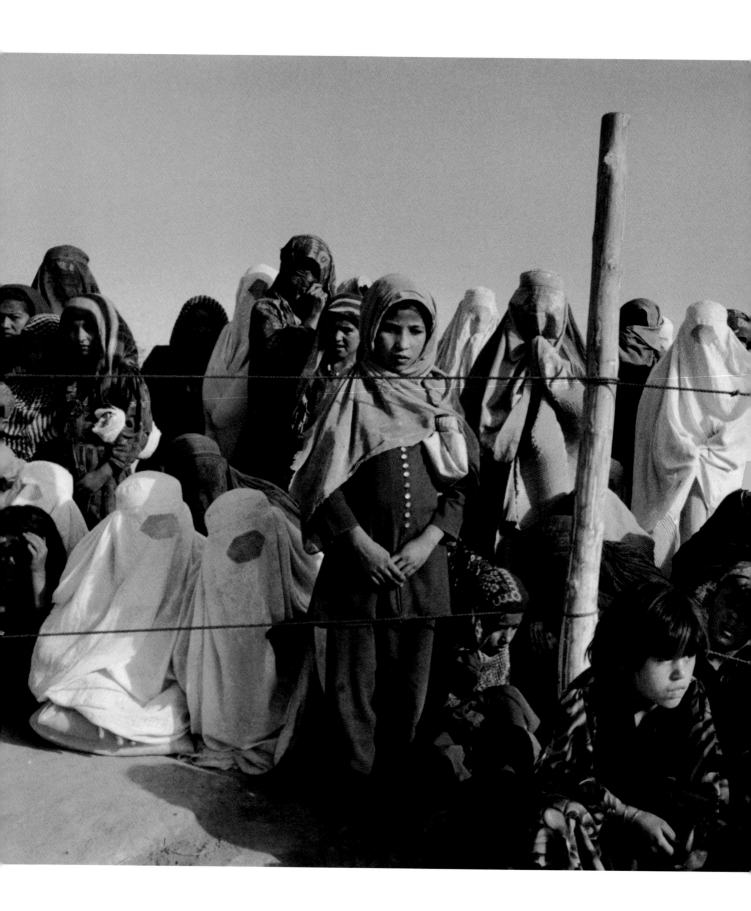

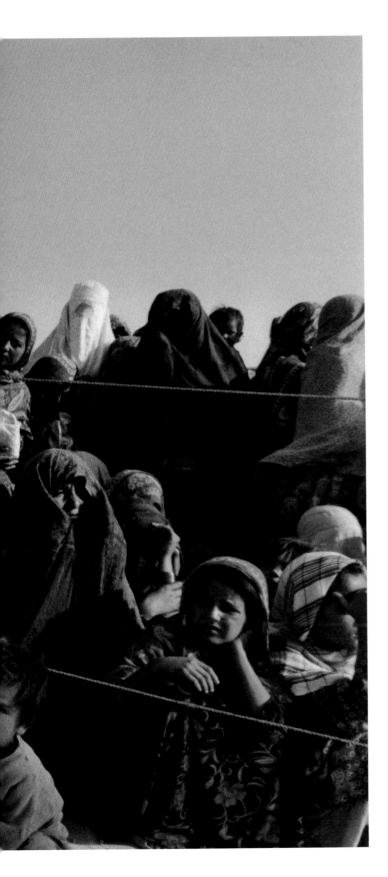

the United States of America. the freest country in the world, a country built on fundamental values that rejects hatred and violence, to fight murderers and evil. We will never tire of this."

There is a long list of countries where America has fought and bombed according to those principles since the end of World War II. It includes China, Korea, Cuba, Belgian Congo, Peru, Laos, Vietnam, Cambodia, Grenada, Libya, Guatemala, El Salvador, Nicaragua, Panama, Iraq, Bosnia, Sudan, Yugoslavia, and now Afghanistan.

To this should be added places where the battle was being waged indirectly by means of conspiracies, assassinations, and coups d'état. The U.S. has conducted many such covert actions including the massacre of hundreds of thousands in Indonesia from 1965 to 1966.

Another war that belongs on this list is the one against Iraq—not the one against the country or its 22 million people, who were the targets of those surgically-precise, laser-guided bombs, but the one against a single man, Saddam Hussein. The Western media has been working overtime to demonize this former ally and friend of George Bush Sr. and Margaret Thatcher, and to justify relentless bombing and countless civilian deaths while omitting the true reasons for this imperial violence. Why has this same media spent thirteen years ignoring the immense suffering of hundreds of thousands of people, especially children—victims of the embargo imposed upon Iraq by the U.S. and U.K.? In light of what has just occurred in Afghanistan, why do they consent silently to another invisible war against an artificially constructed enemy? How can they ignore what are most certain to be terrible consequences for civilians already reduced to extremes of poverty by a previous embargo? Are they not substituting one dictatorship for another, more friendly and manageable group of tyrants?

AT THE KHOJA BAHAUDDIN CAMP, WOMEN AND CHILDREN AWAIT FOOD DISTRIBUTION.

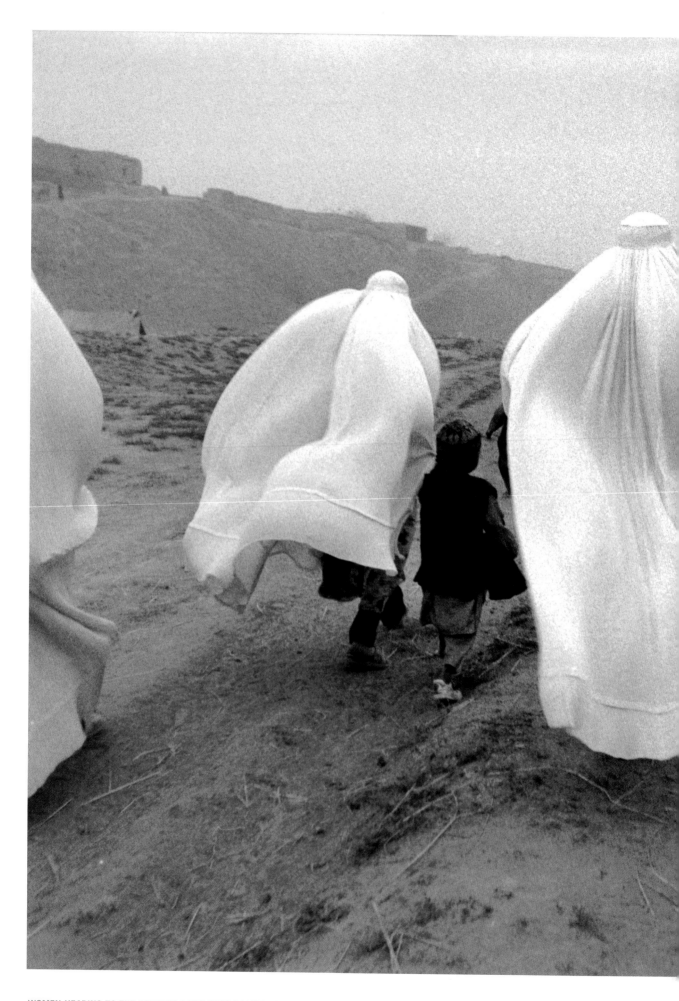

WOMEN HEADING TO THE REFUGEE CAMP NEAR DASHTI KOLA IN TAKHAR PROVINCE, NORTHERN AFGHANISTAN.

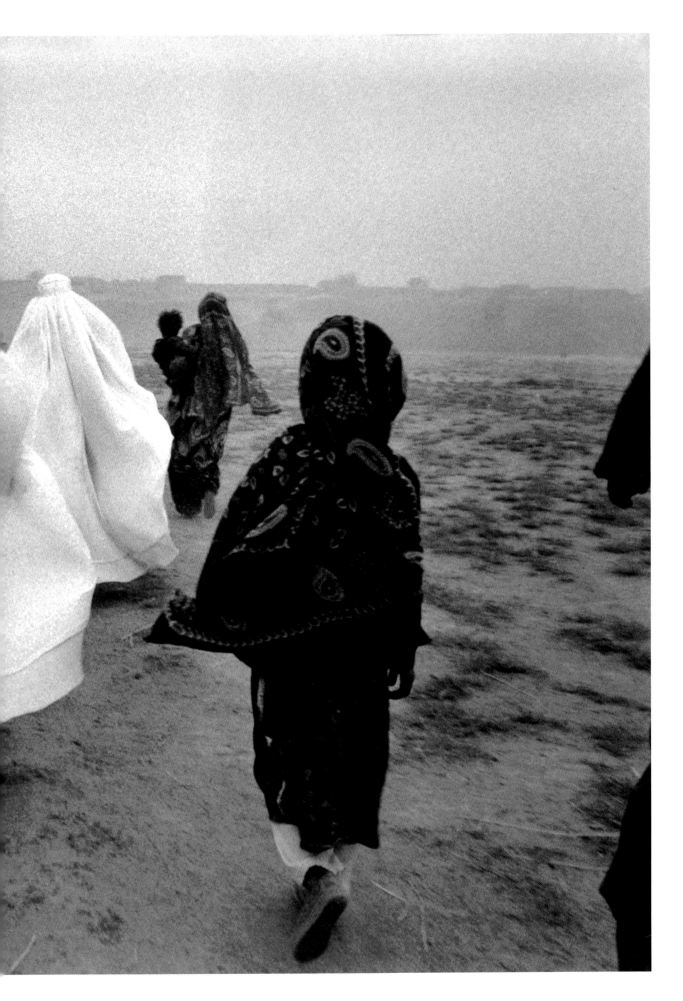

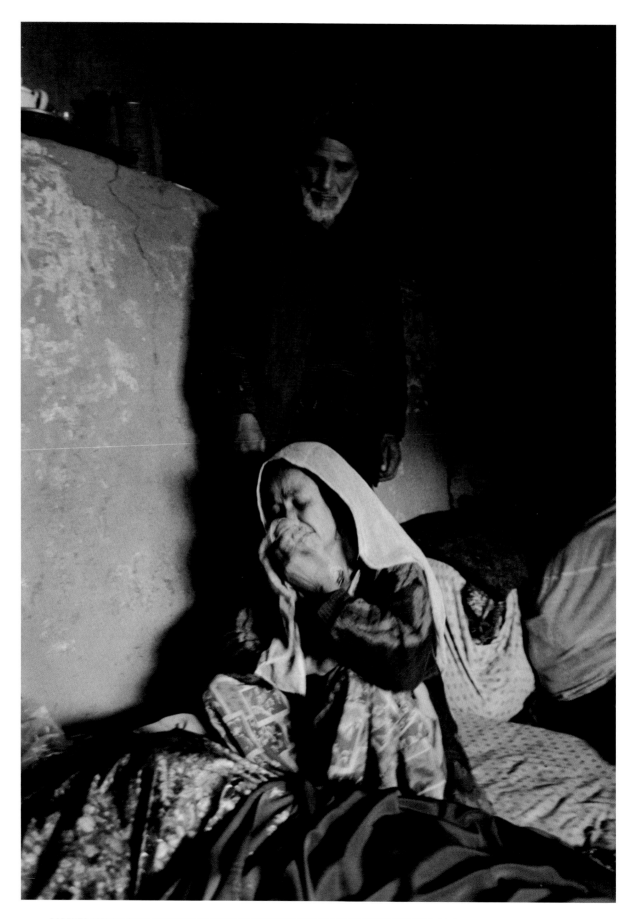

PARENTS MOURN OVER THE BODY OF THEIR 22-YEAR-OLD SON KILLED FIGHTING THE TALIBAN ON THE KALAKATA FRONT LINE.

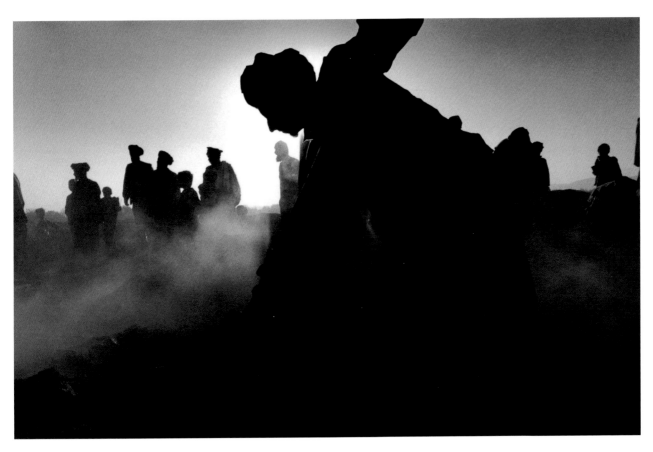

A GRAVEDIGGER PREPARES THE GROUND TO RECEIVE THE BOY'S BODY.

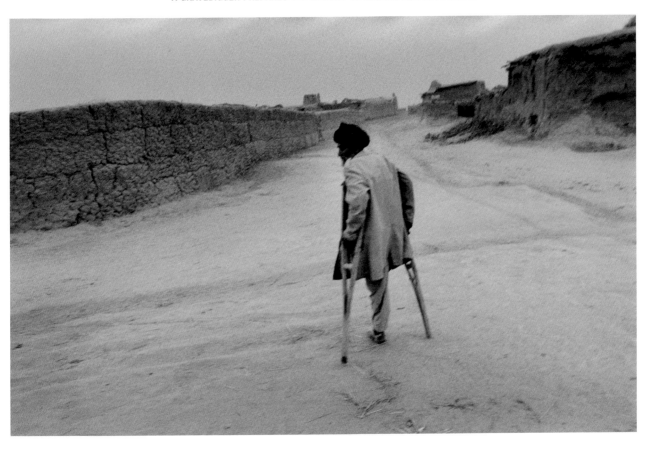

AN ELDERLY MAN WHO LOST HIS LEG IN A LAND MINE EXPLOSION HOBBLES TOWARD THE REFUGEE CAMP AT KHOJA BAHAUDDIN.

2001
THE DIGITAL
CORRESPONDENT

BY THOMAS DWORZAK

I begged to do this job, I thought to myself; I'm on a mission, I'm doing it for something. But mostly, I like doing it because I want to see it.

Most of my headaches for the first weeks had nothing to do with Afghanistan. All it had to with were things like PCI cables through USB connections or ISDN lines. I spent hours on the phone with some techies in front of the computer. Before digital, you would shoot, put the film in your pocket, and then ship it. This time I used a digital camera. I screwed up a lot of pictures because I was still thinking the old way. Which it wasn't, because I got haze on every picture. With digital, I auto-censored the image and omitted pictures that weren't going to work technically. Afterwards, I downloaded my files and looked at the pictures. It all looked so ugly. It's a total shock the first time you see unedited digital. Suddenly, you get the whole take, full-screen, everyday, like shooting Polaroid, but in a news story.

ALLIANCE TROOPS ASSEMBLE AT THEIR HEADQUARTERS IN TALOQAN IN PREPARATION FOR BATTLE AGAINST UNIFIED ELEMENTS OF THE TALIBAN'S NORTHERN COMMAND AT KUNDUZ.

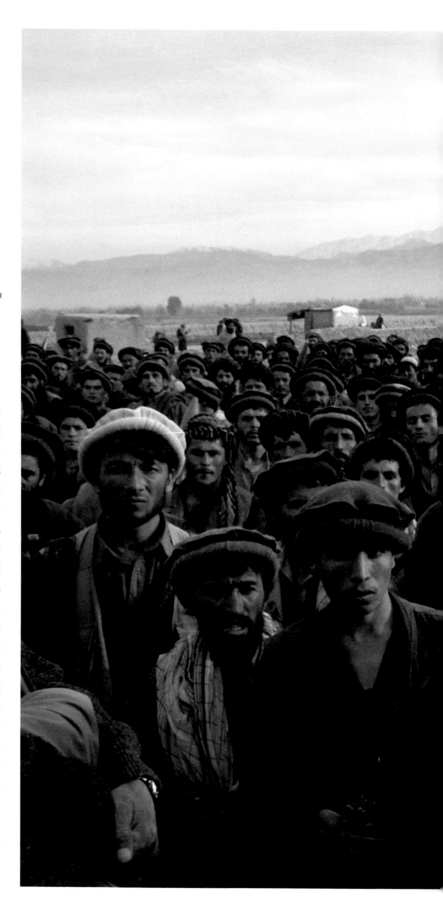

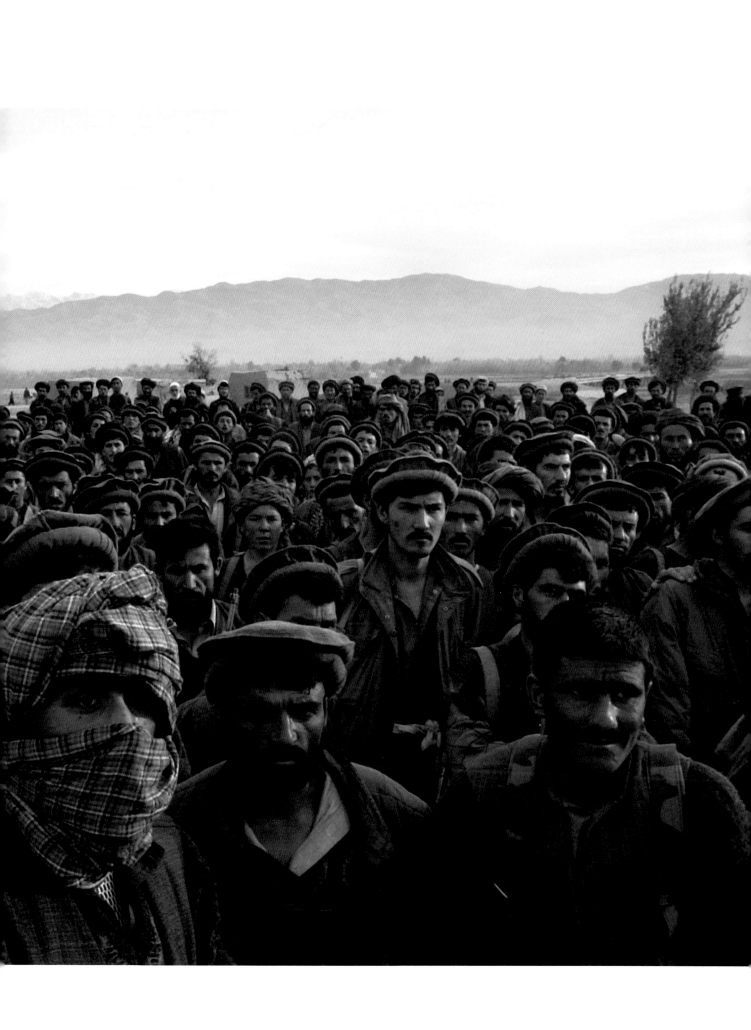

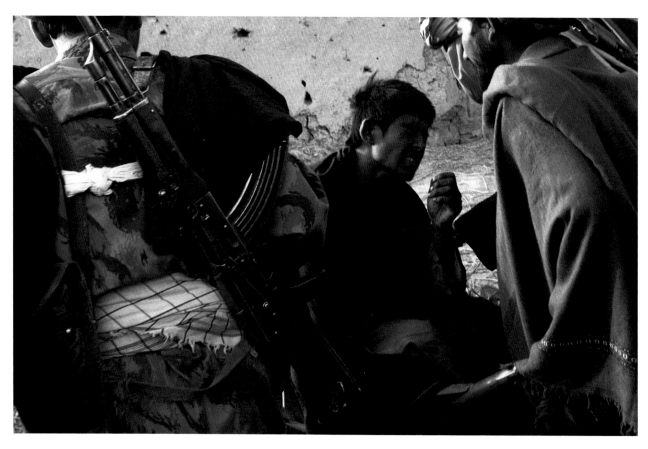

AN INJURED ALLIANCE SOLDIER NEAR KUNDUZ.

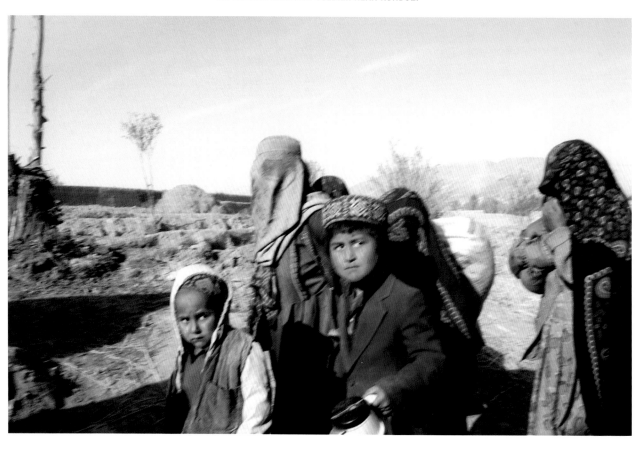

CIVILIANS FLEEING TALIBAN-CONTROLLED VILLAGES NEAR KUNDUZ.

ALLIANCE SOLDIERS CAMP NEAR THE KUNDUZ FRONTLINE.

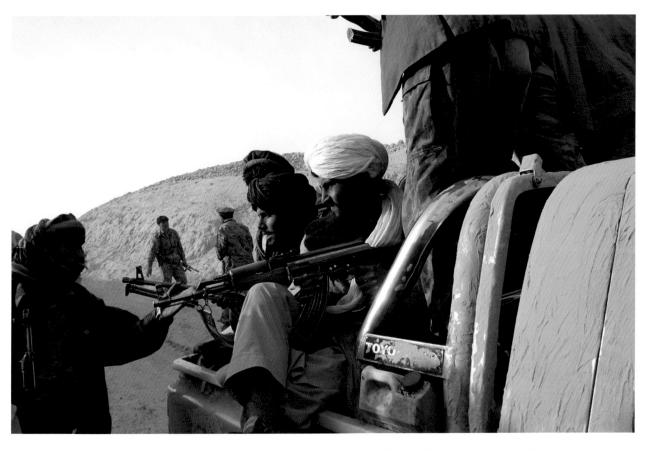

TALIBAN IRREGULARS (IN TRUCK) SURRENDER IN THE WAKE OF THE ALLIANCE'S ASSAULT ON KUNDUZ
THAT WAS SUPPORTED BY MASSIVE AMERICAN BOMBING RAIDS.

Another problem is that the digital camera is too big and delicate, so you're always protecting it. I broke my lens on the way in. Afterwards, I had to hold the new lens like a baby. I have to know about technical things that waste brain space. I haven't read a book in awhile. Instead of talking with other photographers about the conflict, I was figuring out the color balance scheme. You used to go around and meet some locals, you got drunk, anything. Now, no, the job has been reduced to programming or engineering functions. It's funny. But still okay because it's necessary if you want to be there.

If you did not have an assignment, you could forget about it. Afghanistan was unaffordable, the most expensive country in the world to cover. First, you had to get there. By mid-October 2001 the price had gone up to something like two thousand five hundred dollars per person to get into northern Afghanistan by convoy from Dushanbe, in Tajikistan. It was so expensive. If you couldn't pay, there was no point in continuing on. I saw some freelancers at

first, but they had to leave after a few days because they just couldn't afford it.

I was in total panic all the time. I wasn't sure if my story would run in *The New Yorker*. Then I was off assignment for two weeks. I had to really watch out not to lose all my money. When I could share expenses with another photographer, it was okay, but still more than you would spend anywhere else. And for nothing. For bad cars and bad roads. Bad translators. And horrible food. I don't want to seem greedy. I understand that the Afghans had a chance to make some money. But it's become a system now. You're seen as a photographer and a journalist who has a lot of money. You become an easy mark. In Chechnya, by comparison, the people are not much better off than the

LEFT: ALLIANCE TROOPS GUARD TALIBAN PRISONERS, SOME OF FOREIGN ORIGIN, IN DOHAB, A VILLAGE IN THE PANSHIR VALLEY; RIGHT: VILLAGERS OBSERVE DYING TALIBAN FIGHTER NEAR KABUL; FOLLOWING PAGES: A SANDSTORM OBSCURES ALLIANCE SOLDIERS AND UZBEK MERCHANTS CROSSING OVER FROM TALIBAN-HELD TERRITORY IN TAKHAR PROVINCE.

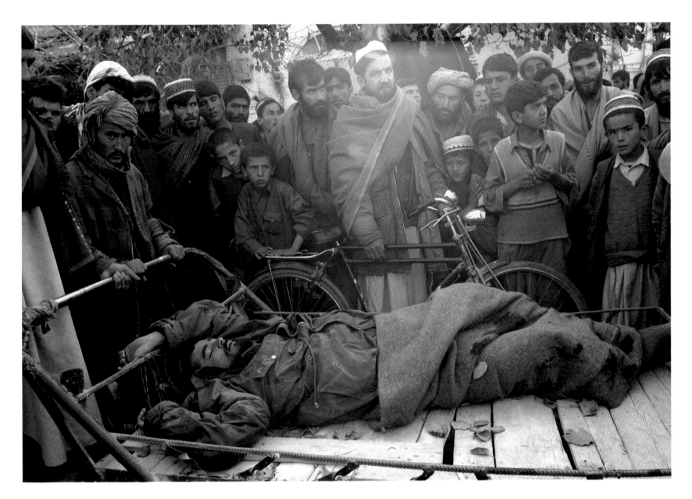

Afghans. However, if a village was bombed and you wanted to get from, say, Grozny to that village, you could always hitchhike by finding someone on the street. "Are you free? Can you help? Could we go to see this village?" And if he's free, he will drive you there and back. It's not about getting the whole thing for free. That's not the point.

There was a lot of spin in Afghanistan too. There were military parades staged for journalists. Some of the training in military academies was just for the journalists. They wanted to send a message. The Afghans are wonderful, the most accessible army people I've ever seen. They don't fool around either. If you wanted to go somewhere and wanted to get shot, your problem. Mostly they didn't do anything. You'd get beautiful front line access...for a guy sitting around and smoking and having tea.

The whole digital thing has made photojournalism a totally different enterprise now. I spent about fifteen grand on equipment. You have to archive all your shots, put a number on every scan. The whole thing is exorbitantly expensive. I

have to pay for little things, like the little flashcards which are delicate and break easily. You don't get reimbursed for film anymore, but you still have to shoot it because you have to duplicate all your work. So you still shoot film, only it's your own money. And then the whole thing with transmission. I bought my own satellite phone and thought, now I'm totally set. Everyone already has to have a mobile phone which is affordable when you're on assignment. If you're not on assignment, you really have watch out, because you get bloody bankrupt within a week. Now we're supposed to have our own sat phones in order to transmit digitally. That's ten times more than a mobile phone. I'm not arguing for a trade union, but...you have to charge a digital processing fee, which sort of pays off all the expenses—if you're on assignment. Sometimes I would take a day off just to stop spending money like crazy. If there's breaking news, then you have to keep going. Shipping, shooting, developing, transmitting—all in a night. You don't go out. You don't know a lot about the place. You're a bit stupid. That's the biggest danger....

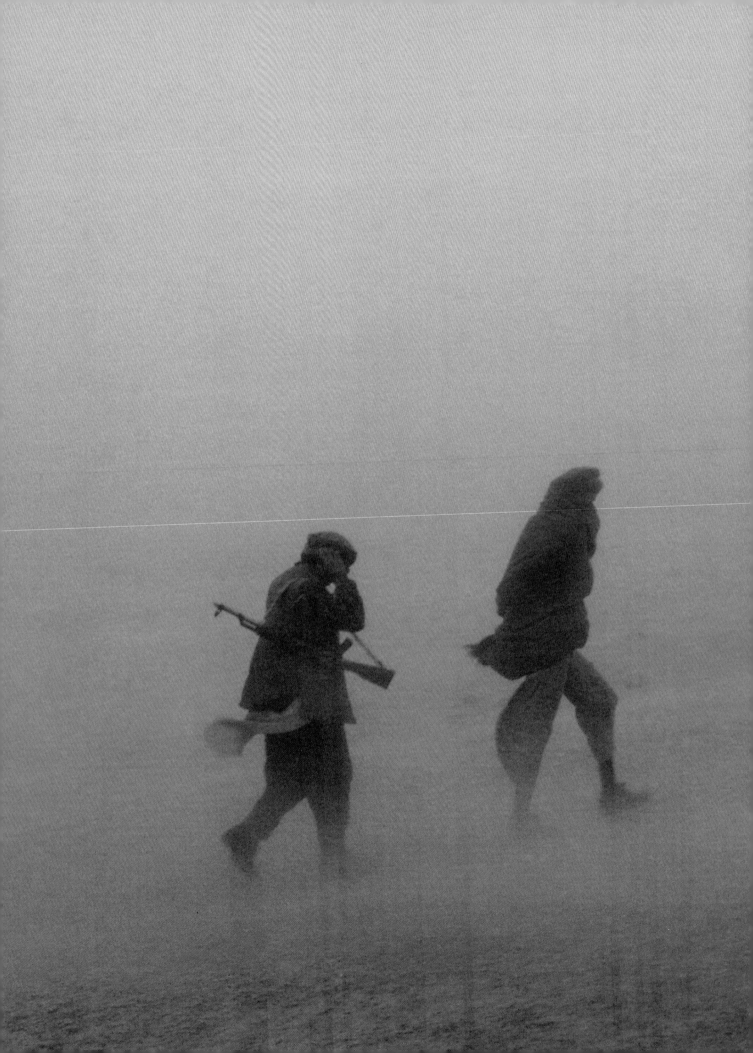

AN ALLIANCE SOLDIER AT PRAYER IN GULBAHAR IN THE PANSHIR VALLEY; FOLLOWING PAGES: A VIOLENT DRUG ADDICT CHAINED TO THE WALL OF

IMAGE AND IDENTITY
IN AFGHANISTAN

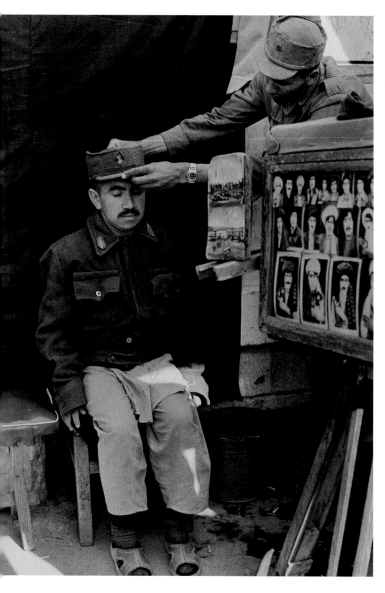

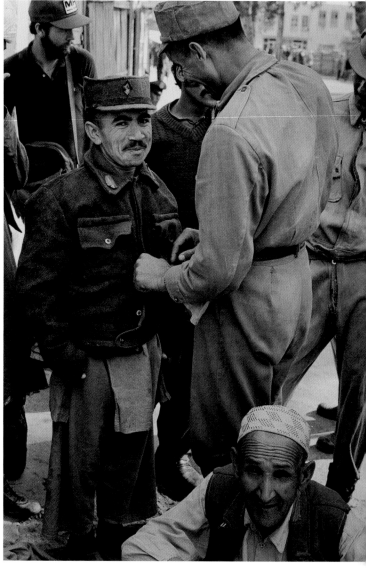

Afghanistan seems an unusual place to contemplate the effect of images and portraits. There exists no consumer culture where faces denote wealth or beauty, and beckon us to imitate them. Save for foreign journalists, there are few professional photographers, no disposable cameras to record the family picnic, and certainly nothing that resembles our obsessive fascination with television, in which we celebrate the anonymous and near-anonymous with a type of religious fervor. There are movies now and then, but they are confined to a designated time and space. In sum, the place suffers an image deficit.

In such an environment, the photographic portrait creates a state of arousal that connotes a wide range of possible uses. The subject may view his portrait as the manifestation of past generations, a record of ancestral time, or, by contrast, he may derive from it an objective self-awareness of the present. The portrait can mediate also between these two poles by reinforcing a supposed continuity that has been disturbed by the upheavals of history. In this way, the photographic portrait becomes an agent for cultural transmission. Alternatively, it permits the viewer to escape a personal isolation, and provides a way of being among others, albeit through images, and despite a Hobbesian state of permanent insecurity.

Another possibility is for the image to signify the very activity of self-reflection. Here it becomes the focal point for achieving identity. A widespread belief holds that portraits embody the soul, and must be avoided. Photography then becomes dangerous magic, akin to heresy in a religious society that condemns any rival to the deistic perspective.

In its tendency toward mechanical perfection and verisimilitude, the photographic portrait fascinated the Mujahid or Taliban in its ability to anticipate the ideals of paradise described in the Qur'an. It became a virtual space for portraying martyrdom in the face of serious doubts about the promised afterlife. This would explain the mullahs' eagerness to banish photography, much in the manner of St. Augustine's decree outlawing paintings in medieval convents and monasteries. The urge to project oneself shamelessly and narcissistically would likewise justify the impulse to sneak off for portraits in defiance of the austere edicts promulgated and enforced by the religious police.

HERAT, 1977

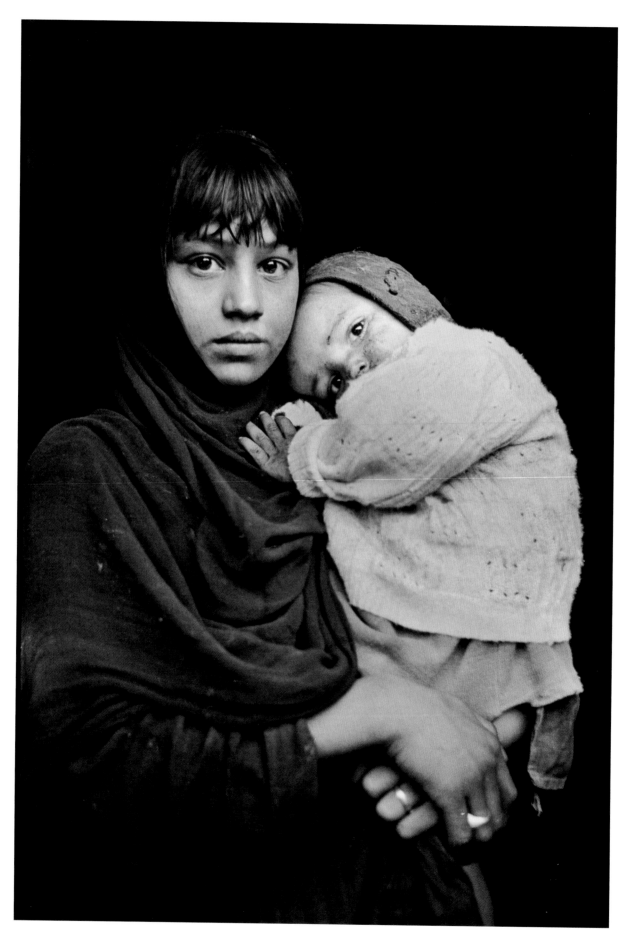

KUNAR PROVINCE, 1979.

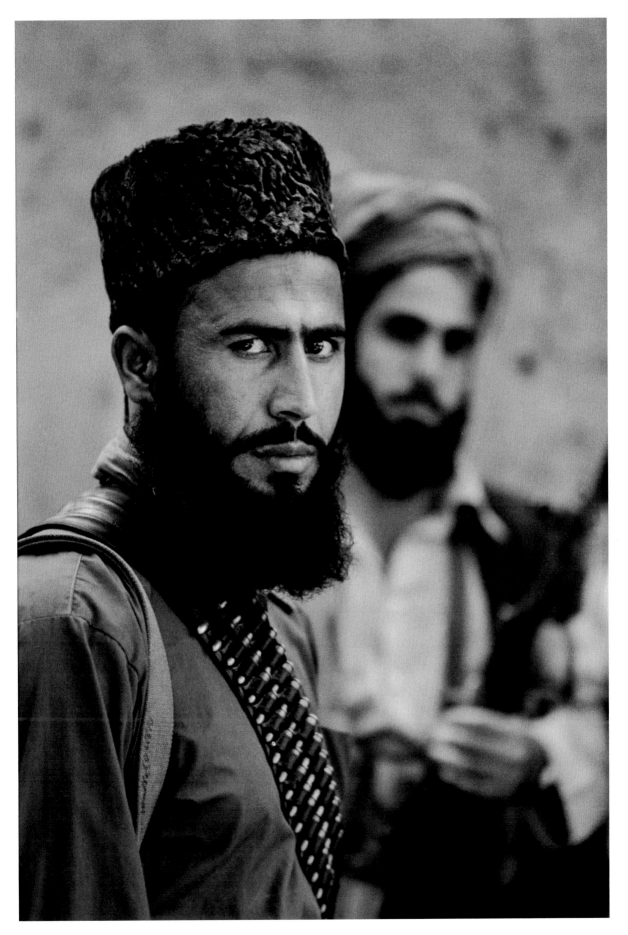

JALALABAD, 1980.

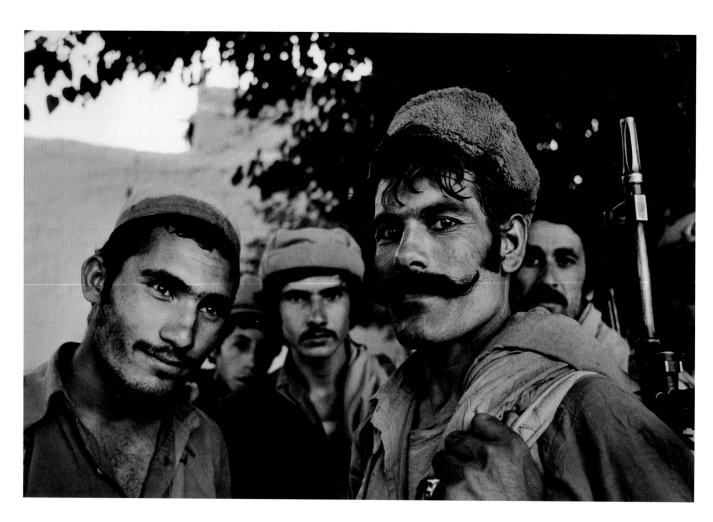

JALALABAD, 1980.

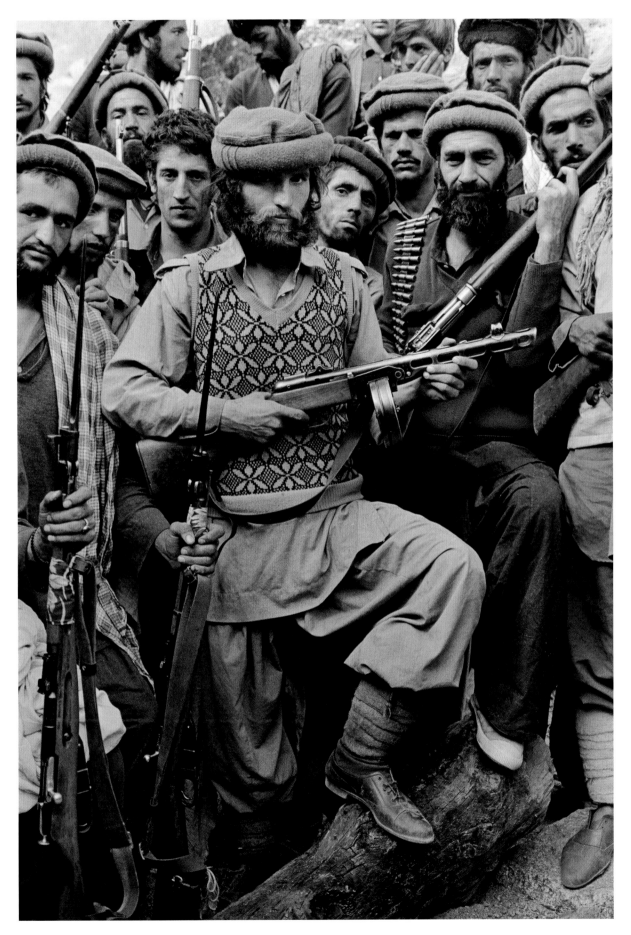

NURISTAN, 1979.

MULLAH MOHAMMED OMAR, TALIBAN LEADER.

MULLAH NOORUDDIN TURABI, TALIBAN MINISTER OF JUSTICE.

2002
AFTER
THE REVOLUTION

BY JOHN LEE ANDERSON

The austerity of the Taliban was particularly anomalous in the Pashtun homelands of eastern and southern Afghanistan, of which Kandahar is the principal city. Mosques, for instance, are more architecturally ornate in the Pashtun region than they are in the north. The streets are filled with motorized rickshaws covered with fanciful bronze embossing and shiny decals. Trucks are decorated with painted tin panels and wooden bulwarks, like the prows of old-fashioned schooners. Metal gewgaws dangling from their fenders tinkle as the trucks lumber along. Pashtun men, Kandaharis in particular, are very conscious of their personal appearance. Many of them line their eyes with black kohl and color their toenails, and sometimes their fingernails, with henna. Some also dye their hair. It is quite common to see otherwise sober-seeming older men with long beards that are a flaming, almost punk-like orange color. Burly, bearded men who carry weapons also wear chaplis, colorful high-heeled sandals.

I noticed that to be really chic in Kandahar you wear your chaplis a size or so too small, which means that you mince and wobble as you walk. Afghans from other regions joke about the high incidence of pederasty among Kandahari men. They say that when crows fly over Kandahar they clamp one wing over their bottoms, just in case. One of the first things the Taliban did—a popular move—was to punish Mujahidin commanders accused of rape or pederasty. Homosexuals who were sentenced to death faced a particularly grisly end. Tanks or bulldozers crushed them and buried them under mud walls. Pederasty was evidently a continuing source of concern to Mullah Omar, who decreed that Taliban commanders couldn't have beardless boys in their ranks.

In downtown Kandahar, directly across from a row of small bakeries and the run-down Noor Jehan hotel, Kandahar's finest, there are several hole-in-the-wall photo shops. After the exodus of the Taliban from the city in early December, the proprietors

hung portraits of their clients in the windows, along with photographs of famous people like Bruce Lee, Leonardo DiCaprio, Ahmad Shah Massoud, and King Zahir Shah. There are many portraits of Taliban fighters posing in front of curtains or painted backdrops. They hold guns and bouquets of plastic flowers. Some are alone, others are with a friend. Some sit rigidly side by side, and a few have their arms draped over one another, and some even clasp their hands together affectionately.

Said Kamal, the proprietor of the Photo Shah Zada shop, did a brisk business in Taliban portraits. Kamal specializes in retouched photos. His artful brushwork removes blemishes and adds color. The backdrops of his portraits are vivid greens or blues with halos of red and orange, and clothing has been transformed from the drab to the garish. Many of the Taliban sat for their portraits with heavily kohled eyes, which made them look like silent-movie stars. Taliban portraits lie under the glass of Said Kamal's front counter and hang on the wall in tin frames. He said that they belong to Taliban who fled the city, and he doesn't expect them to be picked up. I found this confusing, since Mullah Omar had enforced the Koranic prohibition on representations of the human image, but Kamal explained that, after the ban on images was announced and the Taliban forced the photo shops to shut down, they realized that even they needed passport pictures. There was no way around it, if they wanted to travel. So an exception was made to Mullah Omar's edict. Officially, Said Kamal made passport photographs, and he formally complied with the rules, displaying no pictures of human beings in his shop window. But the rules were never fully obeyed by everyone. Said Kamal continued to make portraits of the Taliban, just as he continued taking clandestine wedding pictures at the request of ordinary Kandaharis.

Originally published in The New Yorker, January 28, 2002.

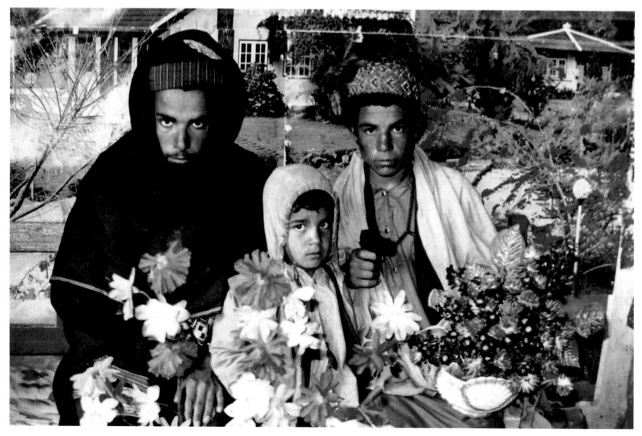

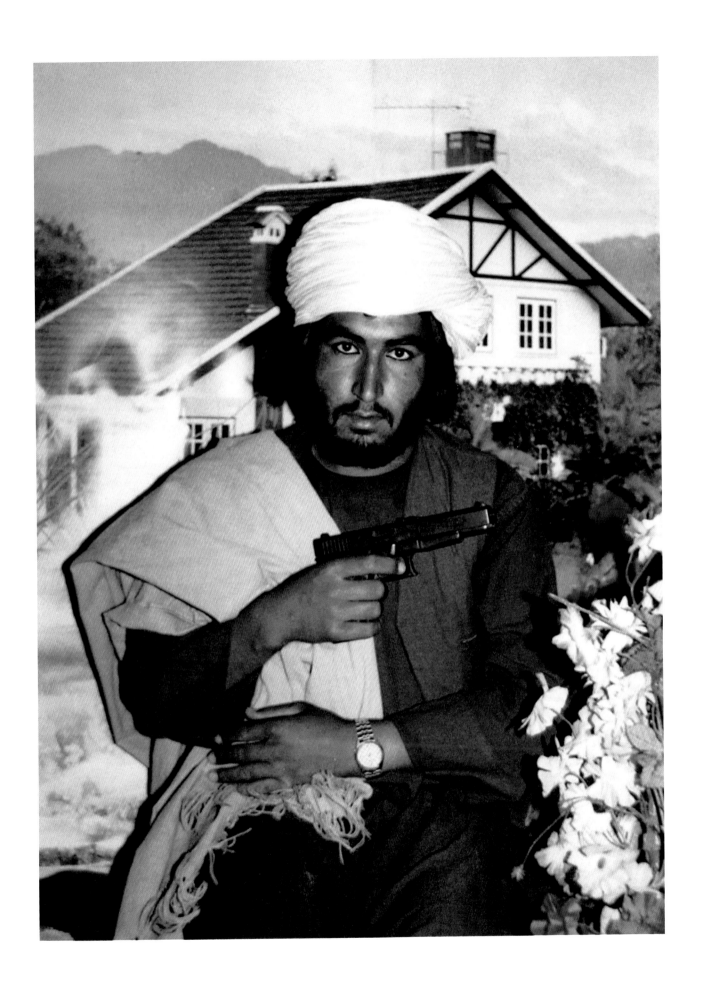

AHMAD SHAH MASSOUD, THE "LION OF PANSHIR," WAS ASSASSINATED ON SEPTEMBER 9, 2001.

ACKNOWLEDGEMENTS

I am appreciative for Professor Douglas Brinkley's permission to reprint "Eisenhower in Kabul," based on his scholarly examination of Ike's presidential papers and an eyewitness account of the trip; it provides a succinct analysis of Afghanistan's role in the Cold War, pinpointing in time the equilibrium whose collapse led to the present disaster. The book concludes with "After the Revolution," John Lee Anderson's report from Kandahar after the Taliban were routed in late 2001.

Following the events of September 11, the publishing industry witnessed a modest revival in photojournalism. With typical verve, Magnum's executives understood the potential for a journalistic exercise that would be unfettered by timid publishers, doddering editors, and self-consumed designers. Someone nominated me as editor, and I accepted enthusiastically when Nathan Benn, New York bureau chief, called to ask. I was dissatisfied by the media's coverage of Afghanistan, and resented the corporate gerrymandering of cable, broadcast, print, and the Internet that results in the rationing of information and a generally deflated sense of reality. The creation of this state of "information inequality" is evidence of oligopoly and a deepening social crisis. In the absence of varying perspectives and multiple sources, there is no basis for free and open debate. Consequently, we cannot help either ourselves or the Afghan people to solve this mess.

But do not look herein for political consensus. That is improbable with Magnum photographers. My collaboration aims only to put their work into circulation in a manner that guarantees its integrity. If we accomplish this small task, it also might be possible to reaffirm the very existence of an independent media as counterweight to the satellite divas and government flak-catchers who manipulate the news.

I am grateful to Eve Arnold, Abbas, Elliott Erwitt, and Steve McCurry, who quickly endorsed my efforts with this book by committing their photographs to this project. Philip Jones Griffiths generously provided sound criticism and his indispensable photographic wisdom. Peter Marlow and Thomas Hoepker sanctioned the project from within Magnum's executive committee. Nathan Benn assembled the team. Designers Yolanda Cuomo and Kristi Norgaard cheerfully kept pace with the rapid deadlines. David Strettell managed the editing and pre-production with exceptional skill and professionalism. Hamish Crooks oversaw the process in London, while Jimmy Fox, an editor's editor, led me through the archives in Paris. Dannette Walker deftly shuffled contact sheets, prints, and slides. Jinx Rodger organized her late husband's work. Thanks to Ed Grazda for bringing Khalid Hadi's portraits of the infamous Taliban leaders to my attention. Pablo Inirio made prints in New York. Jolie Stahl lent me her critical focus and good sense. Finally, publishers Daniel Power and Craig Cohen stepped forward decisively to give this book life. It is to be hoped that powerHouse Books will prosper as an oasis for the authors of concerned photography.

—Robert Dannin
New York City
May 2002

Arms Against Fury
Magnum Photographers in Afghanistan

© 2002 Magnum Photos, Inc.

Preface © 2002 Mohammad Fahim Dashty
"Eisenhower in Kabul" © 2002 Douglas Brinkley
"Behind the Veil" © 2002 Lesley Blanch/London Sunday Times
"After the Revolution" © 2002 John Lee Anderson
All other text © 2002 Robert Dannin

Published in the United States by powerHouse Books,
a division of powerHouse Cultural Entertainment, Inc.
180 Varick Street, Suite 1302, New York, NY 10014-4606
telephone 212 604 9074, fax 212 366 5247
e-mail: info@powerHouseBooks.com
web site: www.powerHouseBooks.com

in association with Magnum Photos, Inc.
151 West 25th Street, New York, NY 10001-7204
telephone 212 929 6000, fax 212 929 9325
email: photography@magnumphotos.com
web site: www.magnumphotos.com

First edition, 2002

Library of Congress Cataloging-in-Publication Data:
Arms against fury : Magnum photographers in Afghanistan / edited by Robert Dannin.
 p. cm.
 ISBN 1-57687-151-7
 1. Afghanistan--History--20th century. 2. Afghanistan--History--2001- 3.
Afghanistan--History--20th century--Pictorial works. 4.
Afghanistan--History--2001---Pictorial works. I. Dannin, Robert, 1952- II. Magnum
Photos, inc.

DS361 .A77 2002
958.104--dc21

 2002068438

Hardcover ISBN 1-57687-151-7

Separations, printing, and binding by Artegrafica, Verona
Design associate, Kristi Norgaard

A complete catalog of powerHouse Books and Limited Editions is available upon request;
please call, write, or visit our web site.

10 9 8 7 6 5 4 3 2 1

Printed and bound in Italy

BOOK DESIGN BY YOLANDA CUOMO, NYC